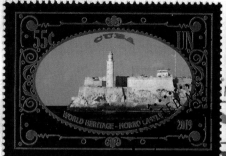

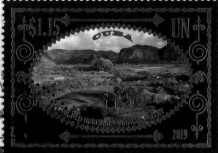

"Nothing Cuban is alien to me."

Emilio Crut (signature)

WORLD HERITAGE
OCTOBER 24, 2019 · FIRST DAY OF ISSUE

PATRIMOINE MONDIAL
PREMIER JOUR : 24 OCTOBRE 2019

World Heritage CUBA

Patrimoine mondial CUBA

Welterbe KUBA

Cover of the United Nations Postal Administration

KUBA
WELTERBE
ERSTTAG: 24. OKTOBER 2019

D1088113

DELIVERING CUBA THROUGH THE MAIL

Cuba's Presence in Non-Cuban Postage Stamps & Envelopes

EMILIO CUETO

Design & Digital Processing:
TRACY E. MACKAY-RATLIFF

All stamps illustrated are in the collection of the author
 - except for figures:

Figs.57-64, p.30	Fig.235, p.51
Fig.86, p.34	Fig.238, p.52
Fig.94, p.35	Fig.413, p.73
Figs.104-107, p.37	Fig.879a, p.157
Figs.108-115, 116, 119, p.37	Fig.892, p.160
Figs.157-168, 173 p.42	Fig.897, p.161
Figs.213-214, p.43	Fig.904, p.163
Fig.222, 224, p.48	Figs.955, 956, p.173

Library of Congress Cataloging-in-Publication Data:
Names: Cueto, Emilio, author. | George A. Smathers Libraries, publisher.
Title: Inspired by Cuba: Delivering Cuba Through the Mail, Cuba's Presence
 in Non-Cuban Postage Stamps and Envelopes / Emilio Cueto.
Description: Gainesville, FL : Library Press @ UF, 2021 |
 Summary: This book explores the many ways in which the island
 of Cuba has been immortalized in stamps and envelopes from outside
 of Cuba. The protagonist of this book is Cuba itself, seen through the
 eyes of stamp creators outside of Cuba.
Identifiers: ISBN 9781944455101
Subjects: LCSH: Cuba--On postage stamps. | Postage stamp design. |
 Commemorative postage stamps. | Cuba--In art. | Envelopes (Stationery).
Classification: HE6185.C9 C84 2021

Para la Biblioteca
de Catholic
University,
Alma Mater

Eli. Cueto

Class of '65

DELIVERING CUBA

THROUGH THE MAIL

Cuba's Presence in Non-Cuban
Postage Stamps & Envelopes

INTRODUCTION

ST. VINCENT
Bee Hummingbird
Mellisuga helenae

PEOPLE

FLORA & FAUNA

PLACES

HISTORICAL & INTERNATIONAL EVENTS

INTERNATIONAL GAMES, PHILATELIC EVENTS, CONGRESSES, FAIRS, MEETINGS & PROGRAMS

FOREIGN RELATIONS

FIRST FLIGHTS & OTHER COMMEMORATIVE COVERS

MISCELLANEOUS

ROUGH RIDERS

"ROUGH RIDERS" WAS THE NAME APPLIED TO THE 1ST U.S. CAVALRY AND 2ND VOLUNTEER CAVALRY IN THE SPANISH-AMERICAN WAR. THESE REGIMENTS, WESTERN RANCHMEN, COMMANDED BY THEODORE THE USA.

CONTENT

José Antonio Medina

Son

Emissão Conjunta Brasil - Cuba

Son INTRODUCTION

"To find a Havana Coco taxi in a Burundi stamp, a native crocodile in Djibouti, a rare mushroom in Argentina, a baseball player in Tajikistan, a chess champion in Laos, a TV personality in Mongolia and Cuba's coat of arms in the Order of Malta is, indeed, **surreal!**"

Emilio Cueto

Inspired by Cuba! DELIVERING CUBA THROUGH THE MAIL ★ CUETO

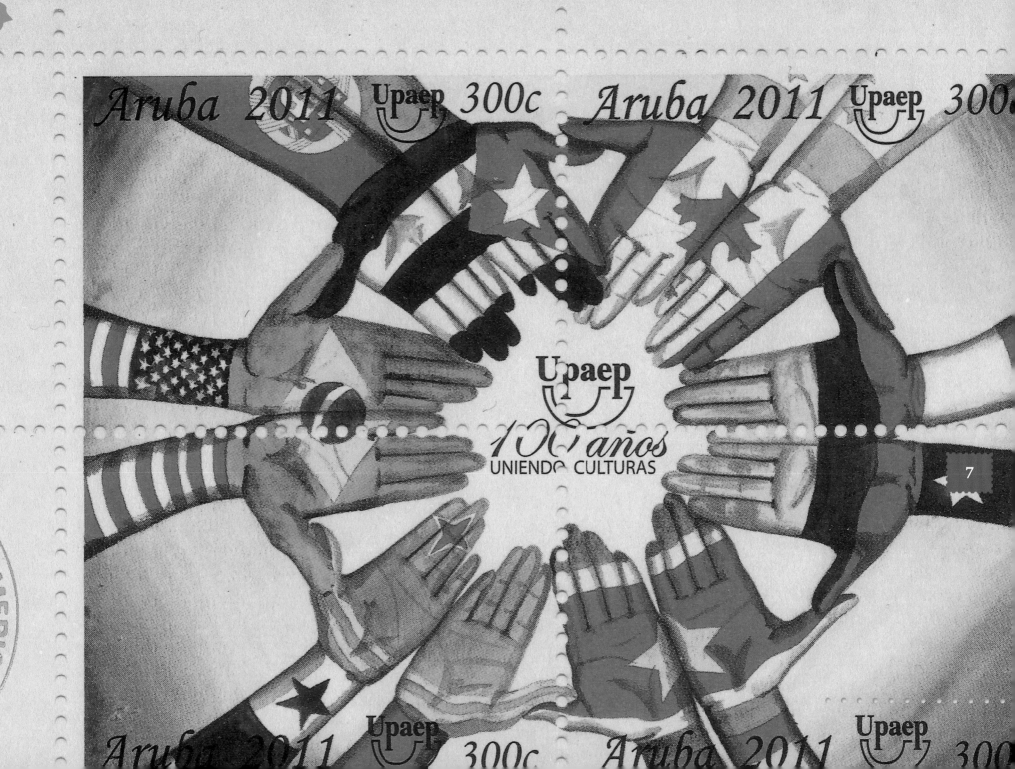

INTRODUCTION

O n May 1st, 1840, the United Kingdom issued the first postage stamps in the world: the Penny Black and Two Pence Blue. Other countries soon followed: United States (1847), France and Belgium (1849), Spain, Switzerland, Austria and Prussia (1850) and many more in the ensuing years. In Cuba, then a colony of Spain, the first stamp was used in 1855 and it depicted the image of Queen Isabella II, the sovereign of the Spanish Empire at the time.

I am no expert in postal history but it makes perfect sense that the images on the stamps have reflected, in a good number of cases, the landscape, people, events and peculiarities of their respective issuing countries. After all, a traveling stamp is one important medium for a country to honor its outstanding citizens and convey its own story to the world at large. Stamps are, in a very real sense, the ambassadors of the countries they represent.

Not surprisingly, the first US stamp (1847) illustrated Benjamin Franklin; France (1849) depicted the French Republic using the image of Ceres, the Roman goddess of Agriculture; Mexico (1856) chose the freedom-fighter priest Miguel Hidalgo y Costilla; Venezuela (1859), Costa Rica (1863) and Guatemala (1871) printed their respective coat of arms; El Salvador (1867) shared its Izalco volcano; and Bolivia (1867) its mighty condor.

In 1899, after Cuba had become separated from Spain and was under US occupation, the first set of Cuban stamps (printed in the US) included an image of Columbus, who discovered an island in 1492, a group of Cuban royal palm trees, the statue of an Indian woman representing the island, a rural scene featuring a field plowed by oxen, and a steamship, highlighting Cuba's lifeline to the rest of the world. Cuba was beginning to tell its own story on stamps. And that has been the practice ever since.

As a result, finding Cuba-related images in Cuban postage stamps is to be expected and comes as no surprise to anyone. Much less known and studied is that fact that, from time to time, Cuba somehow shows up in foreign postage stamps as well as in so-called cinderellas (resembling stamps, but not issued for postal purposes). It also appears in the design of souvenir sheets outside of the stamps themselves and in the cachets printed on commemorative envelopes and post cards. This is a fascinating story in itself and the one we propose to tell in this book for the first time.

Unexpected as it may sound, my research has uncovered the presence of Cuba and Cubans in at least 1232 stamps (counting, for purposes of this book, every single relevant stamp within a so-called souvenir sheet), envelopes and stationery printed between 1896 and 2021. They were issued by postal authorities in 161 countries and international organizations. In the case of postal stationery, private actors were also involved. The list of countries, in alphabetical order for easy reference, appears as an appendix to this text.

To find a Havana Coco taxi in a Burundi stamp, a native crocodile in Djibouti, a rare mushroom in Argentina, a baseball player in Tajikistan, a chess champion in Laos, a TV personality in Mongolia and Cuba´s coat of arms in the Order of Malta is, indeed, surreal! Moreover, I am sure that further research will yield additional stamps that I may have missed and that many more stamps will be issued in the years to come.

That a small island in the Gulf of Mexico could make such an impact in the world of philately—54 countries and postal issuing entities in Europe, 39 in Latin America and the Caribbean, 33 in Africa, 22 in Asia, 11 in Oceania, 3 in North America and even a fake country—is the larger narrative of this book. It should be noted that Cuba´s fraternal ties with the socialist world beginning in the 1960s resulted in a significant Cuban presence in the stamps of those regions.

9

Of all the countries represented, the US tops the list, not so much in terms of stamps, but of covers with Cuba-related imagery (at least 109 pieces). The next most prolific countries are St. Vincent/ St. Vincent and the Grenadines (41), Dominican Republic (38), Guinea (36), Grenada (30), Ukraine (30), Mali (29), Russia (28), Mongolia (27), Nicaragua (27), Chad (26), Congo, Democratic Republic (23), Vietnam (22), Niger (20), Sierra Leone (19), Spain (19), Congo, Republic (18), El Salvador (16), Togo (16), and Venezuela (16).

If the geographic span is impressively wide, so is the thematic spectrum. The stamps herein depict images of Cubans from all walks of life (politics, music, sports, literature), views of world heritage sites, samples of the island´s extended flora and fauna, Cuba´s role in international affairs and sport events, etc. The Cuban flag finds itself displayed in dozens of stamps and envelopes, while five prominent individuals command a remarkable and recurrent presence: communist party leader Fidel Castro (141), guerilla fighter Che Guevara (126), Cuban-American TV personality Desi Arnaz (67), chess master José Raúl Capablanca (61), and patriot, writer and *Apóstol* José Martí (38).

In addition, as fate would have it, Cuba was a protagonist in two of the most significant events of the last 500 years: Columbus' discovery of the Americas in 1492, which brought the world together for the first time, and the nuclear confrontation between the US and the USSR during the October 1962 missile crisis, which threatened to tear that world apart. Both events have been amply documented in world stamps, with Cuba taking center stage.

As would be expected, most views of Cuban localities depicted in foreign stamps show its capital, Havana. A few postal authorities, however, have ventured inland. Poland published an image of the Bellamar caves (Matanzas province) in 1980; in 2012, Guinea incorporated views of Trinidad and Santiago de Cuba in the background of its stamps about Pope Benedict XVI's visit to Cuba; and the Ivory Coast featured the Cienfuegos Provincial Government Palace the next year. More recently, the United Nations issued a set of stamps honoring Cuba´s world heritage sites in the provinces of Pinar del Río, Cienfuegos, Sancti Spiritus, Camagüey and Santiago de Cuba.

Not all individuals depicted in foreign stamps and envelopes who had an impact in Cuba have been included in this book unless the stamp or envelope itself has a specific reference to Cuba. Important figures such as Santiago de Cuba´s mayor Hernán Cortés (1485-1547), Friar Bartolomé de las Casas (1484-1566), English pirate Henry Morgan (1635-1688), Dutch privateer Piet Heyn (1577-1629), German explorer Alexander Humboldt (1769-1859), Spanish Bishop and Saint Antonio Maria Claret (1807-1870) and American nurse Clara Barton (1821-1912), to name but a few, while highly important in Cuban affairs, were also famous for their activities elsewhere. To expand the list in this book to add all such individuals would, in my opinion, expand the scope of this work beyond its reasonable boundaries, as it

10

Inspired by Cuba! DELIVERING CUBA THROUGH THE MAIL ⋆ C U E T O

would necessarily have to incorporate hundreds of additional actors, including every King and Queen of Spain and every President of the United States. Similarly, depictions of plants and animals common in, but not endemic to, Cuba, are not included in this book unless the Cuban connection is evident.

Cuba's presence in the foreign postal world has run the course of one hundred and twenty-five years (1896-2021). It all started as early as May 19, 1896, on the first anniversary of the death of José Martí, when a patriotic cover with a Cuban flag was posted in New York City by Benjamín Guerra, Treasurer of the Cuban Revolutionary Party (illustrated in Yamil H. Kouri Jr., *Under three flags: the postal history of the Spanish-Cuban/American War (1895-1898)*. Chicago, The Collectors Club of Chicago, 2019, p. 101). Many more such patriotic envelopes were printed in the US in 1898, during the Spanish-Cuban-American War, and 1899. Then, beginning with the late 1920s, there was a steady growth of Cuba-themed stamps and envelopes, each decade surpassing the one before.

To allow the reader to make interesting and useful comparisons, I studied the inventory of stamps and postal stationery that is the subject of this book in eight contextual and thematic categories: People; Flora & Fauna; Places; Historical & International Events; International Games, Philatelic Events, Congresses, Fairs, Meetings & Programs; Foreign Relations; First Flights & Other Commemorative Covers; and Miscellaneous. Needless to say, these categories are not mutually exclusive and, thus, the same stamp/envelope will sometimes be listed in each relevant category. However, each stamp will be illustrated only once, generally in the context which prompted the postal issue.

I am not aware of any stamp book which has attempted to depict how a given particular country has fared in world philately. It would be fascinating to compare the presence of, say, Argentina, Brazil, Colombia, Mexico, Venezuela, even Spain, in the stamps of other countries with that of Cuba's significant imprint.

Stamp collecting has been for many decades a favorite hobby of countless people throughout the world. In order to assist collectors in their search and identification of stamps, many specialized catalogs have been issued. The standard world catalog in the United States is Scott International Stamp Album (Sc). Other well-known catalogs with worldwide coverage are Michel (Mi), Stanley Gibbons (SG) and Yvert et Tellier (YT). Spain's stamps are well documented in Edifil. Whenever possible, I have added the Scott catalog number of the stamps herein (and, if readily available, references to other catalogs as well). By consulting these catalogs, the reader can find out additional information, including exact date and context of issue, dimensions, printing techniques and wording on the stamps.

A note on the names of countries. First, the same country may have changed its own name with the passing of time. Thus, what is today Cambodia was once Kampuchea, the two Congos have gone through various name modifications and the former Soviet Union broke up and its core region reverted to its old name of Russia.

In addition, the official name of the country in its own language is one, but often gets a different translation in English: Dominican Republic is República Dominicana, Germany is Deutschland, Hungary is Magyar, Ivory Coast is Côte d´Ivoire, Spain is España. In this book each country will be listed in its current English name as used in the Scott International Stamp Album (2019 edition). The list of countries and the end of the book will include references to other known names for easier recognition.

The reader should be aware that not all stamps are issued by legitimate governments, and many breakaway countries and internal subdivisions do issue postage of their own, probably in search of recognition and acceptance. This phenomenon occurs, for example, in several regions of the Russian Federation in whose name illegal stamps are being issued. Among these entities we shall mention Abkhazia, Altai, Bashkiria, Buriatia, Chechnya, Komi, Kuril Islands, Mari-El, Sakha Yakutia, Tararstan, Tuva and Udmurtia. Other "countries" are simply fake, like P.R. Tongo. In addition, from time to time, unofficial stamps show up in the market in the name of a legitimate postal authority. A list of these "illegal" stamps may be found at The Universal Postal Union WNS website and in specialized publications.

While many people in the philatelic community shy away from these issues–and they are not featured in the Scott Stamp Album–those stamps are included in this book so as to document Cuba´s presence in those remote sections of the world (or in the imagination of fakers).

Finally, there is the issue of personalized stamps, which allow a customer to use a photo or image of his/her own choice and convert it into a regular postage stamp. I am aware of at least two distinguished Cubans featured in these types of stamps: chess Master José Raúl Capablanca (1888-1942) in Spain (TuSello) and social worker and human rights activist Elena Mederos (1900-1981) in the US (PhotoStamps by Stamps.com). Because of the private nature of these stamps, their limited circulation and the impossibility to track them all down, they will not be studied in this book.

Needless to say, it is to be expected that, in the future, more Cuban images will find their way into foreign stamps, so we must keep our eyes open.

GOOD HUNTING!

Ofelia Cuesta
6312 Wilson La.
Bethesda MD 20817

20817$5534

12

Alligator mississippiensis

GRACIAS A TODOS.

A BOOK SUCH AS THIS IS, QUITE OBVIOUSLY, THE RESULT OF MANY WILLS AND HANDS AT WORK.

My thanks go first to my friends at the University of Florida (Gainesville, FL, USA), particularly Dean Judith Russell and Dr. Laurie Nancy Francesca Taylor, who welcomed this new proposal in the context of a UF-sponsored program designed to strengthen Cuban-American scholarly encounters.

13

1. ABKHAZIA
2. AITUTAKI
3. ALBANIA
4. ALGERIA
5. ALTAI
6. ANGOLA
7. ANGUILLA
8. ANTIGUA
9. ARGENTINA
10. ARUBA
11. AUSTRALIA
12. AUSTRIA
13. BAHAMAS
14. BARBADOS
15. BASHKIRIA
16. BELARUS
17. BELGIUM
18. BELIZE
19. BENIN
20. BHUTAN
21. BOLIVIA
22. BRAZIL
23. BULGARIA
24. BURIATIA
25. BURKINA FASO
26. BURMA/MYANMAR
27. BURUNDI
28. CAMBODIA
29. CAMEROON
30. CANADA
31. CAYMAN ISLANDS
32. CENTRAL AFRICAN
 REPUBLIC
33. CHAD
34. CHECHNYA
35. CHILE
36. CHINA/ CHINA,
 PEOPLE'S REPUBLIC
37. COLOMBIA
38. COMORO ISLANDS/
 COMOROS
39. CONGO/ DEMOCRATIC
 REPUBLIC
40. CONGO/ REPUBLIC
 OF CONGO
41. COOK ISLANDS
42. COSTA RICA
43. CYPRUS
44. CZECHOSLOVAKIA/
 CZECHIA
45. DHUFAR
46. DJIBOUTI
47. DOMINICA
48. DOMINICAN REPUBLIC
49. EASDALE ISLAND
50. ECUADOR
51. EL SALVADOR
52. FALKLAND ISLANDS
53. FAROE ISLANDS
54. FINLAND

55. FRANCE
56. GABON/
 REPUBLIQUE GABONAISE
57. GAMBIA
58. GERMANY
59. GHANA
60. GIBRALTAR
61. GREAT BRITAIN
62. GREECE
63. GRENADA
64. GRENADA GRENADINES
65. GUATEMALA
66. GUERNSEY
67. GUINEA/ GUINEA-CONAKRI
68. GUINEA BISSAU/
 GUINÉ-BISSAU
69. GUYANA
70. HAITI
71. HONDURAS
72. HUNGARY/ MAGYAR
73. ICELAND
74. INDIA
75. INDONESIA
76. IRAN
77. IRELAND
78. ISRAEL
79. ITALY
80. IVORY COAST
81. JAMAICA
82. KABARDINO BALKARIA
83. KAZAKHSTAN
84. KHAKASSIA
85. KOMI
86. KOREA, DEMOCRATIC
 PEOPLE'S REPUBLIC
87. KURIL ISLANDS
88. KYRGYZSTAN
89. LAOS
90. LESOTHO
91. LIBERIA
92. LUXEMBOURG
93. MALAGASY REPUBLIC
94. MALAYSIA
95. MALDIVES
96. MALI
97. MANAMA
98. MARI-EL
99. MARSHALL ISLANDS
100. MEXICO
101. MOLDOVA
102. MONGOLIA
103. MONTSERRAT
104. MOZAMBIQUE
105. THE NETHERLANDS
106. NEVIS/
 ST. KITTS & NEVIS
107. NICARAGUA
108. NIGER
109. ORDER OF MALTA

110. OLYMPIC LOCAL
 POST-AUSTRALIA
111. PANAMA
112. PAPUA NEW GUINEA
113. PARAGUAY
114. PERU
115. POLAND
116. PORTUGAL
117. ROMANIA
118. RUSSIA
119. RWANDA
120. SAKHA/ YAKUTIA
121. ST. KITTS/
 ST. KITTS & NEVIS
122. ST THOMAS AND PRINCE
123. ST. VINCENT/ ST. VINCENT
 & THE GRENADINES
124. SAMOA
125. SAN MARINO
126. SERBIA
127. SIERRA LEONE
128. SLOVENIA
129. SOLOMON ISLANDS
130. SOMALIA
131. SOUTHERN SUDAN
132. SPAIN
133. SRI LANKA
134. SURINAME
135. SWEDEN
136. TAJIKISTAN
137. TANZANIA
138. TATARSTAN
139. TOGO
140. TRANSNISTRIA
141. TURKEY
142. TURKMENISTAN
143. TURKISH REPUBLIC OF
 NORTHERN CYPRUS
144. TURKS AND CAICOS ISLAND
145. TUVA/ TYVA/ TOUVA
146. TUVALU
147. UDMURTIA
148. UGANDA
149. UKRAINE
150. UNITED NATIONS
151. UNITED STATES/ US
152. URUGUAY
153. VANUATU
154. VATICAN CITY
155. VENEZUELA
156. VIETNAM, DEMOCRATIC
 PEOPLE'S REPUBLIC
157. VIRGIN ISLANDS, BRITISH/
 BRITISH VIRGIN ISLANDS
158. WALLIS & FUTUNA
159. YEMEN/ PEOPLE'S
 DEMOCRATIC REPUBLIC/
 SOUTH YEMEN
160. YUGOSLAVIA/JUGOSLAVIA
161. ZAMBIA

CUBA'S PRESENCE

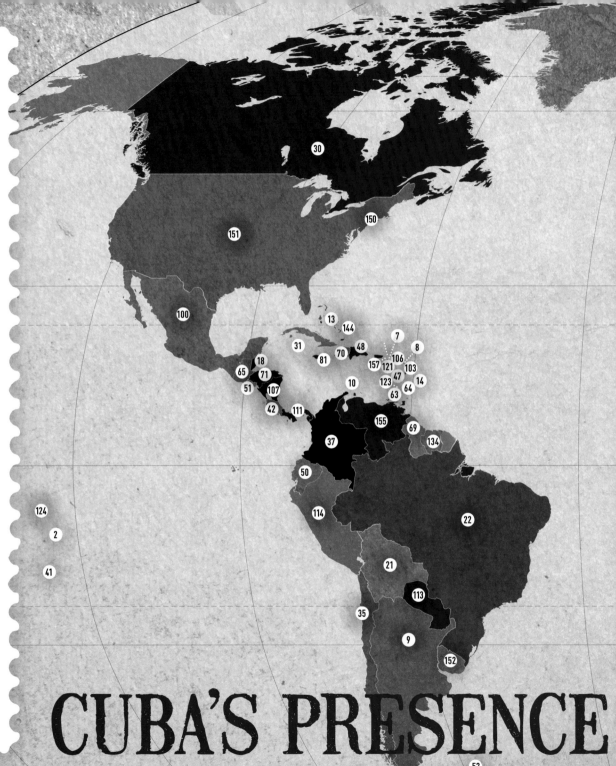

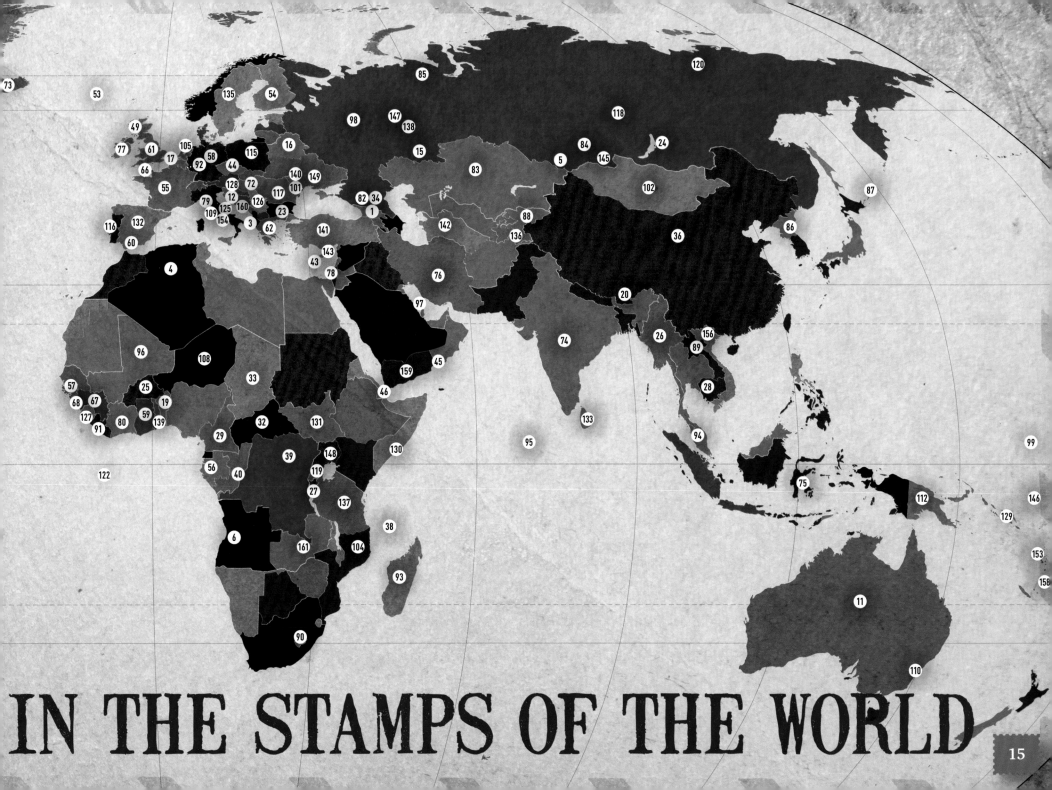

IN THE STAMPS OF THE WORLD

15

Cubans of all walks of life have been depicted in non-Cuban stamps: politicians and military leaders, sportsmen, musicians, literary figures, engineers, cosmonauts, even royalty.

PEOPLE

POLITICAL & MILITARY LEADERS

The following individuals, presented in chronological order of birth, have shaped the political landscape of the island. Not all were Cuban-born themselves, but their trajectories are inseparable from Cuban history.

HATUEY

(HISPANIOLA, ? – YARA, CUBA, FEBRUARY 2, 1512).

Taino chief from neighboring Hispaniola who led a rebellion of the natives in the island Cuba against the Spanish conquistadors. He died at the burning stake in Yara. A bust of Hatuey by Cuban sculptor Thelvia Marin (1922-2016) was placed in Quito´s Indoamerican Plaza in 1974 and is illustrated in the stamp from Ecuador.

18

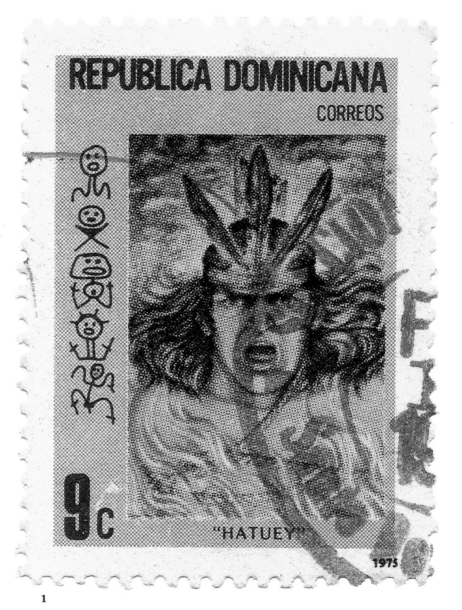

1

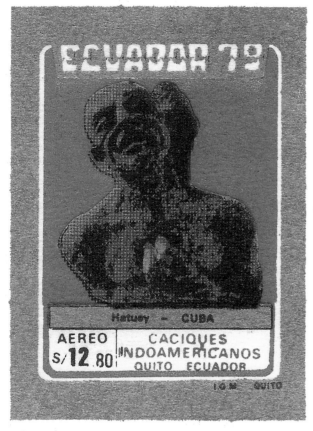

2

NARCISO LÓPEZ

(CARACAS, NOVEMBER 2, 1797 – HAVANA, SEPTEMBER 1, 1851).

After settling in Cuba from Venezuela, he moved to the United States to organize military expeditions against Spanish rule in the island. As an exile in New York, he was involved in the design of Cuba´s flag, which he brought to Cuba in 1850. Made prisoner on his third expedition, he was executed in Havana in 1851.

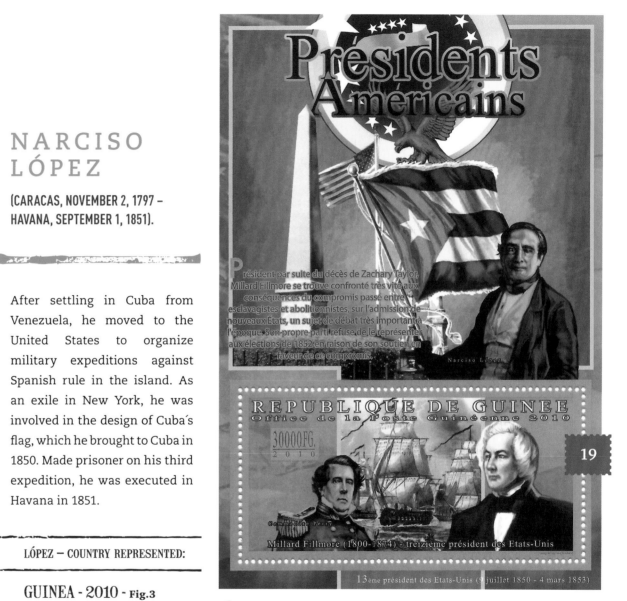

3

HATUEY — COUNTRIES REPRESENTED:

DOMINICAN REPUBLIC - 1975 - Fig.1
ECUADOR - 1980 - Fig.2

LÓPEZ — COUNTRY REPRESENTED:

GUINEA - 2010 - Fig.3

Fig.1. *Dominican Republic, 1975 (Sc 752, Mi 1104, YT 776);* **Fig.2.** *Ecuador, 1980 (Sc C 674);* **Fig.3.** *Guinea, 2010.*

TOMÁS ESTRADA PALMA

(BAYAMO, JULY 9, 1835 – SANTIAGO DE CUBA, NOVEMBER 4, 1908).

AND FIRST LADY

In his native Bayamo, Don Tomás joined the fight against Spain in 1868. He lived in exile in Honduras, where he married Genoveva Guardiola (1858-1926). Exile leader in New York, he was elected the first president of the Republic of Cuba (1902-1906) and his wife became Cuba's first First Lady.

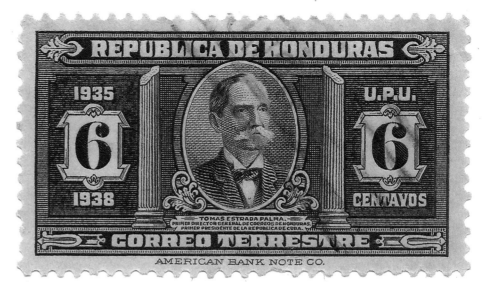

4

MR. & MRS. ESTRADA PALMA —
COUNTRIES REPRESENTED:

HONDURAS - 1938 - Fig.4
- 1956 - Figs.5, 6
- 1966 - Fig.7

Fig.4. *Honduras, 1938 (Sc 331, Mi 335, SG 368);*
Fig.5. *Honduras, 1956 (Sc C251, Mi 173);*
Fig.6. *Honduras, 1956 (Sc CO72);*
Fig.7. *Honduras, 1966 (Sc 389).*

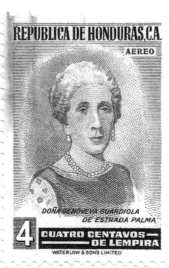

5

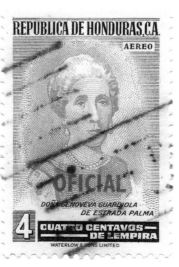

6

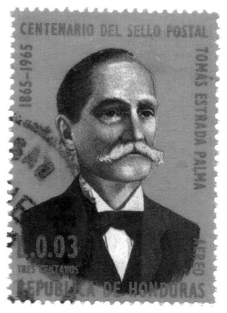

7

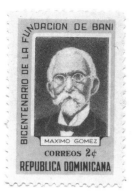

8

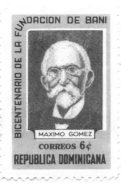

9

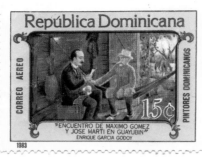

10

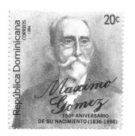

11

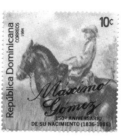

12

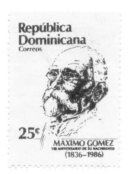

13

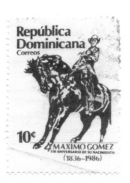

14

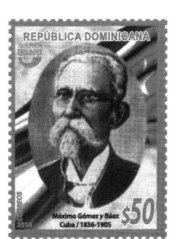

17

MÁXIMO GÓMEZ

(BANÍ, DOMINICAN REPUBIC, NOVEMBER 18, 1836 – JUNE 17, HAVANA, 1905).

Gómez arrived Cuba in 1865 and joined the rebellion against Spain, fighting on Cuban soil for three decades (1868-1898). Mayor General (*Generalísimo*).

GÓMEZ — COUNTRIES REPRESENTED:

DOMINICAN REPUBLIC - 1964 - Figs.8, 9
- 1983 - Fig.10
- 1984 - Figs.11, 12
- 1986 - Figs.13, 14
- 1995 - Figs.15, 16
- 2014 - Fig.17

15

16

Figs.8, 9. *Dominican Republic, 1964 (Sc 594-595);* Fig.10. *Dominican Republic, 1983 (Sc 893, SG 1560);* Figs.11, 12. *Dominican Republic, 1984 (Sc 921-922);* Figs.13, 14. *Dominican Republic, 1986 (Sc 993-994);* Figs.15, 16. *Dominican Republic, 1995 (Sc 1183, Mi 1736; SG 1891, Sc 1185, Mi 1738, SG 1893);* Fig.17. *Dominican Republic, 2014 (Sc 1562c).*

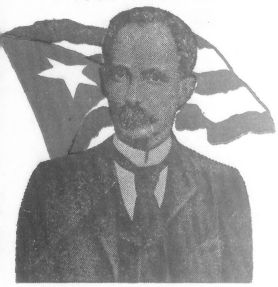

HOMENAJE DE COLOMBIA
A
JOSE MARTI

LA HABANA Enero 28, 1.853

DOS RIOS Mayo 19, 1.895

CLUB FILATELICO DE BOGOTA

22

JOSÉ MARTÍ

(HAVANA, JANUARY 28, 1853 –
DOS RÍOS, ORIENTE, MAY 19, 1895).

Cuba's foremost political and literary figure. Often referred to as the Apostle and the most universal of all Cubans. For a more detailed description of Martí´s presence in the world stamps, see Emilio Cueto, "Martí en el mundo", in *Opus Habana* (Havana), Vol XII no 3, Sept. 2009- Jan. 2010, pp. 34-5 [Filatelia de colecciones]. The absence of Martí among the stamps of Guatemala, the United States and Venezuela is truly regrettable.

Particularly surprising is his appearance in *Dream of a Sunday Afternoon in the Alameda Central*, the masterpiece by Mexican muralist Diego's Rivera (1886-1957). In 1982, Guinea Bissau issued a limited-edition gold foiled stamp depicting Martí's 1915 Cuban gold coin.

MARTÍ – COUNTRIES & POSTAL
AUTHORITIES REPRESENTED:

ARGENTINA - 1995 - Fig.18
CHINA - 1953 - Fig.19
COLOMBIA - 1995 - Figs.20, 21, 22
COSTA RICA - 1995 - Fig.23
DOMINICAN REPUBLIC - 1954 - Fig.24
 - 1983 - Fig.10, p.21
 - 1995 - Figs.25, 15-16, p.21
 - 2003 - Fig.26
 - 2014 - Fig.27
EL SALVADOR - 1953 - Figs.30-35
GUINEA BISSAU - 1982 - Fig.44
HUNGARY - 1973 - Fig.28
INDIA - 1997 - Fig.29
INDONESIA - 2008 - Fig.52
MEXICO - 1986 - Fig.36
 - 1995 - Fig.37
NICARAGUA - 1983 - Figs.38, 39
 - 1989 - Fig.40
PARAGUAY - 1995 - Figs.41, 42
SPAIN - 1995 - Fig.43
UNITED NATIONS - 2012 - Fig.45
 - 2015 - Figs.46-51

जोस मार्टी
JOSE MARTI

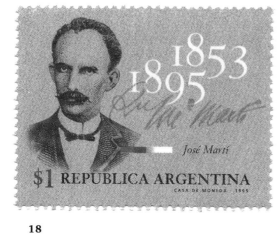

18

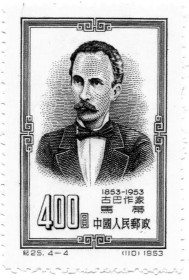

19

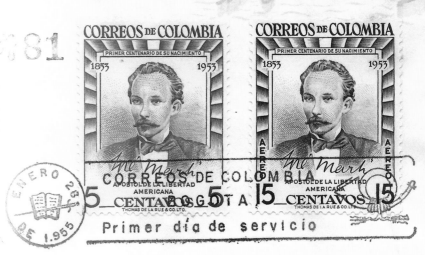

20 21

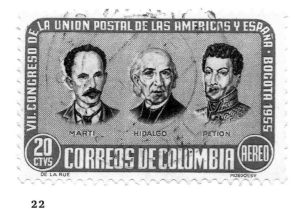

22

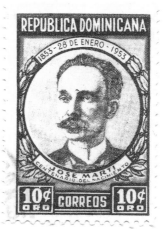

23 24

23

Fig.18. Argentina, 1995 (Sc 1886, Mi 2249); Fig.19. China, 1953 (Sc 203); Figs.20, 21. Colombia, 1955 (Sc 634, Mi 724-725 SG 840); Fig.22. Colombia, 1955 (Sc 635); Fig.23. Costa Rica, 1995 (Sc 479; Mi 1445); Fig.24. Dominican Republic, 1954 (Sc 457, YT 430).

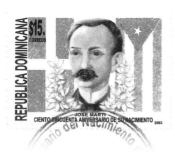

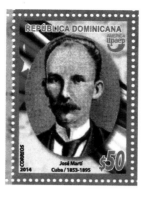

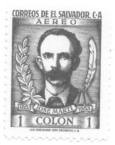
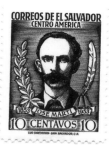
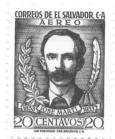

25

26

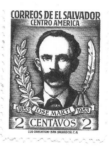

27

30

31

32

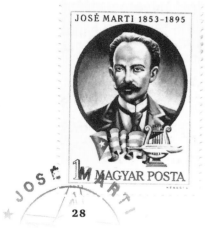

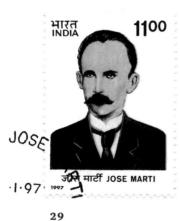

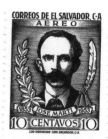

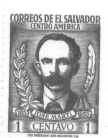

28

29

33

34

35

Fig.25. *Dominican Republic, 1995 (Sc 1183-1185, Mi 1736-1738, SG 1891-1893);* **Fig.26.** *Dominican Republic, 2003 (Sc 1398);* **Fig.27.** *Dominican Republic, 2014 (Sc 1561e);* **Fig.28.** *Hungary, 1973 (Sc 2259, Mi 2917, SG 2845, YT 2343);* **Fig.29.** *India, 1997 (Sc 1596, SG 1699);* **Fig.30.** *El Salvador, 1953 (Sc 631);* **Fig.31.** *(Sc 632);* **Fig.32.** *(Sc 633);* **Fig.33.** *(Sc C142);* **Fig.34.** *(Sc C143);* **Fig.35.** *(Sc C144);* **Fig.36.** *Mexico, 1986 (Sc 1453);* **Fig.37.** *Mexico, 1995 (Sc 1916, Mi 2478).*

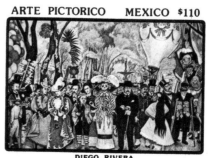

36

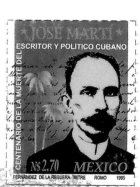

37

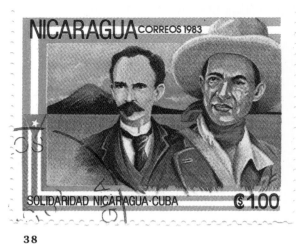

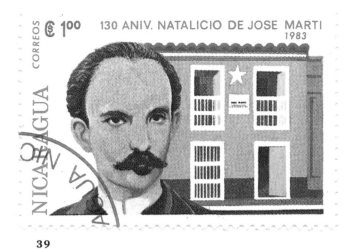

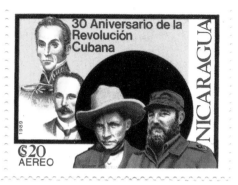

38

39

40

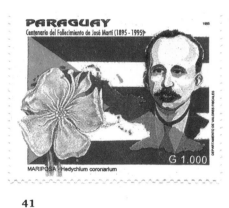

41

42

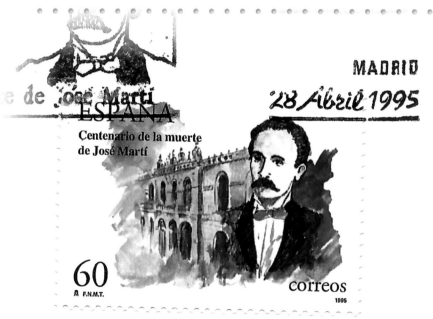

43

Fig.38. *Nicaragua, 1983 (Sc 1313);* Fig.39. *Nicaragua, 1983 (Sc 1200);*
Fig.40. *Nicaragua, 1989 (Sc C 1161, SG 3019);* Fig.41. *Paraguay, 1995*
(Sc 2527, SG 1484); Fig.42. *Paraguay, 1995 (Sc 2528, SG 1485);*
Fig.43. *Spain, 1995 (Sc 2816; Mi 3214; YT 2948, Edifil 3358).*

25

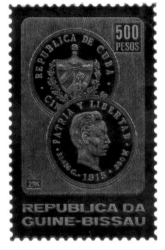

44

46-51

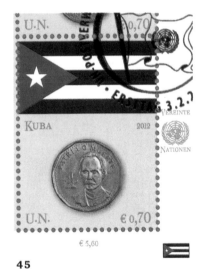

45

52

Fig.44. Guinea Bissau, 1982 (PALOP Romao 310); Fig.45. United Nations, 2012 (Sc 459, Mi 742-745); Figs.46-51. United Nations, 2015; Fig.52. Indonesia, 2008.

26

Inspired by Cuba! DELIVERING CUBA THROUGH THE MAIL ★ CUETO

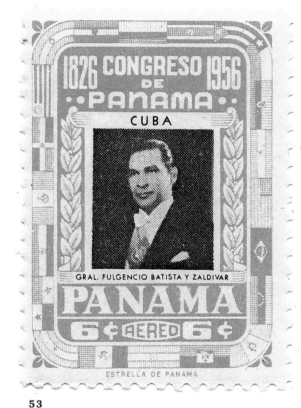

53

Fig.53. *Panama, 1956 (Sc C164).*

FULGENCIO BATISTA ZALDÍVAR

(BANES, ORIENTE, JANUARY 16, 1901 – GUADALMINA, MARBELLA, SPAIN, AUGUST 6, 1973).

Cuban military officer, twice President of Cuba (1940-1944, and 1952-1958). His dictatorship was overthrown by Fidel Castro on January 1, 1959.

BATISTA — COUNTRIES REPRESENTED:

KYRGYZSTAN - 1999 - **Fig.208, p.43**
PANAMA - 1956 - **Fig.53**

JOSÉ MIRÓ CARDONA

(HAVANA, AUGUST 22, 1902 – SAN JUAN, PUERTO RICO, AUGUST 10, 1972).

Prime Minister in the initial Cuban Revolutionary Cabinet of 1959, he arrived in the US the following year and became the head of Cuban Revolutionary Council in exile. He greeted President John Kennedy at Miami Orange Bowl ceremony honoring the Bay of Pigs veterans on December 29, 1962. To the left of Miró is journalist Luis Conte Agüero (1924).

MIRÓ — COUNTRY REPRESENTED:

LIBERIA - 2009 - **Fig.718, p.141**

27

JULIO ANTONIO MELLA

(HAVANA, MARCH 25, 1903 – MEXICO CITY, JANUARY 10, 1929).

Communist student leader who fought against the dictatorship of Gerardo Machado (1869-1939), and was assassinated in Mexico.

MELLA – COUNTRY REPRESENTED:

SAKHA/YAKUTIA - 2009 - **Fig.177, p.43**

OSVALDO DORTICÓS TORRADO

(CIENFUEGOS, APRIL 17, 1919 – HAVANA, JUNE 23, 1983).

President of Cuba from 1959 until 1976. Participant at the march mourning the dead after the explosion of the French cargo ship *La Coubre* in Havana harbor, March 4, 1960.

DORTICÓS – COUNTRIES REPRESENTED:

IVORY COAST - 2013 - **Fig.85, p.33**
RWANDA - 2013 - **Fig.963, p.174**

AUGUSTO MARTÍNEZ SÁNCHEZ

(MAYARÍ, ORIENTE, 1923 – HAVANA, FEBRUARY 2, 2013).

ANTONIO NÚÑEZ JIMÉNEZ

(ALQUÍZAR, HAVANA, APRIL 20, 1923 – HAVANA, SEPTEMBER 13, 1998).

Geographer, speleologist and revolutionary leader. President of the Cuban Academy of Sciences between 1962 and 1972. Participant at the march mourning the dead after the explosion of the French cargo ship *La Coubre* in Havana harbor, March 4, 1960.

NÚÑEZ JIMÉNEZ – COUNTRY REPRESENTED:

IVORY COAST - 2013 - **Fig.85, p.33**

Cuban political and military leader. Participant at the march mourning the dead after the explosion of the French cargo ship *La Coubre* in Havana harbor, March 4, 1960.

MARTÍNEZ – COUNTRY REPRESENTED:

IVORY COAST - 2013 - **Fig.85, p.33**

28

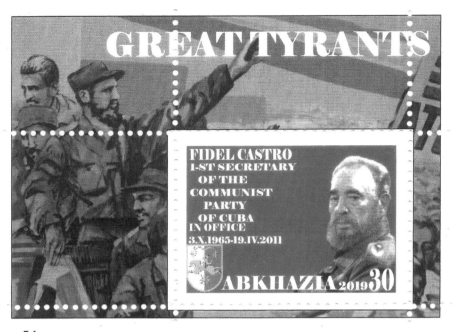

Fig.54. Abkhazia, 2019

56

FIDEL CASTRO

(BIRÁN, ORIENTE, AUGUST 13, 1926 – HAVANA, NOVEMBER 25, 2016).

Leader of the Revolution against dictator Fulgencio Batista (1901-1973). After the triumph of the Revolution in 1959, he led Cuba into the socialist camp and was Cuba's very controversial strongman for almost six decades. Castro stamps generally appear in the contexts of celebrating the 1959 triumph of the Cuban revolution and in the field of foreign relations, including the greeting of foreign dignitaries. It is worth noting that no Castro stamps have been issued in any of the socialist countries of Europe before the fall of communism, nor in Venezuela or Bolivia.

55

Fig.54. *Abkhazia, 2019;* Fig.55. *Algeria, 2017;* Fig.56. *Altai, undated.*

CASTRO — COUNTRIES REPRESENTED:

ABKHAZIA - 2019 - Fig.54
ALGERIA - 2017 - Fig.55
ALTAI - UNDATED - Fig.56
 - 2010 - Fig.86
BASHKIRIA - 2009 - Figs.57-64
BENIN - 2014 - Fig.65
 - 2016 - Figs.66, 67
 - 2016 - Fig.1015, p.179
 - 2016 - Fig.979, p.177
 - 2019 - Fig.68
CAMBODIA - 1989 - Fig.69
CAMEROON - 2017 - Figs.722-729, pp.142-143
 - 2018 - Fig.730, p.143

CENTRAL AFRICAN REPUBLIC - 2011 - Fig.972, p.176
 - 2012 - Fig.1013, p.179
 - 2013 - Fig.976, p.177
 - 2017 - Figs.748, 750, p.145
CHAD - 1999 - Fig.70
 - 2013 - Figs.71, 72
 - 2014 - Fig.73
CHINA, PEOPLE´S REPUBLIC - 1963 - Fig.692, p.137
 - 2006 - Fig.959, p.174
CONGO, REPUBLIC - 2012 - Fig.1014, p.179
 - 2014 - Fig.74
CONGO, DEMOCRATIC REPUBLIC - 2017 - Figs.734, 735, 738, 740-743, p.144
 - 2019 - Fig.75-81

DJIBOUTI - 2005 - Fig.1006, p.179
 - 2014 - Fig.99
EASDALE ISLAND - 1990s? - Fig.958, p.174
GABON - 2017 - Fig.767, p.145
GAMBIA - 2018 - Figs.82, 83
GRENADA - 2007 - Figs.744-747, p.14
 - 2012 - Fig.1010, p.179
GUINEA - 1998 - Fig.84
 - 2012 - Fig.1019, p.180
 - 2012 - Fig.720, p.141
 - 2017 - Figs.755, 756, 757, 761, 764, p.145
GUYANA - 2004 - Fig.1032, p.181
INDONESIA - 2008 - Fig.961, p.174
IVORY COAST - 2013 - Fig.85
KOMI - 1999 - Fig.87
KOREA, DPR - 2003 - Fig.964, p.174
 - 2010 - Fig.965, p.174
KYRGYZSTAN - 1999 - Fig.209, p.43
LAOS - 1989 - Fig.696, p.137
 - 2017 - Figs.773, 775, 776, 778, 779, p.146

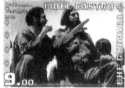 57
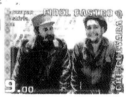 58
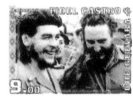 59

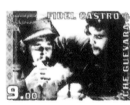 60
61
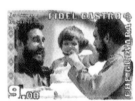 62

Figs.57-64.
Bashkiria, 2009.

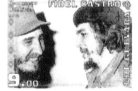 63
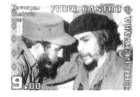 64

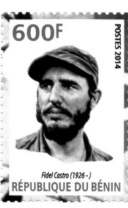

65

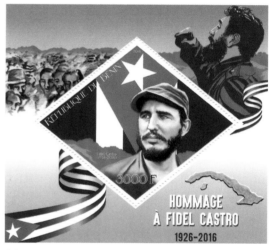

66

31

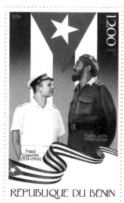

67

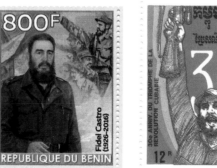

68

69

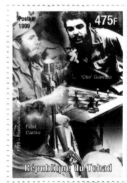

70

Fig.65. Benin, 2014; **Fig.66.** Benin, 2016; **Fig.67.** *Benin, 2016;* **Fig.68.** *Benin, 2019;* **Fig.69.** *Cambodia, 1989 (Sc 937);* **Fig.70.** *Chad, 1999 (Sc 809i).*

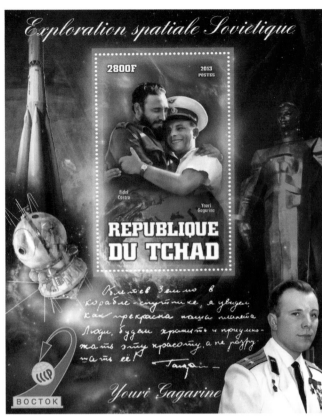

71

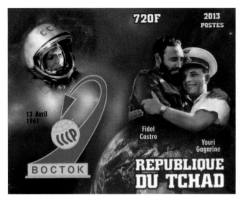

72

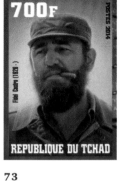

73

74

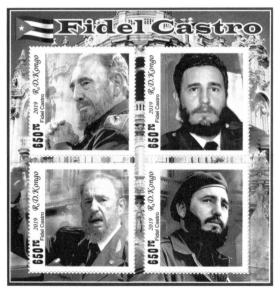

75, 76, 76a, 76b

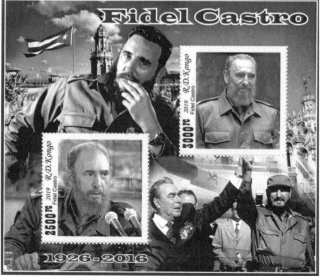

77, 77a

Figs.71, 72. *Chad, 2013;* **Fig.73.** *Chad, 2014;*
Fig.74. *Congo, Republic, 2014;* **Figs.75, 76, 76a,**
76b, 77, 77a. *Congo, Democratic Republic, 2019.*

32

Inspired by Cuba! DELIVERING CUBA THROUGH THE MAIL ★ CUETO

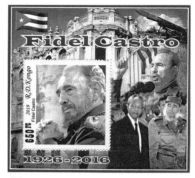

78

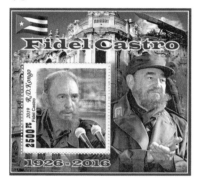

79

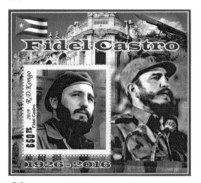

80

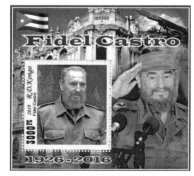

81

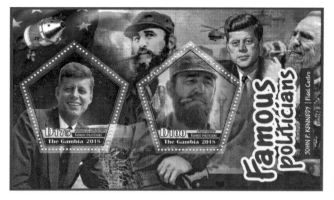

82

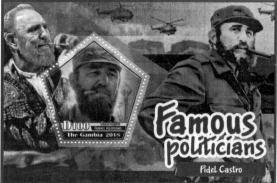

83

84

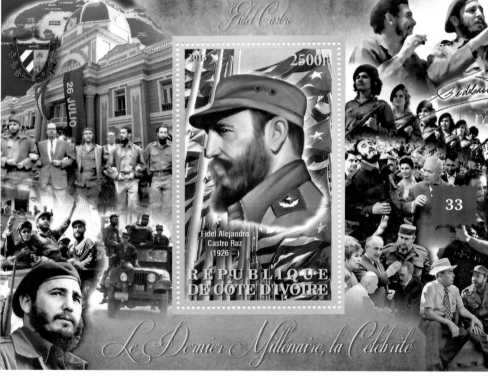

85

Figs.78-81. Congo, Democratic Republic, 2019; Figs.82, 83. Gambia, 2018; Fig.84. Guinea, 1998; Figs.85. Ivory Coast, 2013.

86

1999 Fidel Castro

5,00 KOMI

87

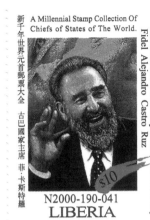

新千年·世界元首郵票大全
古巴國家主席 菲·卡斯特羅

A Millennial Stamp Collection Of
Chiefs of States of The World.

Cuba General Secretary of Communist Party
Fidel Alejandro Castro Ruz

$10

N2000-190-041
LIBERIA

88

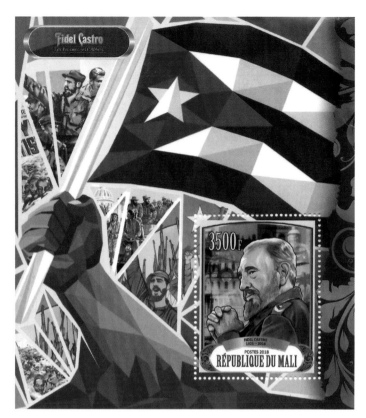

Fidel Castro
Les Personnages Célèbres

3500F

FIDEL CASTRO
1926 — 2016
POSTES 2018
RÉPUBLIQUE DU MALI

89

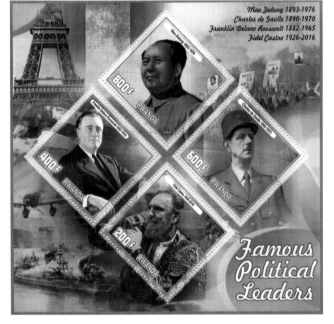

Mao Zedong 1893-1976
Charles de Gaulle 1890-1970
Franklin Delano Roosevelt 1882-1945
Fidel Castro 1926-2016

800 F RWANDA
400 F RWANDA
600 F RWANDA
200 F RWANDA

Famous
Political
Leaders

90

34

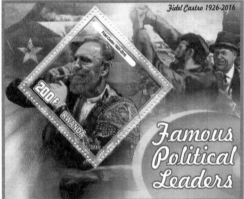

Fidel Castro 1926-2016

200 F RWANDA

Famous
Political
Leaders

91

SIERRA LEONE 2019

Fidel Castro
1926-2016

Le 12500

Tigran Petrosian 1929-1984

92

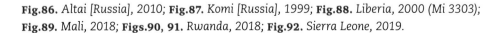

Fig.86. Altai [Russia], 2010; Fig.87. Komi [Russia], 1999; Fig.88. Liberia, 2000 (Mi 3303);
Fig.89. Mali, 2018; Figs.90, 91. Rwanda, 2018; Fig.92. Sierra Leone, 2019.

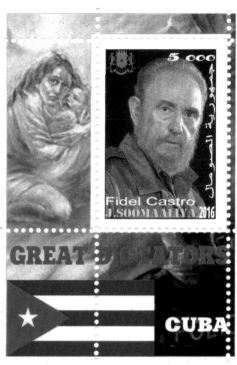

GREAT DICTATORS

CUBA

93

94

95

96

97

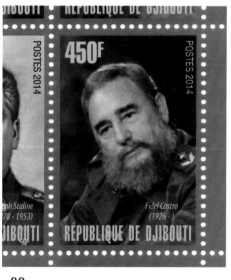

98

99

Fig.93. Somalia, 2016; Fig.94. Southern Sudan, 2010; Fig.95. Togo, 2000; Fig.96. Turkmenistan, 2000; Fig.97. Tuva, 2002; Fig.98. Tuva, 2011; Fig.99. Djibouti, 2014.

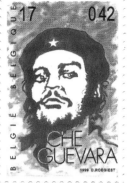

17 0.42

CHE GUEVARA

100

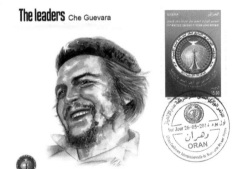

The leaders Che Guevara

The Non-Aligned Movement (NAM)

1er JOUR D'EMISSION - اليوم الأول للإصدار

101

The leaders Che Guevara

The Non-Aligned Movement (NAM)

1er JOUR D'EMISSION - اليوم الأول للإصدار

102

ERNESTO CHÉ GUEVARA

(ROSARIO, ARGENTINA, JUNE 14, 1928 – LA HIGUERA, BOLIVIA OCTOBER 9, 1967).

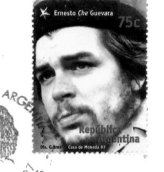

103

Argentine-born revolutionary doctor who joined Castro's forces in Mexico, landing in Cuba in 1956 and distinguishing himself as a guerrilla fighter. After occupying official positions in the Cuban economic sphere, he left the island to lead guerrilla movements abroad, meeting his death in Bolivia. His most famous portrait was taken in March 1960 by Cuban photographer Alberto Korda (1928-2001) and has been reproduced in many stamps (as well as variations thereof, notably the illustrations by American artists Andy Warhol (1928-1987) and Paul Davis (1938). Because of his policies and trajectory, Ché remains an extremely controversial figure across the political spectrum.

Guevara stamps have been issued mostly in Africa and Asia, but, surprisingly, none were printed in the socialist countries of Europe before the fall of communism, nor in Venezuela or Nicaragua. Even more unexpected: his metal silhouette in Havana´s Revolutionary Square appears in two 2012 stamps depicting Pope Benedict XV (Central African Republic and Grenada) and in a 2015 envelope from the Vatican commemorating Pope Francis visit to the island.

Stamps of Western Sahara issued to commemorate the 1492 Columbus discoveries have appeared with overprints with the face of Ché. They will not be included in this book and the reader interested in these pieces should consult Gilberto Gallo M., *Ernesto Ché Guevara y el coleccionismo*. Compilado por Colecciones de Colombia ASODEFILCO, Colombia, 2ª ed. April, 2013 (please note that Figs. 86, p. 34 and 107, p. 37, from Altai, have been incorrectly attributed to Khakasia).

Fig.100. *Belgium, 1999 (Sc 1779h, Mi 2909);* **Figs.101, 102.** *Algeria, 2014;* **Fig.103.** *Argentina, 1997 (Sc 1978).*

36

Inspired by Cuba! DELIVERING CUBA THROUGH THE MAIL ★ CUETO

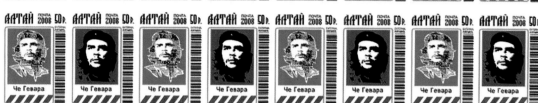

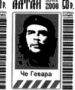
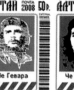

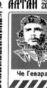
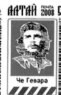

104, 105

CHÉ GUEVARA — COUNTRIES REPRESENTED:

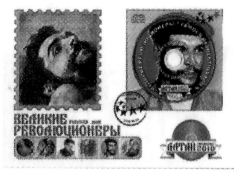

106, 106a

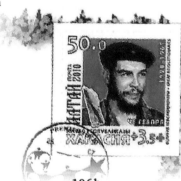

106b

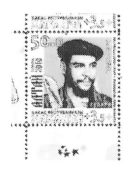

107

37

Figs.104, 105. *Altai [Russia], 2008;* **Figs.106, 106a, 106b.** *Altai [Russia], 2010;* **Fig.107.** *Altai [Russia], 2010.*

Buriatia, 2010, 1

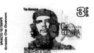

Buriatia, 2010, 2

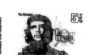

Buriatia, 2010, 3

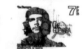

Buriatia, 2010, 5

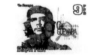

Buriatia, 2010, 7

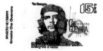

Buriatia, 2010, 9

Buriatia, 2010, 15

Buriatia, 2010, 25

108-115

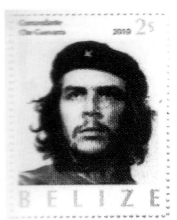

116

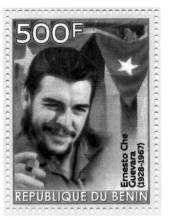

117

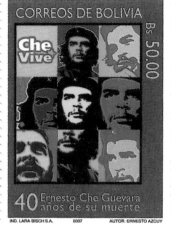

118

119

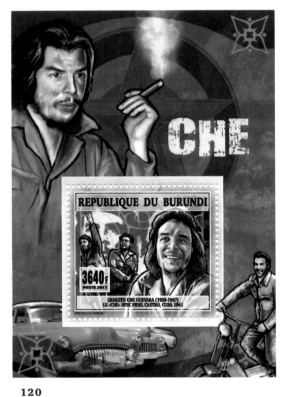

120

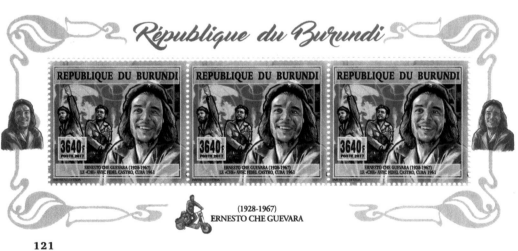

121

Figs.108-115. *Buriatia, 2010;* Fig.116. *Belize, 2010;* Fig.117. *Benin, 2019;* Figs.118, 119. *Bolivia, 2007 (Sc 1343-1344);* Figs.120, 121. *Burundi, 2017.*

38

Inspired by Cuba! DELIVERING CUBA THROUGH THE MAIL ★ CUETO

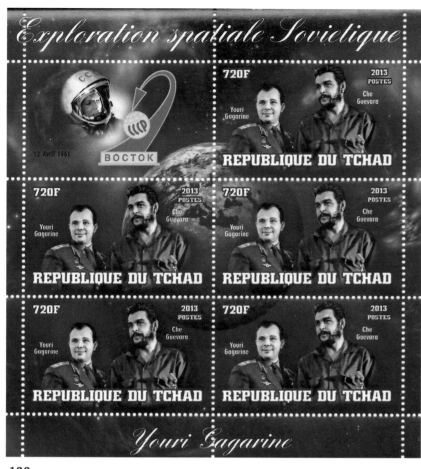

Exploration spatiale Soviétique

720F 2013 POSTES
Youri Gagarine Che Guevara
REPUBLIQUE DU TCHAD

720F 2013 POSTES
Youri Gagarine Che Guevara
REPUBLIQUE DU TCHAD

720F 2013 POSTES
Youri Gagarine Che Guevara
REPUBLIQUE DU TCHAD

720F 2013 POSTES
Youri Gagarine Che Guevara
REPUBLIQUE DU TCHAD

720F 2013 POSTES
Youri Gagarine Che Guevara
REPUBLIQUE DU TCHAD

Youri Gagarine

122

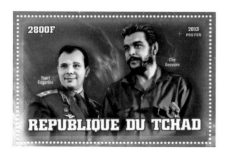

123

124

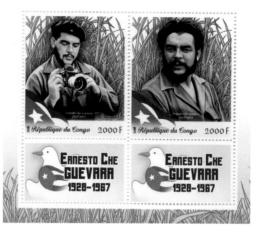

125, 125a

126

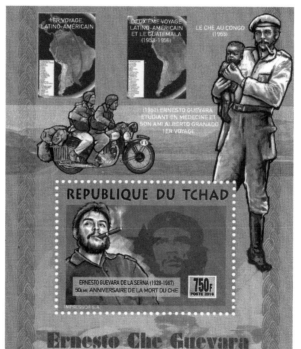

127

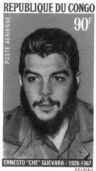

128

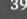

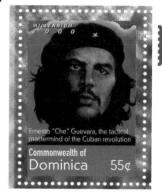

129

Fig.122, 123. Chad, 2013; **Fig.124.** Chechnya [Russia], 2016; **Fig.125, 125a, 126.** Congo, Republic, 2018; **Fig.127.** Chad, 2016; **Fig.128.** Congo, Republic, 1969; **Fig.129.** Dominica, 2000 (Sc 2251).

Che Guevara

130

Che Guevara

131

REPUBLIQUE DU CONGO 1000F

132

REPUBLIQUE DU CONGO 1000F

133

REPUBLIQUE DU CONGO 1000F

134

REPUBLIQUE DU CONGO 1000F

137

REPUBLIQUE DU CONGO 1000F

136

HASTA LA VICTORIA SIEMPRE

REPUBLIQUE DU CONGO 1000F

135

Evénements de 20ème siècle

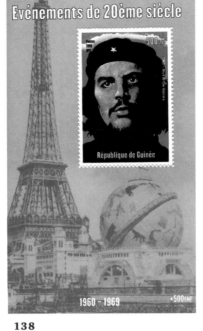

Postes 1998 500 GNF
République de Guinée

1960 ~ 1969 +500GNF

138

BEATLES
fabulous 500GNF

1960 - Let Beatles
République de Guinée

500GNF Postes 1998 500 GNF
République de Guinée

139

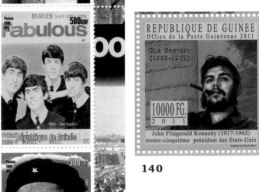

REPUBLIQUE DE GUINEE
Office de la Poste Guinéenne 2011
Che Guevara
(1928-1967)
10000 FG.
2011
John Fitzgerald Kennedy (1917-1963)
trente-cinquième président des Etats-Unis
designed by Paul Puellard

140

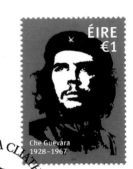

ÉIRE €1
Che Guevara
1928–1967

141

BAILE ÁTHA CLIATH • LÁ CHÉAD EISIÚNA • 5.X.2017

80e anniversaire de la naissance d'Ernesto Che Guevara

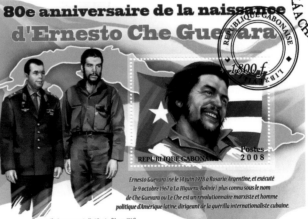

REPUBLIQUE GABONAISE 1800 f

REPUBLIQUE GABONAISE Postes 2008

Ernesto Guevara (né le 14 juin 1928 a Rosario, Argentine, et exécuté
le 9 octobre 1967 a La Higuera, Bolivie) plus connu sous le nom
de Che Guevara ou Le Che est un révolutionnaire marxiste et homme
politique d'Amérique latine, dirigeant de la guérilla internationaliste cubaine.

Che Guevara rencontre Yuri Gagrine (Moscou, 1964).

142

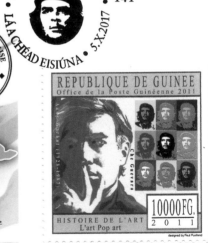

REPUBLIQUE DE GUINEE
Office de la Poste Guinéenne 2011
Che Guevara
10000 FG.
2011
HISTOIRE DE L'ART
L'art Pop art
designed by Paul Puellard

143

Figs.130-137. *Congo, Republic, undated;* **Figs.138, 139.** *Guinea, 1998;*
Fig.140. *Guinea, 2011;* **Fig.141.** *Ireland, 2017 (Sc 2165);* **Fig.142.** *Gabon,*
2008; **Fig.143.** *Guinea, 2011 (Mi 8834-37).*

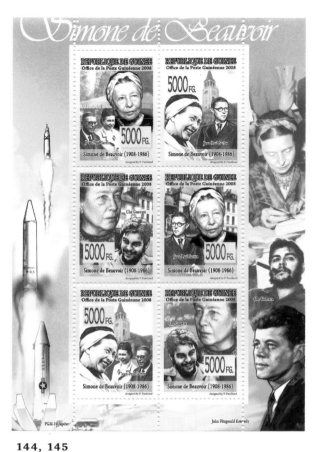

144, 145

148-150

151

153

41

154, 155

146, 146a

147

152

156

157-160

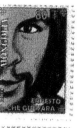
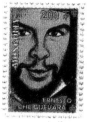
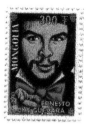

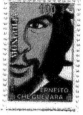
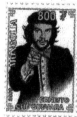
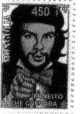
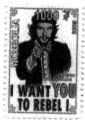

161-168

169

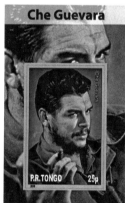
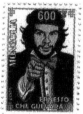

170

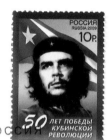

171

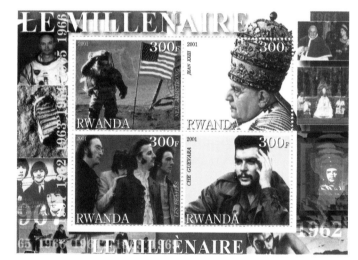

172

173

174

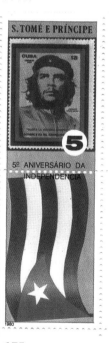

175

Fig.156. Mari-El [Russia], 2009; **Figs.157-160.** Mongolia, 2009; **Figs.161-168.** Mongolia, undated; **Fig.169.** Mozambique, 2002 (Sc 1603a); **Fig.170.** P. R. Tongo, 2010; **Fig.171.** Russia, 2009 (Sc 7124, Mi 1530); **Fig.172.** Rwanda, 2001; **Fig.173.** Sakha/ Yakutia, 1999; **Fig.174.** Somalia, 2002; **Fig.175.** St Thomas and Prince, 1980 (Sc 583i, Mi 651-62, YT 603-14).

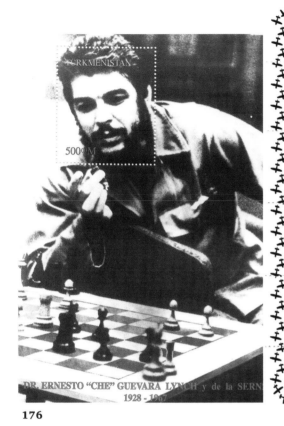

TURKMENISTAN

5000M

DR. ERNESTO "CHE" GUEVARA LYNCH y de la SERNA
1928 - 1967

176

Julio Antonio Mella
Camilo Cienfuegos
Che Guevara

Julio Antonio Mella
Camilo Cienfuegos
Che Guevara

Julio Antonio Mella
Camilo Cienfuegos
Che Guevara

Julio Antonio Mella
Camilo Cienfuegos
Che Guevara

177

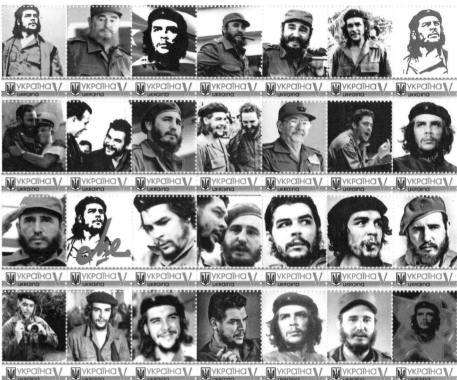

178-205

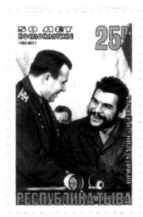

208-211

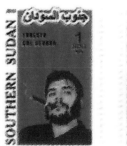

212

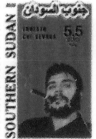

SOUTHERN SUDAN

SOUTHERN SUDAN

213, 214

43

Fig.176. *Turkmenistan, 1998;* **Fig.177.** *Sakha/ Yakutia
[Russia], 2009;* **Figs.178-205.** *Ukraine, 2016;* **Figs.206, 207.**
not assigned; **Figs.208-211.** *Kyrgyzstan, 1999;* **Fig.212.**
Tuva, 2011; **Figs.213, 214.** *Southern Sudan, 2010.*

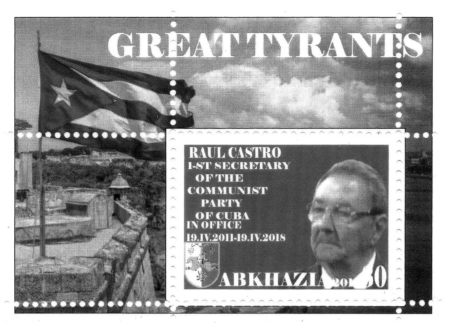

GREAT TYRANTS

215

RAÚL CASTRO

(BIRÁN, ORIENTE, JUNE 3, 1931).

Younger brother of Fidel, who succeeded him as President of the Council of Ministers of Cuba and Communist Party chief, following Fidel's illness in 2006. In 2019 he stepped down as President of Cuba, while retaining the all-powerful position of Party First Secretary until April 2021.

CASTRO – COUNTRIES REPRESENTED:

ABKHAZIA - 2019 - **Fig.215**
GRENADA - 2012 - **Fig.1011, p.179**
　　　　　- 2016 - **Fig.997, p.178**
GUINEA - 2012 - **Figs.1016-1018, p.180**
RWANDA - 2013 - **Fig.963, p.174**
ST. VINCENT - 2016 - **Figs.1001, 1005, p.178**
TOGO - 2012 - **Fig.1030, p.181**
TUVALU - 2016 - **Figs.982, 984, 985, 987, 993, p.178**
UKRAINE - 2017 - **Fig.189, p.43**

CAMILO CIENFUEGOS

(HAVANA, FEBRUARY 6, 1932 – AT SEA, OCTOBER 28, 1959).

Guerrilla commander against the Batista dictatorship, he entered triumphally in Havana in the same vehicle as Fidel. His death later that year in a plane crash remains unexplained.

CIENFUEGOS – COUNTRIES REPRESENTED:

LAOS - 1989 - **Fig.696, p.137**
NICARAGUA - 1984 - **Fig.698, p.137**
SAKHA YAKUTIA - 2009 - **Fig.177, p.43**
VIETNAM - 1965 - **Fig.705, p.138**

Fig.215. *Abkhazia, 2019.*

PEOPLE

SPORTS & GAMES

BASEBALL

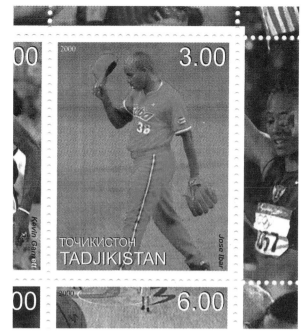

217

CARLOS COLÁS

(HAVANA, DECEMBER 4, 1917 – HAVANA, DECEMBER 4, 1987).

"Suset" played in the Mexican League, Cuban Winter League, Negro Leagues, Venezuela League, Cienfuegos, Almendares and Memphis Red Sox teams.

COLÁS – COUNTRY REPRESENTED:

NICARAGUA - 1984 - Fig.216

JOSÉ IBAR MARTÍNEZ

(LA MAYA, ORIENTE, MAY 4, 1969).

Baseball player, winner of Olympic silver (2000 Sydney).

IBAR – COUNTRY REPRESENTED:

TAJIKISTAN - 2000 - Fig.217

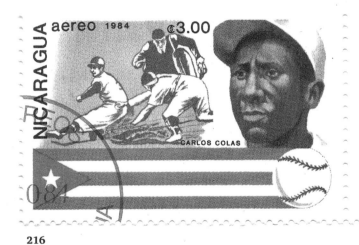

216

Fig.216. *Nicaragua, 1984;* **Fig.217.** *Tajikistan, 2000.*

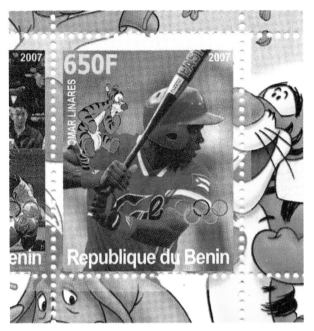

218

OMAR LINARES IZQUIERDO

(SAN JUAN Y MARTÍNEZ, PINAR DEL RÍO, OCTOBER 23, 1967).

Baseball player, winner of Olympic gold (1992 Barcelona, 1996 Atlanta) and silver (2000 Sydney).

LINARES — COUNTRY REPRESENTED:

BENIN - 2007 - Fig.218

GERMAN MESA FRESNEDA

(HAVANA, MAY 12, 1967).

"El Imán"/"The Magnet", winner of Olympic gold (1992 Barcelona) and silver (2000 Sydney).

MESA — COUNTRY REPRESENTED:

KYRGYZSTAN - 2000 - Fig.219

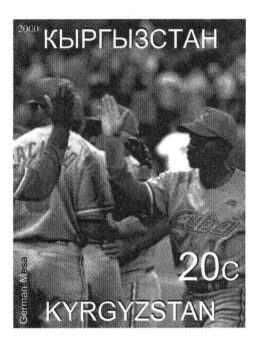

Fig.218. *Benin, 2007;*
Fig.219. *Kyrgyzstan, 2000.*

219

PEOPLE

SPORTS & GAMES

BOXING

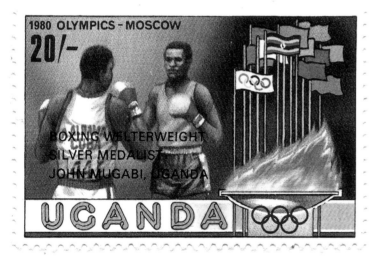

220

Fig.220. *Uganda, 1980;* **Fig.221.** *Nicaragua, 1996 (Sc 2174d).*

221

ANDRÉS ALDAMA CABRERA

(MATANZAS, APRIL 9, 1956).

Winner of the Olympic light welterweight silver medal (1976 Montreal) and welterweight gold medal (1980 Moscow).

ALDAMA — COUNTRY REPRESENTED:

UGANDA - 1980 - **Fig.220**

ÁNGEL HERRERA VERA

(GUANTÁNAMO, AUGUST 2, 1957).

Featherweight, lightweight boxer, winner of two Olympic gold medals (1976 Montreal, 1980 Moscow).

HERRERA — COUNTRY REPRESENTED:

NICARAGUA - 1996 - **Fig.221**

47

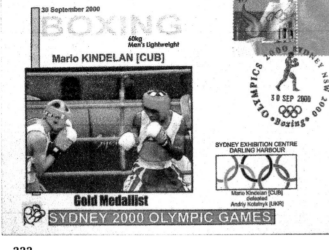

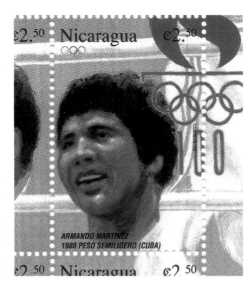

222

223

224

MARIO KINDELÁN MESA

(HOLGUÍN, AUGUST 10, 1971).

Lightweight boxer, winner of two Olympic gold medals (2000 Sydney, 2004 Athens).

KINDELÁN – COUNTRY REPRESENTED:

AUSTRALIA - 2000 - **Fig.222**

ARMANDO MARTÍNEZ LIMENDÚ

(MAJAGUA, TODAY CIEGO DE ÁVILA, AUGUST 29, 1961).

Light middleweight boxer, winner of Olympic gold (1980 Moscow) and silver (Munich, 1982)

MARTÍNEZ – COUNTRY REPRESENTED:

NICARAGUA - 1996 - **Fig.223**

GUILLERMO RIGONDEAUX ORTIZ

(SANTIAGO DE CUBA, SEPTEMBER 30, 1980).

Super bantamweight boxer, winner of two Olympic gold medals (2000 Sydney, 2004 Athens).

RIGONDEAUX – COUNTRY REPRESENTED:

AUSTRALIA - 2000 - **Fig.224**

48

Fig.222. *Australia, 2000 (Sc 1873, Mi 1971 zf);* **Fig.223.** *Nicaragua, 1996 (Sc 2174f);* **Fig.224.** *Australia, 2000 (Sc 1873, Mi 1971 zf).*

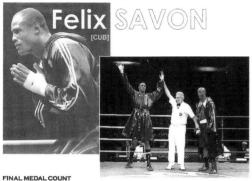

GOLDEN GREATS
SYDNEY
XXVII SUMMER OLYMPIC GAMES

September 15 - October 1 2000

Felix SAVON
[CUB]

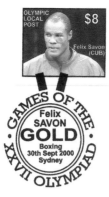

OLYMPIC LOCAL POST
$8

Felix Savon (CUB)

GAMES OF THE XXVII OLYMPIAD

Felix SAVON
GOLD
Boxing
30th Sept 2000
Sydney

FINAL MEDAL COUNT

GOLD Men's Boxing Heavyweight 91kg Final (30 Sept.)
Won on Points 21 to 13

OLYMPIC LOCAL POST

225

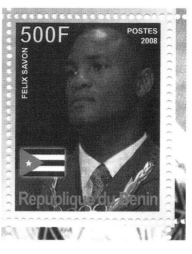

500F POSTES
2008

FELIX SAVON

Republique du Benin

226

FÉLIX SAVÓN FABRE

(GUANTÁNAMO, SEPTEMBER 22, 1967).

Heavyweight boxer, winner of three Olympic gold medals (1992 Barcelona, 1996 Atlanta, 2000 Sydney).

SAVÓN – COUNTRIES & POSTAL AUTHORITIES REPRESENTED:

BENIN - 2008 - **Fig.226**
OLYMPIC LOCAL POST-AUSTRALIA - 2000 - **Fig.225**
TOGO - 1992 - **Fig.227**

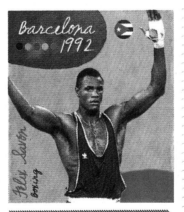

Barcelona 1992

Felix Savon boxing

RÉPUBLIQUE
TOGOLAISE 200F

227

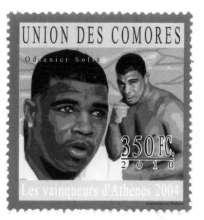

UNION DES COMORES

Odlanier Solis

350 FC
2010

Les vainqueurs d'Athènes 2004

228

ODLANIER SOLÍS FONTE

(HAVANA, APRIL 5, 1980).

Heavyweight boxer, winner of Olympic gold (2004 Athens) and three World Championships (2001 Belfast, 2003 Bangkok, 2005 Mianyang).

SOLÍS – COUNTRY REPRESENTED:

COMORO - 2010 - **Fig.228**

Fig.225. *Olympic Local Post-Australia, 2000;* **Fig.226.** *Benin, 2008;* **Fig.227.** *Togo, 1992;* **Fig.228.** *Comoro, 2010.*

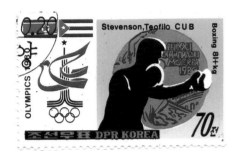

229

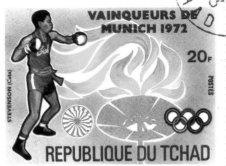

230

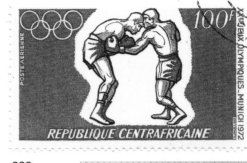

232

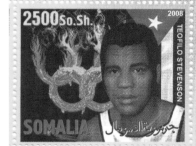

231

233

TEÓFILO STEVENSON

(PUERTO PADRE, ORIENTE, MARCH 29, 1952 – HAVANA, JUNE 11, 2012).

Heavyweight boxer, winner of three Olympic gold medals (1972 Munich, 1976 Moscow, 1980 Montreal).

STEVENSON — COUNTRIES REPRESENTED:

CENTRAL AFRICAN REPUBLIC - 1972 - Fig.232
CHAD - 1973 - Fig.230
GREECE - 2003 - Fig.234
KOREA DPR - 1980 - Fig.229
NICARAGUA - 1996 - Fig.231
SOMALIA - 2008 - Fig.233

Fig.229. *Korea DPR, 1980 (Sc 1997);* **Fig.230.** *Chad, 1973 (YT 288E);* **Fig.231.** *Nicaragua, 1996 (Sc 2174h);* **Fig.232.** *Central African Republic, 1972 (Sc C94);* **Fig.233.** *Somalia, 2008;* **Fig.234.** *Greece, 2003 (Sc 2063).*

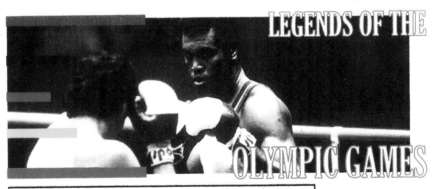

LEGENDS OF THE OLYMPIC GAMES

TEOFILO STEVENSON

It is difficult to think of a similarly dominant figure in the history of the Olympic Games. At the 1972 Games in Munich he won his first gold medal by beating the favourite, Duane Bobick of the United States, in the preliminary rounds, the same man who had recently defeated him in the Pan American Games. Two more gold medals in the heavyweight category at the 1976 Games in Montreal and the 1980 Games in Moscow were further indications of the hurricane that blew through amateur boxing for almost a decade. He won the world championships and the Pan American Games, and held innumerable other titles. His boxing career spanned the incredible figure of over 170 medals, with fewer than 15 defeats. A large part of his success lay in the power of his right hand, which knocked out his opponents in his first two Olympic finals.

234

ATHENS 2004
OLYMPIC GAMES
STAMP ISSUE
FIRST DAY COVER

50

Inspired by Cuba! DELIVERING CUBA THROUGH THE MAIL ★ CUETO

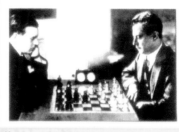

SPORTS & GAMES

CHESS

JOSÉ RAÚL CAPABLANCA

(HAVANA, NOVEMBER 19, 1888 – NEW YORK, MARCH 8, 1942).

Precocious chess player who was world champion from 1921 to 1927. He was the first Cuban to appear on the cover of prestigious *Time* magazine (Dec. 7, 1925), which is illustrated in one of the stamps (Fig.257). For a more detailed description of Capablanca´s presence in world stamps see Emilio Cueto, "Capablanca en el mundo," in *Opus Habana* (Havana), vol. XIII, no. 3, Feb.- Jul. 2011 [Filatelia de colecciones].

Beginning in 1962, 55 Capablanca Memorial chess tournaments have been held in Cuba. The 2010 event was celebrated in two Guinea Bissau stamps (Figs.886, 887, p.158).

Fig.235. *Austria, undated.*

RAÚL — COUNTRIES REPRESENTED:

AUSTRIA - UNDATED - **Fig.235**
BENIN - 1999 - **Fig.236**
 - 2002 - **Fig.237**
 - 2019 - **Fig.238**
BURMA/ MYANMAR - 2001 - **Fig.239**
CAMBODIA - 1986 - **Fig.245**
 - 1996 - **Fig. 244**
CHAD - 1983 - **Fig.241**
 - 1998 - **Fig.242**
 - 1999 - **Fig.246**
 - 2002 - **Fig.243**
 - 2015 - **Fig.240**
COMORO - 1999 - **Fig.252**
CONGO, DR - 1975 - **Fig.247**
DJIBOUTI - 2007 - **Fig.248**
GUINEA BISSAU - 1983 - **Fig.253**
 - 1988 - **Fig.251**
 - 2008 - **Fig.250**
 - 2011 - **Fig.249**
ISRAEL - 2010 - **Fig.254**
IVORY COAST - 2009 - **Fig.259**
 - 2013 - **Figs.257, 258**
 - 2016 - **Fig.256**

KABARDINO BALKARIA - UNDATED - **Fig.255**
KOREA, DPR - 2001 - **Fig.260**
LAOS - 1988 - **Fig.262**
MALI - 2010 - **Fig.265**
MOLDOVA - 2007 - **Fig.266**
MOZAMBIQUE - 2000 - **Fig.264**
 - 2001 - **Fig.261**
 - 2002 - **Fig.263**
NIGER - 1999 - **Fig.273**
 - 2018 - **Figs.267-271**
ROMANIA - 1988 - **Fig.272**
RWANDA - 2010 - **Fig.274**
TAJIKISTAN - 2001 - **Fig.275**
 - 2002 - **Fig.278**
TOGO - 2010 - **Fig.276**
 - 2011 - **Fig.277**
 - 2012 - **Figs.279-283**
TRANSNITRIA - 1999 - **Figs.287-294**
VIETNAM - 1994 - **Fig.285**
VIRGIN ISLANDS, BRITISH - 1988 - **Fig.286**
YUGOSLAVIA - 1995 - **Fig.284**

REPUBLIQUE DU BENIN POSTES 1999

José Raúl Capablanca

200f

236

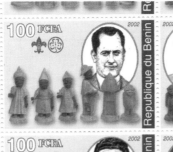

HISTOIRE

100 FCFA 2002

100 FCFA 2002

237

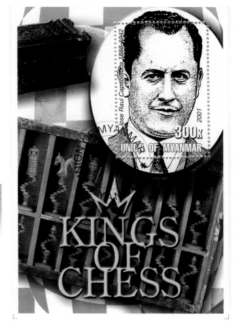

José Raul Capablanca 1888-1942

300k

UNION OF MYANMAR

KINGS OF CHESS

239

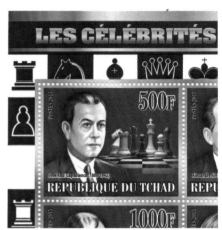

LES CÉLÉBRITÉS

500F

José Raúl Capablanca 1888-1942

REPUBLIQUE DU TCHAD

1000F

240

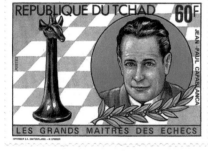

REPUBLIQUE DU TCHAD 60F

JEAN PAUL CAPABLANCA

POSTES

LES GRANDS MAITRES DES ECHECS

241

Gerry Kasparov

Jose Raúl Capablanca 1888-1942

Magnus Carlsen

1800 F Républuque du Bénin

238

52

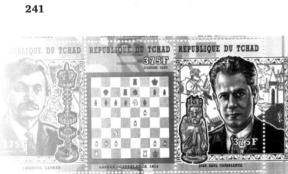

REPUBLIQUE DU TCHAD

REPUBLIQUE DU TCHAD 375F

REPUBLIQUE DU TCHAD 375F

EMANUEL LASKER

LASKER-CAPABLANCA 1914

JOSÉ RAÚL CAPABLANCA

242

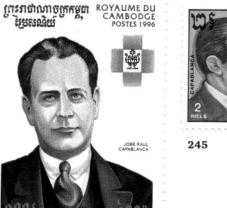

300F Postes 2002

300F Postes 2002

Wilhelm Steinitz

Alexander Alekhine

REPUBLIQUE DU TCHAD

REPUB

300F

243

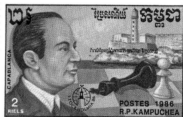

ព្រះរាជាណាចក្រកម្ពុជា

ROYAUME DU CAMBODGE POSTES 1996

JOSE RAUL CAPABLANCA

100s

100R

244

CAPABLANCA

STOCKHOLM 48

POSTES 1986 R.P.KAMPUCHEA

2 RIELS

245

Fig.236. Benin, 1999 (Sc 1136); Fig.237. Benin, 2002; Fig.238. Benin, 2019; Fig.239. Burma/ Myanmar, 2001; Fig.240. Chad, 2015; Fig.241. Chad, 1983 (Sc 430); Fig.242. Chad, 1998 (Sc 798J, o-p, Mi 1899); Fig.243. Chad, 2002; Fig.244. Cambodia, 1996 (Sc 1551); Fig.245. Cambodia, 1986 (Sc 718, SG 754, Mi 796).

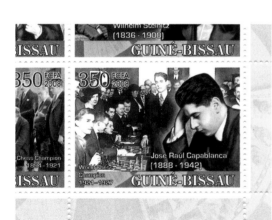

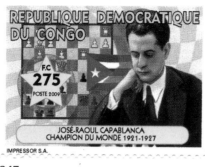

247

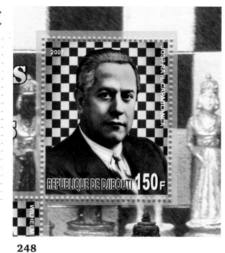

248

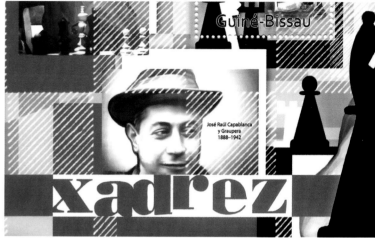

Guiné-Bissau

José Raúl Capablanca y Graupera 1888-1942

xadrez

249

246

Jeu d'échecs par Josef Jambor - 1916 (coll. Marino Montero)

République du Tchad

300F

1921 - Capablanca et Lasker

REPUBLIQUE DEMOC

REPUBLIQUE DEMOCRATIQUE DU CONGO

F.C 275 POSTE 2009

JOSÉ-RAOUL CAPABLANCA CHAMPION DU MONDE 1921-1927

IMPRESSOR S.A.

2007

REPUBLIQUE DE DJIBOUTI 150F

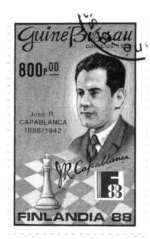

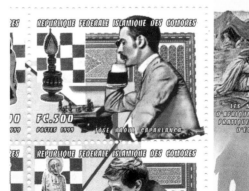

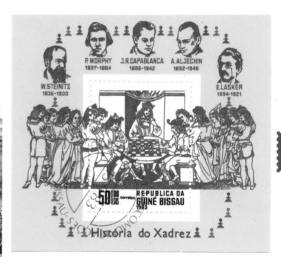

250

251

252

253

P. MORPHY 1837-1884 J.R. CAPABLANCA 1888-1942 A. ALJECHIN 1892-1946

W. STEINITZ 1836-1900 E. LASKER 1894-1921

50.00 REPUBLICA DA GUINÉ BISSAU

Historia do Xadrez

53

Fig.246. *Chad, 1999 (Sc 807);* **Fig.247.** *Congo, DR, 1975;* **Fig.248.** *Djibouti, 2007;* **Fig.249.** *Guinea Bissau, 2011;* **Fig.250.** *Guinea Bissau, 2008;* **Fig.251.** *1988 (Sc 740);* **Fig.252.** *Comoro, 1999 (Sc 954, 956, 958);* **Fig.253.** *Guinea Bissau, 1983 (Sc 473-479).*

254

Хосе Рауль Капабланка - чемпион мира по шахматам 1921-1927 гг.

255

2.50

KABARDINO-BALKARIA
КАБАРДИНО-БАЛКАРИЯ

Куда _____

Кому _____

256

ANNIVERSAIRES 2013

2013 1000F

José Raúl Capablanca
(1888 – 1942)

Côte d'Ivoire

José Raúl Capablanca
(1888 — 1942)

2013 1000F

José Raúl Capablanca
(1888-1942)

Côte d'Ivoire

125E ANNIVERSAIRE
DE LA NAISSANCE

257, 258

JOSÉ RAÚL
CAPABLANCA

150 FCFA

Poste 2009

REPUBLIQUE DE CÔTE D'IVOIRE

259

Fig.254. Israel, 2010 (see Sc 1838); Fig.255. Kabardino Balkaria, undated; Fig.256. Ivory Coast, 2016; Figs.257, 258. Ivory Coast, 2013; Fig.259. Ivory Coast, 2009.

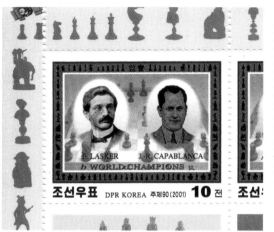

260

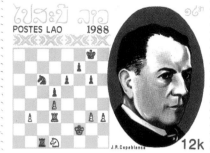

262

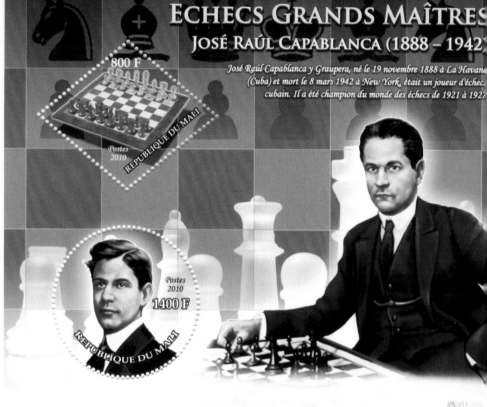

José Raúl Capablanca y Graupera, né le 19 novembre 1888 à La Havane
(Cuba) et mort le 8 mars 1942 à New York, était un joueur d'échec.
cubain. Il a été champion du monde des échecs de 1921 à 1927.

800 F

Postes
2010

RÉPUBLIQUE DU MALI

1400 F

Postes
2010

RÉPUBLIQUE DU MALI

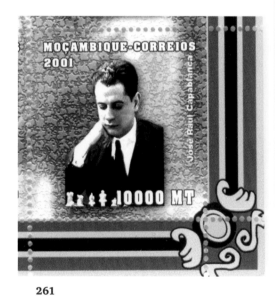

261

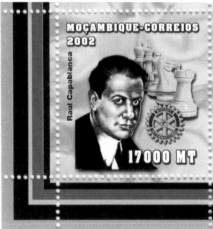

263

265

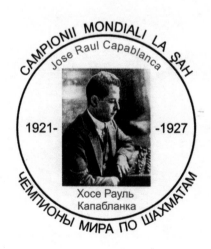

CAMPIONII MONDIALI LA ŞAH
Jose Raul Capablanca
1921- -1927
Хосе Рауль
Капабланка
ЧЕМПИОНЫ МИРА ПО ШАХМАТАМ

266

55

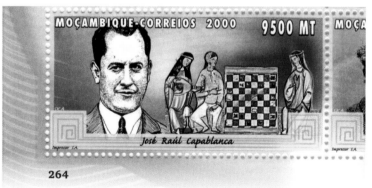

264

Fig.260. Korea, DPR, 2001 (Sc 4106);
Fig.261. Mozambique, 2001 (Sc 1434,
Mi 1939-1947); **Fig.262.** Laos, 1988 (Sc
901 F, Mi 1122); **Fig.263.** Mozambique,
2002 (Sc 1598d); **Fig.264.** Mozambique,
2000 (Sc 1403 c); **Fig.265.** Mali, 2010;
Fig.266. Moldova, 2007.

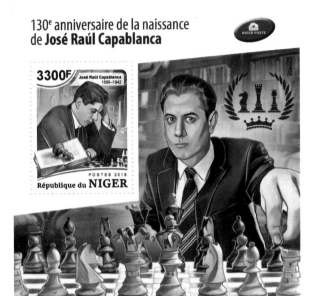

130ᵉ anniversaire de la naissance de **José Raúl Capablanca**

267

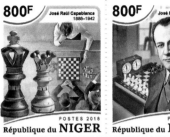
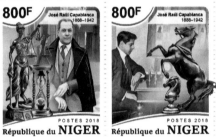

130ᵉ anniversaire de la naissance de **José Raúl Capablanca**

268-271

MARI MAEȘTRI AI ȘAHULUI

HOZE RAUL CAPABLANCA

CAMPION MONDIAL 1921–1927

19 noiembrie
1888
✦
1968

100 de ani de la naștere

A.F.R. TIMIȘ
CERCUL FILATELIC MUNICIPAL TIMIȘOARA

272

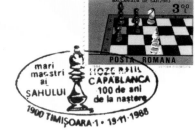

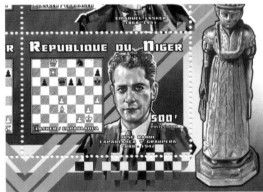

273

Figs.267-271. *Niger, 2018;* **Fig.272.** *Romania, 1988;*
Fig.273. *Niger, 1999 (Sc 1025 f, Mi 1645);* **Fig.274.**
Rwanda, 2010; **Fig.275.** *Tajikistan, 2001 (Sc 168c).*

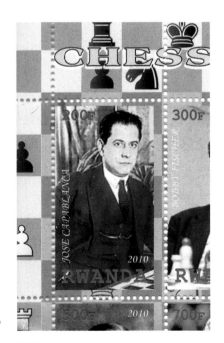

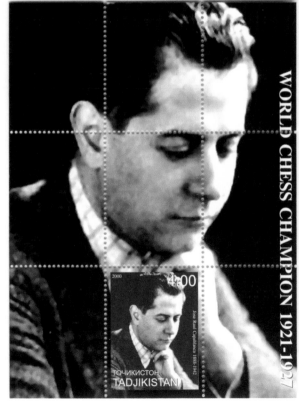

274

275

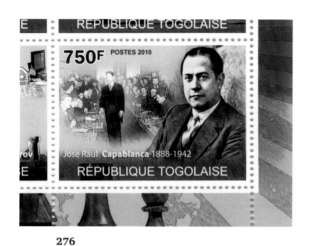

276

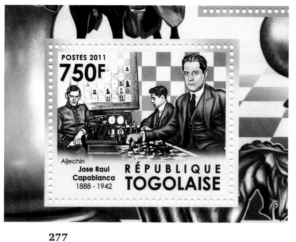

277

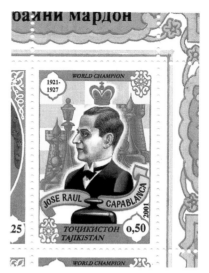

278

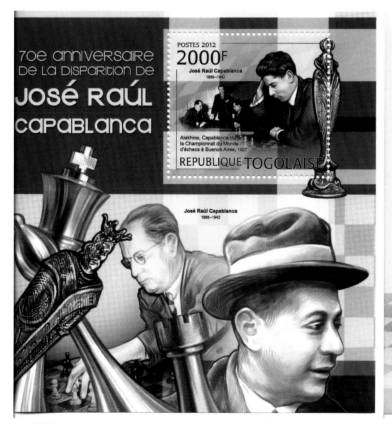

279

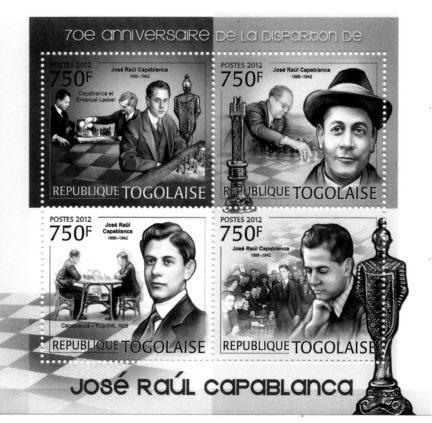

280-283

Fig.276. Togo, 2010;
Fig.277. Togo, 2011;
Fig.278. Tajikistan, 2002 (Sc 197);
Figs.279-283. Togo, 2012.

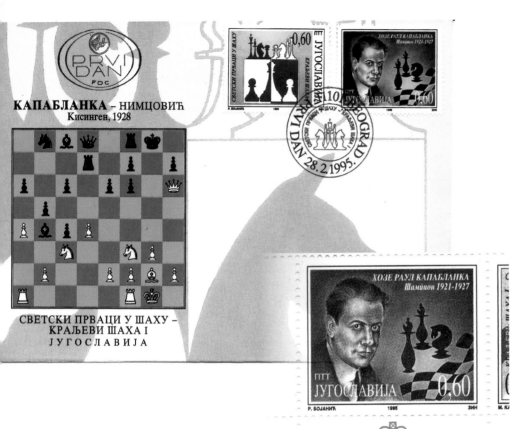

КАПАБЛАНКА – НИМЦОВИЋ
Кисинген, 1928

СВЕТСКИ ПРВАЦИ У ШАХУ –
КРАЉЕВИ ШАХА I
ЈУГОСЛАВИЈА

284

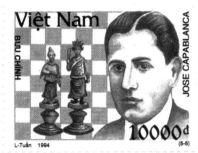

285

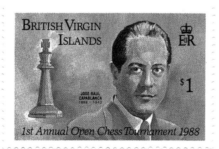

286

Fig.284. *Yugoslavia, 1995 (Sc 2288 f);* **Fig.285.** *Vietnam, 1994 (Sc 2500);*
Fig.286. *Virgin Islands, British, 1988 (Sc 606);* **Fig.287-294.** *Transnitria, 1999.*

РАУЛЬ ХОСЕ КАПАБЛАНКА

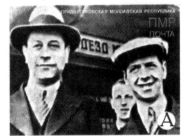

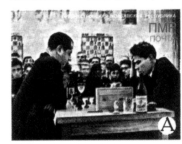
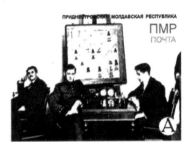

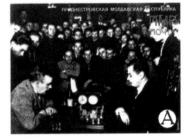

287-294

PEOPLE

SPORTS & GAMES

TRACK & FIELD

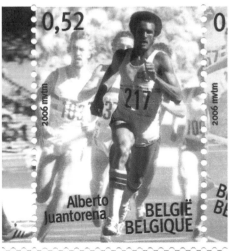

295

ALBERTO JUANTORENA

(SANTIAGO DE CUBA, DECEMBER 3, 1950).

First athlete to win gold medals in both the 400- and 800-metre races (Montreal 1976 Olympics).

JUANTORENA – COUNTRY REPRESENTED:

BELGIUM - 2006 - Fig.295

Fig.295. *Belgium, 2006 (Sc 2144a).*

LITERARY FIGURES

The presence of Cuban writers in foreign stamps is small and disappointing. Perhaps in the near future Spain will honor the holders of the prestigious Cervantes prize, awarded in 1977 **to Alejo Carpentier** (1904-1980), **in** 1992 **to Dulce Maria Loynaz** (1902-1997) **and in** 1997 **to Guillermo Cabrera Infante** (1929-2005).

In 2012, Uruguay issued a stamp (Sc 2402) in honor of Afro-Uruguayan writer Virginia Brindis de Salas (1908 – 1958). While her relationship with Cuban violinist Claudio Brindis de Salas (1852 – 1911) has not been clarified, we should not lose sight of it.

59

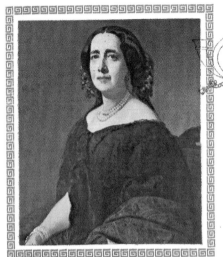

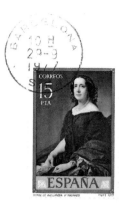

Primer día ★ FDC

296

GERTRUDIS GÓMEZ DE AVELLANEDA

(CAMAGÜEY, MARCH 23, 1814 – SEVILLE, SPAIN, FEBRUARY 1, 1873).

Poet, novelist and playwright. Her novel *Sab* (1841) is hailed as an early example of denunciation of the horrors of slavery in Cuban fiction.

GÓMEZ DE AVELLANEDA – COUNTRY REPRESENTED:

SPAIN - 1977 - Fig.296

297

SARA HERNÁNDEZ-CATÁ

(LE HAVRE, FRANCE, JULY 22, 1909 – CARACAS, VENEZUELA, FEBRUARY 15, 1980)

Daughter of Cuban writer Alfonso Hernández Catá. During her active years in Cuba (1940 – 1961) Sara wrote soap operas for radio and published interviews of people in show business. Poet Andrés Eloy Blanco wrote her a poem, which is quoted in the border of a Venezuelan stamp.

HERNÁNDEZ-CATÁ – COUNTRY REPRESENTED:

VENEZUELA - 1996 - Fig.297

Fig.296. *Spain, 1977 (Sc 2064, Edifil 2436, Mi 2329, SG 2485, YT 2082);* **Fig.297.** *Venezuela, 1996 (Sc 1321, SG 3304).*

The stamp border text reads:

"Y eso lo sabe cualquiera: cuando el pan se pone amargo o ha llorado el panadero o quien lo come está llorando"

Palabreo de Sara Catá

"...aunque la Virgen sea

100 años del nacimiento de Andrés Eloy Blanco
Presidente de la Constituyente

60

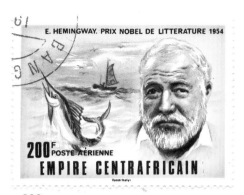

298

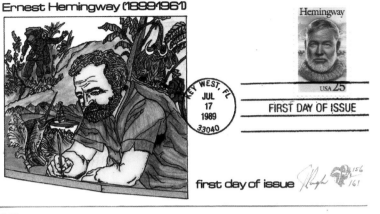

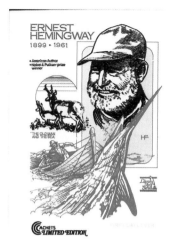

299

301

ERNEST HEMINGWAY

(OAK PARK, ILLINOIS, JULY 21, 1899 – KETCHUM, IDAHO, JULY 2, 1961).

1954 Nobel Prize winner in Literature. He lived in Cuba for many years and the village of Cojímar, near Havana, was the setting for his acclaimed novel *The Old Man and the Sea*. He donated his Nobel medal to the people of Cuba wishing that it should be kept at the shrine of Our Lady of Charity in El Cobre, Santiago de Cuba. Various stamps and the cachet on First Day Covers highlight his Cuban connection.

HEMINGWAY – COUNTRIES REPRESENTED:

CENTRAL AFRICAN REPUBLIC - 1977 - Fig.298
GUINEA - 1999 - Fig.84, p.33
KYRGYZSTAN - 1999 - Fig.210, p.43
US - 1989 - Figs.299-302

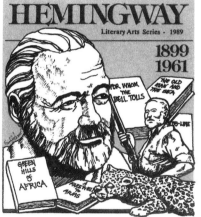

300

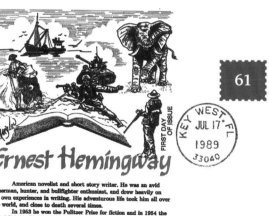

302

Fig.298. *Central African Republic, 1977 (Sc 293-294, C180-C182, C183, Mi 458-462);* **Figs.299-302.** *US, 1989 (Sc 2418).*

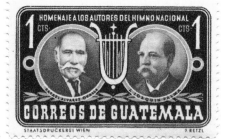
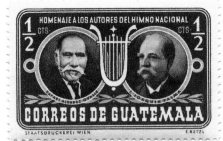
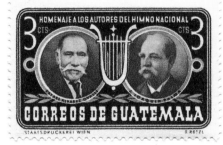
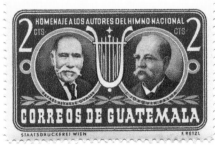

303-306

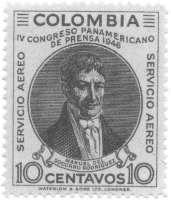

307

308

JOSÉ JOAQUÍN PALMA

(BAYAMO, SEPTEMBER 11, 1844 – GUATEMALA CITY, AUGUST 2, 1911).

Poet, journalist and patriot who, while in exile in Guatemala, wrote the lyrics of the national anthem of his adopted country.

PALMA — COUNTRY REPRESENTED:

GUATEMALA - 1953 - **Figs.303-306**

MANUEL DEL SOCORRO RODRÍGUEZ

(BAYAMO, APRIL 3, 1758 – BOGOTÁ, COLOMBIA, JUNE 2, 1819).

He is celebrated as the founder of journalism in Colombia. Among his notable works, *El Semanario* (1791), *Papel Periódico de la Ciudad de Santafé de Bogotá* (1791), *El Redactor Americano* (1806), *El Alternativo del Redactor Americano* (1807) and *La Constitución Feliz* (1810).

RODRIÍGUEZ — COUNTRY REPRESENTED:

COLOMBIA - 1947 - **Fig.307**
- 1991 - **Fig.308**

Fig.303. *Guatemala, 1953 (Sc 350, Mi 538);* **Fig.304.** *(Sc 351, Mi 539);* **Fig.305.** *(Sc 352, Mi 540);* **Fig.306.** *(Sc 353, Mi 541);* **Fig.307.** *Colombia 1947 (Sc C147, Mi 506-509);* **Fig.308.** *Colombia, 1991 (Sc C837, cinderella).*

 62

Inspired by Cuba! DELIVERING CUBA THROUGH THE MAIL ★ CUETO

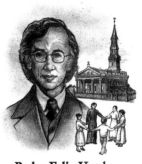

309

FÉLIX VARELA

(HAVANA, NOVEMBER 20, 1788 – ST. AUGUSTINE, FLORIDA, FEBRUARY 27, 1853).

Catholic priest, philosopher, pro-independence patriot and exiled writer and journalist. He was the first Cuban to be honored in a US stamp.

VARELA — COUNTRY REPRESENTED:

U.S. - 1997 - Figs.309-312

Figs.309-312. US, 1997 (Sc 3166).

Official First Day of Issue

Padre Felix Varela
Social Reformer

Mr. Walter R. Stearly
P. O. Box 450
Collegeville, Pennsylvania 19426

310

Colorano "Silk" Cachet

Padre Felix Varela

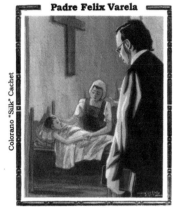

FIRST DAY OF ISSUE

First Day of Issue

311

63

OFFICIAL
FIRST DAY OF ISSUE

FIRST DAY OF ISSUE

Padre Felix Varela
SOCIAL REFORMER
1788-1853
HELPED POOR MINORITIES IN NEW YORK CITY
ESTABLISHED FIRST SPANISH NEWSPAPER IN U.S.

312

THE MUSIC WORLD

Because Cuba is the home country of many world-famous musicians, I did expect to find many more of its composers and interpreters depicted in foreign stamps. I hope that Spain will some day honor Ernesto Lecuona (1895-1963), whose *Malagueña* is synonymous with Spanish music.

DESI ARNAZ

(SANTIAGO DE CUBA, MARCH 2, 1917 – DEL MAR, CALIFORNIA, DECEMBER 2, 1986).

Cuban-American TV personality and singer. Married to actress Lucille Ball (1911-1989) and co-host of the popular *I Love Lucy* show (1951-1957).

ARNEZ — COUNTRIES REPRESENTED:

ANTIGUA - 2001 - **Figs.323-330**
CHAD - 1999 - **Figs.313-322**
COMORO - 1998 - **Fig.331**
GAMBIA - 2000 - **Figs.332-335**
 - 2001 - **Figs.339-343**
GRENADA - 2001 - **Figs.336-338**
GUINEA - 1998 - **Fig.350**
 - 2011 - **Figs.348, 349**
GUYANA - 1990s - **Figs.344-347**
MALI - 1998 - **Figs.351-360**
 - 1999 - **Figs.361-369**
MONGOLIA - 1999 - **Figs.372-375**
 - 2001 - **Figs.376-379**
SIERRA LEONE - 2000 - **Fig.370**
US - 1999 - **Fig.371**

313

314-322

Figs.313-322. *Chad, 1999 (Sc 812-814, 865-867).*

323

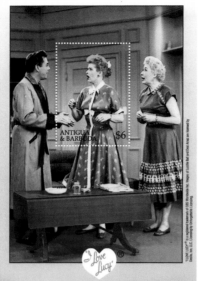
324

325

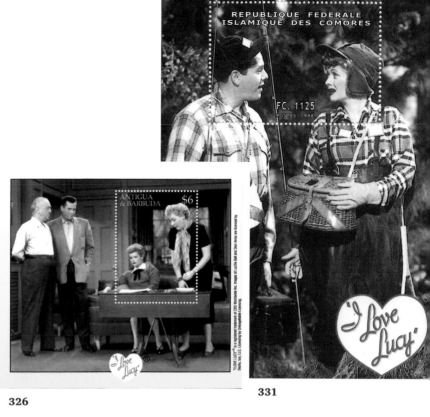

326

331

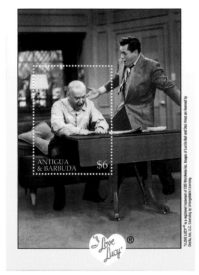
327

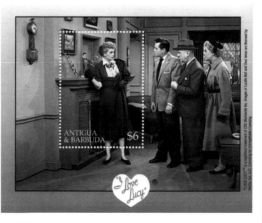
328

329

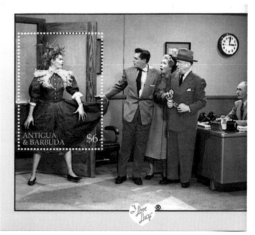
330

Figs.323-326. *Antigua, 2001 (Sc 2522-2525);* **Figs.327-330.** *Antigua, 2001 (Sc 2640-2643);*
Fig.331. *Comoro, 1998 (Sc 833 F, 833 P, 834-835, 836-837).*

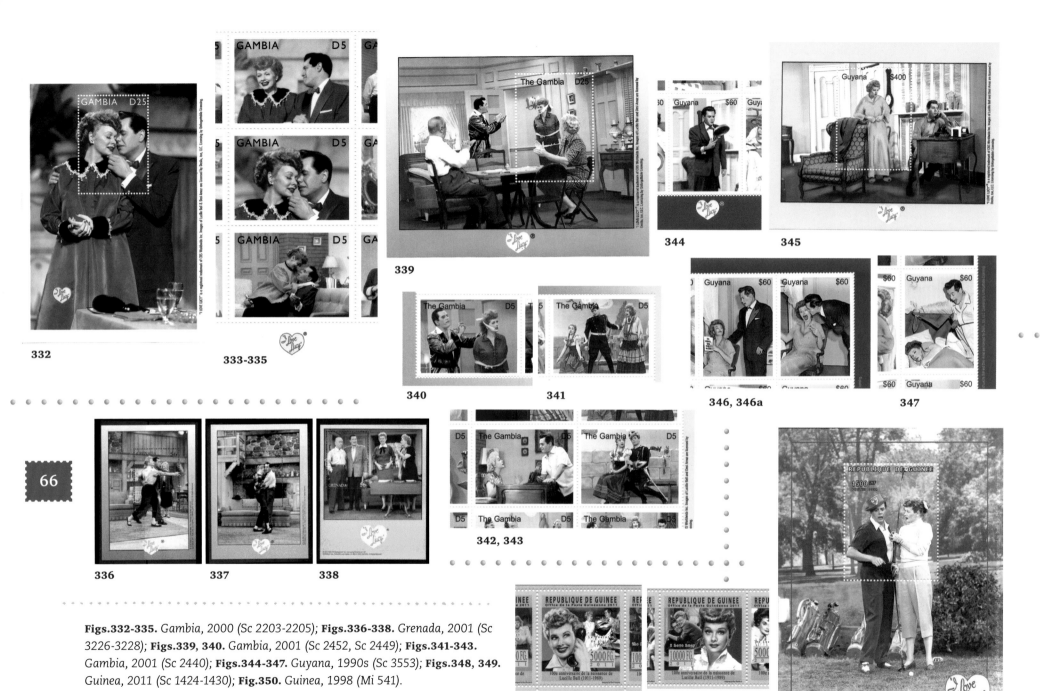

Figs.332-335. Gambia, 2000 (Sc 2203-2205); Figs.336-338. Grenada, 2001 (Sc 3226-3228); Figs.339, 340. Gambia, 2001 (Sc 2452, Sc 2449); Figs.341-343. Gambia, 2001 (Sc 2440); Figs.344-347. Guyana, 1990s (Sc 3553); Figs.348, 349. Guinea, 2011 (Sc 1424-1430); Fig.350. Guinea, 1998 (Mi 541).

66

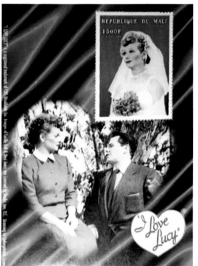

351

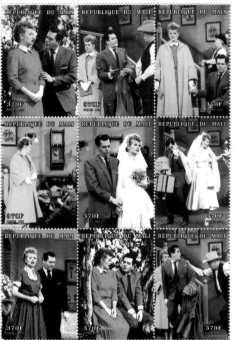

352-360

361-369

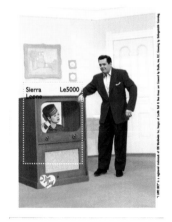

370

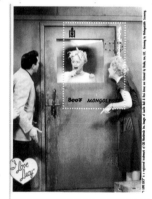

371

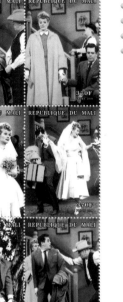

372

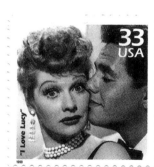

373, 374

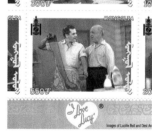

375

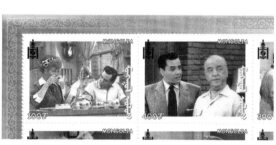

376, 377

379

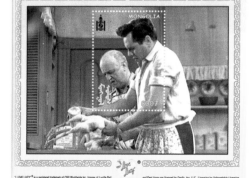

378

67

Figs.351-360. *Mali, 1998 (Mi 1996-2004);* **Figs.361-369.**
Mali, 1999 (Sc 1045-1047); **Fig.370.** *Sierra Leone, 2000 (Sc
2292);* **Fig.371.** *US, 1999 (Sc 3187);* **Figs.372-375.** *Mongolia,
1999 (Sc 2365-2368);* **Figs.376-379.** *Mongolia, 2001.*

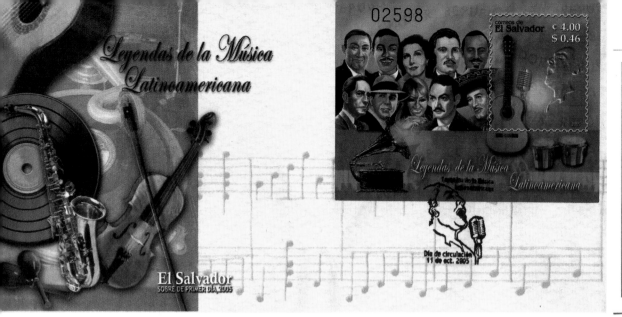

380

381

68

OFFICIAL FIRST DAY OF ISSUE

Celia Cruz
LATIN MUSIC LEGENDS

382

DAY OF ISSUE

CELIA CRUZ

(HAVANA, OCTOBER 21, 1925 – FORT LEE, NEW JERSEY, JULY 16, 2003).

"La Guarachera de Cuba" and "Queen of Salsa Music". With three Grammys and four Latin Grammys to her name, some of her costumes have been on display at the Smithsonian Institution in Washington, D.C.

CRUZ – COUNTRIES REPRESENTED:

EL SALVADOR - 2005 - **Figs.380, 381**
US - 2011 - **Fig.382**

383

Recipients honored at this 40th annual national celebration of the arts included Gloria Estefan. The international superstar is a singer, actress, songwriter, author of two *New York Times* best-selling children's books, philanthropist, and humanitarian. Having sold more than 100 million records worldwide, she's been awarded with seven Grammy Awards®, and Oscar®-nominated performance for the song "Music of My Heart," a Star on the Hollywood Walk of Fame, an American Music Award for Lifetime Achievement, an induction into the Latin Songwriters Hall of Fame, an Ellis Island Medal of Honor, a National Artistic Achievement Award from the U.S. Congress, among many others. Most recently, President Obama honored Emilio and Gloria Estefan with the Presidential Medal of Freedom, the nation's highest civilian honor, presented to individuals who have made meritorious contributions to the United States, to world peace, and to cultural endeavors. *On Your Feet!* is the Broadway musical based on the lives and music of Emilio and Gloria Estefan. Since opening, it has received rave critical reviews and nominations for Tony Awards®, Outer Critics Circle Awards, and Drama League Awards. Gloria along with her husband Emilio, are successful entrepreneurs owning and operating several business, including a globally recognized music publishing company, seven restaurants, and two hotels. They also are the first Cuban-American couple to own a minority share in a major NFL franchise, the Miami Dolphins. The Kennedy Center Honors gala was held December 3, 2017, and broadcast on CBS December 26, 2017, the first day of Kwanzaa.

GLORIA ESTEFAN

(BORN GLORIA FAJARDO, HAVANA, SEPTEMBER 1, 1957).

Composer and interpreter. Recipient of many awards, including several Grammys, Kennedy Center Honors, the Library of Congress Gershwin Prize for Popular Song, the American Music Award for Lifetime Achievement and the Presidential Medal of Freedom.

ESTEFAN – COUNTRY REPRESENTED:

US - 2017 - **Fig.383**

Figs.380, 381. *El Salvador, 2005 (Sc 1626, 1627);*
Fig.382. US, 2011 (Sc 4501); **Fig.383.** US, 2017.

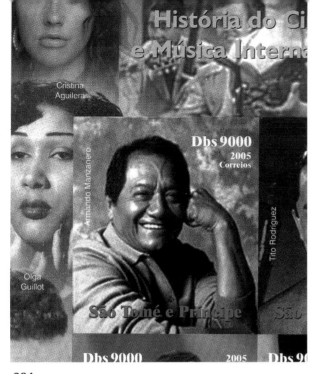

384

OLGA GUILLOT

(SANTIAGO DE CUBA, OCTOBER 9, 1922 –
MIAMI BEACH, FLORIDA, JULY 12, 2010).

Best known as the Queen of Bolero,
she can be heard in the more than one
hundred records (mostly in Puchito,
Musart and Adria labels) she left behind.

GUILLOT — COUNTRY REPRESENTED:

ST THOMAS AND PRINCE - 2005 - **Fig.384**

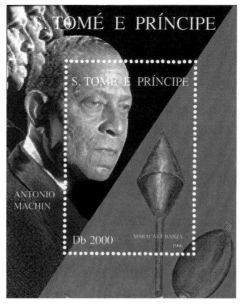

385

ANTONIO MACHÍN

(ANTONIO ABAD LUGO MACHÍN, SAGUA LA GRANDE,
FEBRUARY 11, 1903 – MADRID, AUGUST 4 1977).

Popular singer who made over 60 recordings
in Madrid and is well remembered for his
versions of *The Peanut Vendor* (*El manisero*)
and *Angelitos negros*.

MACHÍN — COUNTRY REPRESENTED:

ST THOMAS AND PRINCE - 1996 - **Fig.385**

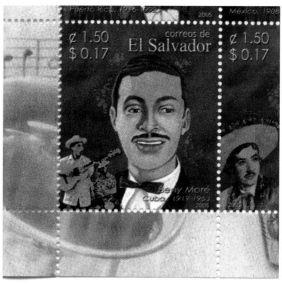

386

BENNY MORÉ

(SANTA ISABEL DE LAS LAJAS, LAS VILLAS,
AUGUST 24, 1919 – HAVANA, FEBRUARY 19, 1963).

Composer and performer. Famous for his
renditions of *Bonito y sabroso*, *Cienfuegos*,
Francisco Guayabal, *Maracaibo Oriental*,
Pachito Eché and *Qué bueno baila usted*.

MORÉ — COUNTRY REPRESENTED:

EL SALVADOR - 2005 - **Figs.380, 386**

69

Fig.384. *St Thomas and Prince, 2005;* **Fig.385.** *St Thomas and Prince, 1996;* **Fig.386.** *El Salvador, 2005 (Sc 1626).*

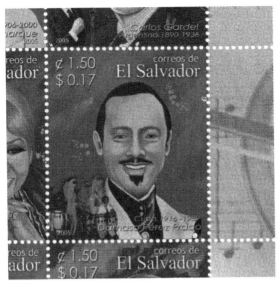

387

PEOPLE

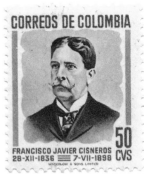

388

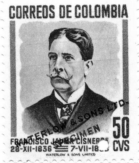

389

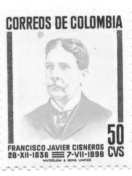

390

DÁMASO PÉREZ PRADO

(MATANZAS, DECEMBER 11, 1916 – MEXICO CITY, SEPTEMBER 14, 1989).

Composer and performer, credited with the popularization of the mambo rhythm. *Mambo No. 5, Patricia* and his cha cha version of *Cherry Pink and Apple Blossom White* earned him well-deserved fame.

PÉREZ PRADO — COUNTRY REPRESENTED:

EL SALVADOR - 2005 - **Figs.380, 387**

FRANCISCO JAVIER CISNEROS

(SANTIAGO DE CUBA, DECEMBER 28, 1836 – NEW YORK, JULY 7, 1898).

Engineer, railroad developer, patriot.

CISNEROS — COUNTRY REPRESENTED:

COLOMBIA - 1949 - **Figs.388-391**

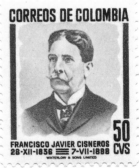

391

Figs.387. El Salvador, 2005 (Sc 1626); **Figs.388-391.** Colombia, 1949 (Sc 577, 578, 579, Specimen).

392

393

394

CARLOS J. FINLAY

(CAMAGUEY, DECEMBER 3, 1833 – HAVANA, AUGUST 20, 1915).

& YELLOW FEVER ASSOCIATES

Finlay was a physician and epidemiologist who in 1881 made known his discovery that yellow fever was transmitted by the *Aedes aegypti* mosquito, not humans. Further experiments and confirmation of this theory by Walter Reed (1851-1902) and others led to the eradication of the disease and made it possible to advance in the construction of the Panama Canal. American nurse Clara Maass (1876-1901) died in Cuba, victim of the yellow fever experiments. She is also honored in a 1951 Cuban stamp. The Cuban Philatelic Circle in Miami circulated an envelope honoring Finlay which was posted on December 3, 1972 (*not illustrated*).

FINLAY & ASSOCIATES – COUNTRIES REPRESENTED:

PANAMA - 1950 - **Fig.397**

US - 1940 - **Figs.392-394**

- 1976 - **Figs.395, 396**

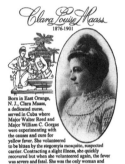

395, 396

71

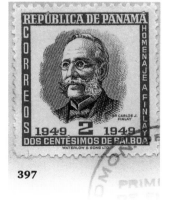

397

Figs.392-394.
US, 1940 (Sc 877),
Figs.395, 396.
US, 1976 (Sc 1699);
Fig.397. Panama,
1950 (Sc 372, C 120).

401

402

403

398

399

400

300F

JOSÉ ARMANDO LÓPEZ FALCÓN

(HAVANA, FEBRUARY 8, 1950).

Air Force pilot and cosmonaut. Backup to Arnaldo Tamayo-Méndez on the Soviet spaceship Soyuz 38 (1980).

LÓPEZ FALCÓN — COUNTRY REPRESENTED:

RUSSIA - 2016 - **Fig.398**

MARÍA TERESA MESTRE BATISTA

(HAVANA, MARCH 22, 1956).

Grand Duchess of Luxemburg. She has five Cuban-Luxembourger children: Guillaume, Felix, Louis, Alexandra and Sebastien. Stamps of the children without their mother are not included in this book.

MESTRE — COUNTRIES REPRESENTED:

LUXEMBOURG - 1981 - **Fig.403**
- 1988 - **Fig.400**
- 2016 - **Figs.401, 402**
NICARAGUA - 2003 - **Fig.399**

CARDINAL JAIME ORTEGA ALAMINO

(JAGÜEY GRANDE, OCTOBER 18, 1936 – HAVANA, JULY 26, 2019).

Catholic Archbishop of Havana (1981 - 2016). Second Cuban cardinal (1994). Ortega had to navigate the hurdles confronting a Christian pastor inside an atheistic, communist regime.

ORTEGA ALAMINO — COUNTRIES REPRESENTED:

DJIBOUTI - 2005 - **Fig.1006, p.179**
CONGO, REPUBLIC - 2005 - **Fig.1014, p.179**

72

Fig.398. Russia, 2016; **Fig.399.** Nicaragua, 2003 (Sc 2392, YT 2549); **Fig.400.** Luxembourg, 1988 (Sc 786); **Figs.401, 402.** Luxembourg, 2016 (Sc 1426 a, b); **Fig.403.** Luxembourg, 1981 (Sc 662).

404

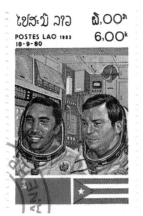

407

Арнальдо Тамайо Мендес
Первый лётчик-космонавт Кубы.
В 1980 г. совершил космический полёт на КК «Союз-38»

Частный сувенирный выпуск. Не является товарной продукцией или рекламой

411

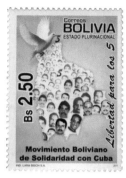

BOLIVIA
Correos
Libertad para los 5
Bs 7.50
MOVIMIENTO BOLIVIANO
DE SOLIDARIDAD
CON CUBA
IND. LARA BISCH S.A.

412

Correos
BOLIVIA
ESTADO PLURINACIONAL
Bs 2.50
Libertad para los 5
Movimiento Boliviano
de Solidaridad con Cuba
IND. LARA BISCH S.A.

413

405

409

VIỆT NAM BƯU CHÍNH 2đ
TAMAYO MENDET
I. RUMANENKO
18.9.80

410

406

ARNALDO TAMAYO MÉNDEZ

(GUANTÁNAMO, JANUARY 29, 1942).

Cosmonaut. First individual of Hispanic and African heritage to orbit the earth (Soviet spaceship Soyuz 38, 1980).

TAMAYO — COUNTRIES REPRESENTED:

LAOS - 1983 - **Fig.407**
MALAGASY REPUBLIC - 1985 - **Fig.409**
MONGOLIA - 1981 - **Fig.408**
RUSSIA - 1980 - **Figs.404-406**
- 2016 - **Fig.411**
VIETNAM - 1983 - **Fig.410**

THE "CUBAN FIVE"

Arrested in the US for spying for Cuba and other illegal activities, five Cuban nationals (Antonio Guerrero, Fernando González, Gerardo Hernández, Ramón Labañino and René González) were sentenced to prison in 1998. In 2014, as part of the negotiations for the reestablishment of diplomatic relations between the two countries, the last remaining prisoners were returned to Cuba, where they were hailed as heroes.

THE "CUBAN FIVE" — COUNTRY REPRESENTED:

BOLIVIA - 2009 - **Fig.412**
- 2011 - **Fig.413**

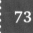

Figs.404-406. *Russia, 1980 (Sc 4865-4867);* **Fig.407.** *Laos, 1983 (Sc 456);* **Fig.408.** *Mongolia, 1981 (Sc 1232);* **Fig.409.** *Malagasy Republic, 1985 (Sc 744);* **Fig.410.** *Vietnam, 1983 (Sc 1277, Michel 1317-1325, YT 411-419);* **Fig.411.** *Russia, 2016;* **Fig.412.** *Bolivia, 2009 (Sc 1397);* **Fig.413.** *Bolivia, 2011.*

FLORA & FAUNA

The national flower is the Mariposa, oddly enough, a native of Asia.

The national bird is the Tocororo.

The reader should also know that the so-called Havana cat was originally bred in England, not Cuba, and probably got its name because of its distinct color, reminiscent of the Havana cigar.

The Cuban archipielago is home to thousands of species, both endemic and introduced during the course of many centuries.

"Pássaros diversos"

"Flamingo"

FLOWERS

Cattleyopsis cubensis

Antigua & Barbuda $3

414

CUBAN CATTLEYOPSIS

(CATTLEYOPSIS CUBENSIS).

CUBAN CATTLEYOPSIS —
COUNTRY REPRESENTED:

ANTIGUA - 2007 - **Fig.414**

Cuban Lily *Scilla peruviana*

St.Kitts $6

415

CUBAN LILY

(SCILLA PERUVIANA).

CUBAN LILY — COUNTRY REPRESENTED:

ST. KITTS - 2011 - **Fig.415**

*Hibiscus rosa-sinensis
"Cuban Variety" 1996*

Vanuatu 200

416

HIBISCUS ROSA SINENSIS "CUBAN VARIETY"

HIBISCUS ROSA SINENSIS —
COUNTRY REPRESENTED:

VANUATU - 1996 - **Fig.416**

Fig.414. *Antigua, 2007 (Sc 2956);* **Fig.415.** St Kitts, 2011 (Sc 819); **Fig.416.** *Vanuatu, 1996 (Sc 692).*

WHITE GINGER

(HEDYCHIUM CORONARIUM, MARIPOSA).

WHITE GINGER — COUNTRIES REPRESENTED:

PARAGUAY - 1995 - **Fig.41, p.25**
VIETNAM - 2010 - **Fig.1041, p.182**

WHITE WATER LILY

(NYMPHAEA AMPLA).

WHITE WATER LILY — COUNTRY REPRESENTED:

IRAN - 2009 - **Fig.966, p.175**

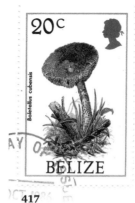

417

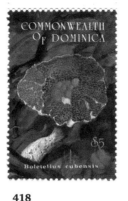

418

BOLETELLUS CUBENSIS

BOLETELLUS CUBENSIS — COUNTRIES REPRESENTED:

BELIZE - 1986 - **Fig.417**
DOMINICA - 1987 - **Fig.419**
 - 1994 - **Fig.418**
GRENADA - 1994 - **Fig.420**
GRENADA GRENADINES - 1991 - **Fig.421**
NEVIS - 1991 - **Fig.422**
ST. KITTS - 1987 - **Fig.423**
TURKS & CAICOS ISLAND - 1991 - **Fig.424**

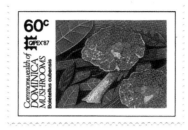

419

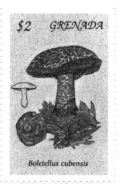

420

421

422

423

424

Fig.417. Belize, 1986 (Sc 845, SG 964); **Fig.418.** Dominica, 1994 (Sc 1664); **Fig.419.** Dominica, 1987 (Sc 1025); **Fig.420.** Grenada, 1994 (Sc 2321); **Fig.421.** Grenada Grenadines, 1991 (Sc 1321-1328); **Fig.422.** Nevis, 1991 (Sc 696); **Fig.423.** St. Kitts, 1987 (Sc 214); **Fig.424.** Turks and Caicos Island, 1991 (Sc 930).

$6

GRENADA CARRIACOU & PETITE MARTINIQUE

Psilocybe cubensis

424a

Mushrooms & Fungi NEVIS

40c

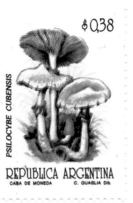

Psilocybe cubensis

425

$0.38

PSILOCYBE CUBENSIS

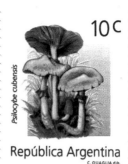

REPUBLICA ARGENTINA

CASA DE MONEDA C. QUAGLIA Dib.

426

10c

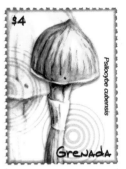

Psilocybe cubensis

República Argentina

C. QUAGLIA dib.

427

$4

Psilocybe cubensis

Grenada

428

PSILOCYBE CUBENSIS

**PSILOCYBE CUBENSIS –
COUNTRIES REPRESENTED:**

ANTIGUA - 1989 - **Fig.429**
ARGENTINA - 1992 - **Fig.426**
— - 1994 - **Fig.427**
GRENADA - 1991 - **Fig.433**
— - 1994 - **Fig.434**
— - 2009 - **Fig.428**
GRENADA GRENADINES-CARRIACOU
— - 2009 - **Fig.431**
— - 2011 - **Fig.424a**
HONDURAS - 1995 - **Fig.432**
LIBERIA - 2000 - **Fig.435**
MONTSERRAT - 1991 - **Fig.430**
NEVIS - 1991 - **Fig.425**
ST. KITTS - 1987 - **Fig.436**

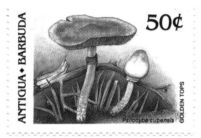

ANTIGUA ◆ BARBUDA

50¢

Psilocybe cubensis

GOLDEN TOPS

429

EIIR $2

PSILOCYBE CUBENSIS

Specimen

-Montserrat-

430

$5

GRENADA CARRIACOU & PETITE MARTINIQUE

Psilocybe, cubensis

431

HONDURAS L 2.00

CUBANA

SILAMIS RAYMUNDOS '95

Psilocybe cubensis

HONGOS DE HONDURAS

432

GRENADA

15¢

Psilocybe cubensis

433

$5 GRENADA

Psilocybe cubensis

434

LIBERIA $35

Psilocybe cubensis

435

Boletellus cubensis

St.Kitts $3

436

Fig.424a. *Grenada Grenadines-Carriacou, 2011 (Sc 2807);* **Fig.425.** *Nevis, 1991 (Sc 693);* **Fig.426.** *Argentina, 1992 (Sc 1748, SG 2279);* **Fig.427.** *Argentina, 1994 (Sc 1819, SG 2365, YT 1836-1840);* **Fig.428.** *Grenada, 2009 (Sc 3714, Mi 4507, SG 4009, YT 3792);* **Fig.429.** *Antigua, 1989 (Sc 1225, SG 1315);* **Fig.430.** *Montserrat, 1991 (Sc 774);* **Fig.431.** *Grenada Grenadines-Carriacou, 2009 (Sc 2730);* **Fig.432.** *Honduras, 1995 (Sc C951, YT 859A);* **Fig.433.** *Grenada, 1991 (Sc 1989);* **Fig.434.** *1994 (Sc 2323);* **Fig.435.** *Liberia, 2000;* **Fig.436.** *St. Kitts, 1987 (Sc 212).*

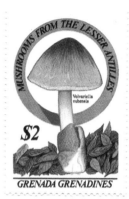

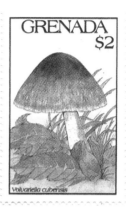

437

438

439

441

442

PSILOCYBE SUBCUBENSIS

PSILOCYBE SUBCUBENSIS – COUNTRIES REPRESENTED:

GRENADA GRENADINES-CARRIACOU- 2009 - Fig.437

PAPUA - 2005 - Fig.438

Fig.437. *Grenada Grenadines-Carriacou, 2009 (Sc 2730);* **Fig.438.** *Papua, 2005 (Sc 1179);* **Fig.439.** *Benin, 1996 (Sc 764, SG 1432);* **Fig.440.** *Papua, 2005 (Sc 1180d);* **Fig.441.** *Grenada, 1991 (Sc 1994, Mi 2273);* **Fig.442.** *Grenada Grenadines, 1986 (Sc 764);* **Fig.443.** *Brazil, 2019.*

STROPHARIA CUBENSIS

STROPHARIA CUBENSIS – COUNTRIES REPRESENTED:

BENIN - 1996 - Fig.439

PAPUA - 2005 - Fig.440

440

VOLVARIELLA CUBENSIS

VOLVARIELLA CUBENSIS – COUNTRIES REPRESENTED:

GRENADA - 1991 - Fig.441

GRENADA GRENADINES - 1986 - Fig.442

OUDEMANSIELLA CUBENSIS

OUDEMANSIELLA CUBENSIS – COUNTRY REPRESENTED:

BRAZIL - 2019 - Fig.443

443

FLORA & FAUNA

BIRDS

AMERICAN [CUBAN] FLAMINGO

(PHOENICOPTERUS RUBER).

PHOENICOPTERUS RUBER

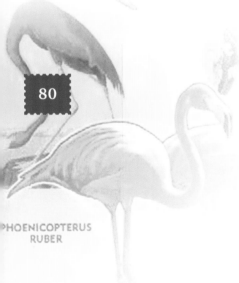

DRYOCOPUS PILEATUS

John J. Audubon

REPUBLIQUE DU TCHAD

200f

JEAN-JACQUES AUDUBON (1785-1851)
(MUSCICAPA BONAPARTII) A. AUDUBON

IMPRESSOR S.A. POSTE 2013

PHOENICOPTERUS RUBER

VERMIVORA CYANOPTERA

SETOPHAGA RUTICILLA

444

The famous Haitian-born American bird illustrator John James Audubon (1785-1851) collected an American flamingo when he was exploring the birds in Key West, Florida. However, once in London for the actual printing of his monumental *Birds of America*, he needed another, fresher, specimen and the one he finally painted and published (1838) was actually a specimen sent from Cuba. I find it remarkable that such a famous image has not yet made it into a US stamp.

AMERICAN FLAMINGO — COUNTRIES REPRESENTED:

CHAD - 2014 - **Fig.444**
GRENADA - 1985 - **Fig.445**
GUINEA BISSAU - 1985 - **Figs.447, 449**
NIGER - 1985 - **Fig.446**
UDMURTIA - 1999 - **Fig.448**

Fig.444. *Chad, 2014.*

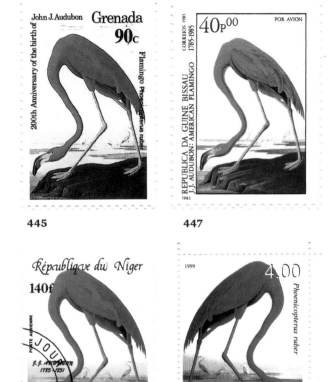

445

447

446

448

Fig.445. Grenada, 1985 (Sc 1353, Mi 1449, YT 1291); Fig.446. Niger, 1985; Fig.447. Guinea Bissau, 1985; Fig.448. Udmurtia, 1999; Fig.449. Guinea Bissau, 1985.

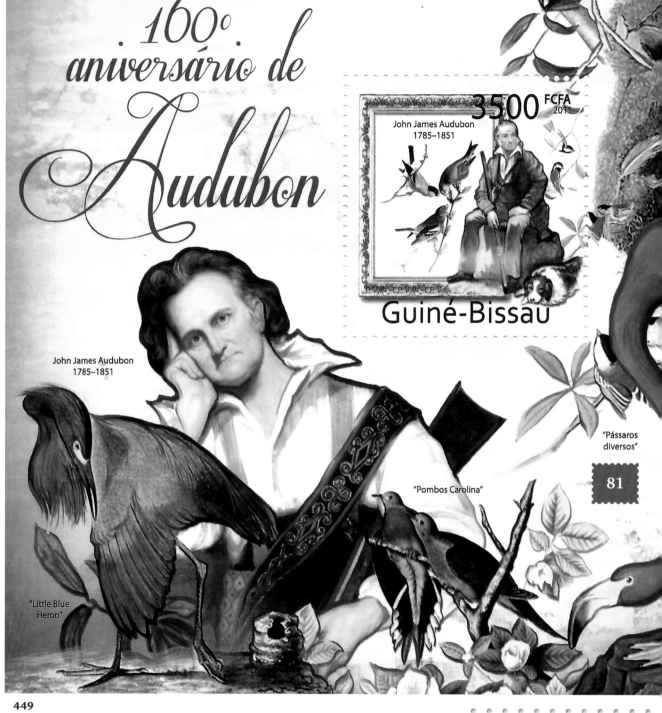

449

450

451

452

453

BEE HUMMINGBIRD

(MELISUGAE HELENAE, ZUNCUNCITO).

BEE HUMMINGBIRD — COUNTRIES REPRESENTED:

ANTIGUA - 1992 - **Fig.456**

COOK ISLANDS - 1992 - **Fig.450**

DJIBOUTI - 2019 - **Fig.454**

DOMINICA - 2001 - **Figs.451, 452**

GRENADA GRENADINES-CARRIACOU - 2001 - **Fig.453**

ST. VINCENT - 1992 - **Fig.455**

ST. VINCENT GRENADINES - 2019 - **Fig.457**

454

455

Fig.450. *Cook Islands, 1992 (Sc 1103);* **Figs.451, 452.** *Dominica, 2001 (Sc 2253c, Sc 2254d);* **Fig.453.** *Grenada Grenadines-Carriacou, 2001 (Sc 2290c);* **Fig.454.** *Djibouti, 2019;* **Fig.455.** *St. Vincent 1992 (Sc 1651);* **Fig.456.** *Antigua, 1992 (Sc 1587);* **Fig.457.** *St. Vincent Grenadines, 2019.*

456

457

BAHAMAS
NATIONAL TRUST
40th Anniversary

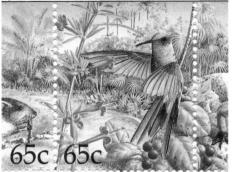

65c 65c

458

BAHAMAS

Cuban Emerald · Hummingbirds · *Chlorostilbon ricordii*

10c

459

RÉPUBLIQUE CENTRAFRICAINE

COLIBRI CARAÏBE

460

Commonwealth of **DOMINICA**

Cuban Hummingbird · *Chlorostilbon ricordii*

$2

461

CUBAN EMERALD
(CHLOROSTILBON RICORDII).

GRENADA

Chlorostilbon ricordii

50¢

1992 · Cuban Emerald

462

RÉPUBLIQUE de GUINÉE
OFFICE DE LA POSTE GUINÉENNE

500F · Mâle Cuban

463

1000F · EMERAUDE DE RICORD · *Chlorostilbon ricordii*

RÉPUBLIQUE DE GUINÉE
OFFICE DE LA POSTE GUINÉENNE

464

CUBAN EMERALD – COUNTRIES REPRESENTED:

BAHAMAS - 1989 - **Fig.459**
 - 1999 - **Fig.458**
CENTRAL AFRICAN REPUBLIC - 2001 - **Fig.460**
DOMINICA - 2007 - **Fig.461**
GRENADA - 1992 - **Fig.462**
GUINEA - 1999 - **Fig.463**
 - 2001 - **Fig.464**
NEVIS - 1995 - **Fig.465**
ST. VINCENT - 1992 - **Fig.466**
ST. VINCENT GRENADINES-UNION - 2013 - **Fig.467**

NEVIS
50c

JAMAICAN MANGO

465

St. Vincent
$2

Chlorostilbon ricordii · Cuban Emerald

466

Humming

$3.²⁵

Cuban Emerald
Chlorostilbon ricordii

UNION ISLAND
GRENADINES OF ST.VINCENT

Green-throated Carib
Eulampis holosericeus

$3.²⁵

467

Fig.458. *Bahamas, 1999 (SG 1207a);* **Fig.459.**
Bahamas, 1989 (Sc 668, Mi 695, SG 849, YT 685);
Fig.460. *Central African Republic, 2001 (Sc 1410a);*
Fig.461. *Dominica, 2007 (Sc 2623d);* **Fig.462.**
Grenada, 1992 (Sc 2075); **Fig.463.** *Guinea, 1999*
(Sc 1584a); **Fig.464.** *Guinea, 2001 (Sc 2041);* **Fig.465.**
Nevis, 1995 (Sc 901); **Fig.466.** *St. Vincent, 1992*
(Sc 1652); **Fig.467.** *St. Vincent*
Grenadines-Union, 2013.

83

EXTINTOS

Papagaios extintos

66.00MT

MOÇAMBIQUE

Guiné-Bissau 850 FCFA 2012

472 473

471

474

468

ANTIGUA & BARBUDA $1.20

469

470

CUBAN GRASSQUIT/ CUBAN FINCH

(TIARIS CANORA, TOMEGUÍN DEL PINAR).

CUBAN GREEN WOODPECKER

(XIPHIDIOPICUS PERCUSSUS).

CUBAN MACAW

(ARA TRICOLOR).

ANIMAUX EN VOIE DE DISPARITION
RHINOCEROS NOIR

REPUBLIQUE CENTRAFRICAINE 400F

475

CUBAN GRASSQUIT/CUBAN FINCH — COUNTRIES REPRESENTED:

ANTIGUA - 2000 - **Fig.469**
RUSSIA - 1983 - **Fig.468**
SWEDEN - 1977 - **Fig.470**

CUBAN GREEN WOODPECKER — COUNTRIES REPRESENTED:

BHUTAN - 1999 - **Fig.471**

CUBAN MACAW — COUNTRIES REPRESENTED:

CENTRAL AFRICAN REPUBLIC - 1983 - **Fig.475**
GUINEA BISSAU - 2012 - **Fig.473**
MOZAMBIQUE - 2012 - **Fig.472**
 - 2017 - **Fig.474**
TOGO - 2017 - **Fig.476**

Fig.468. *Russia, 1983;* **Fig.469.** *Antigua, 2000 (Sc 2309g);* **Fig.470.** *Sweden, 1977;* **Fig.471.** *Bhutan, 1999 (Sc 1226e);* **Fig.472.** *Mozambique, 2012 (Sc 2589);* **Fig.473.** *Guinea Bissau, 2012;* **Fig.474.** *Mozambique, 2017;* **Fig.475.** *Central African Republic, 1983 (Sc C291a);* **Fig.476.** *Togo, 2017.*

476

Parrots of the Caribbean

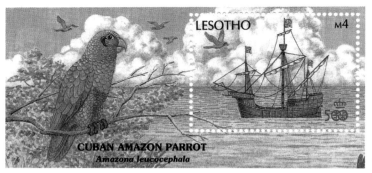

479

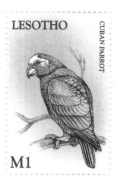

LESOTHO M1

CUBAN PARROT

480

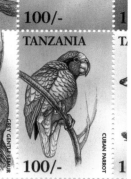

100/- TANZANIA 100/-

CUBAN PARROT

481

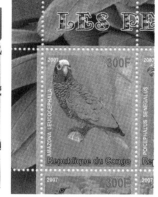

482

Cuban Amazon *Amazona leucocephala*

Union Island $9
GRENADINES OF ST. VINCENT

1404

477

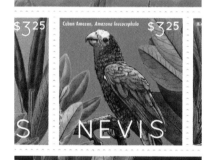

$3.25 Cuban Amazon, *Amazona Amazona leucocephala* $3.25

S NEVIS

478

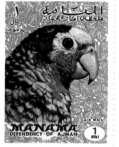

483

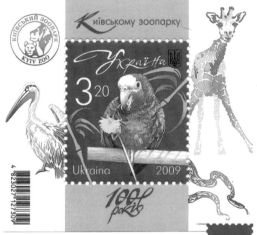

3.20 Ukraina 2009

486

85

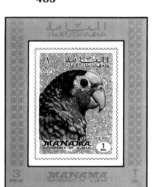

484

REPUBLIQUE DU NIGER

Amazona leucocephala 850F

485

Cuban Parrot *Amazona leucocephala*

St. Vincent & The Grenadines $5

487

CUBAN PARROT

(AMAZONA LEUCOCEPHALA LEUCOCEPHALA/ COTORRA CUBANA).

The reader should be aware that The Cayman Islands and Bahamas also depict *Amazona leucocephala* birds, but these are variants of the endemic Cuban species *leucocephala leucocephala* and, thus, not included here.

CUBAN PARROT — COUNTRIES REPRESENTED:

CONGO, REPUBLIC - 2007 - **Fig.482**
LESOTHO - 1987 - **Fig.479**
 - 1991 - **Fig.480**
MANAMA - 1972 - **Figs.483, 484**
NEVIS - 2013 - **Fig.478**
NIGER - 2016 - **Fig.485**
ST. VINCENT GRENADINES - 2018 - **Fig.487**
ST. VINCENT GRENADINES -UNION - 2014 - **Fig.477**
TANZANIA - 1999 - **Fig.481**
UKRAINE - 2009 - **Fig.486**

Fig.477. *St. Vincent Grenadines-Union, 2014;* **Fig.478.** *Nevis, 2013 (Sc 1750b);* **Fig.479.** *Lesotho, 1987;* **Fig.480.** *Lesotho, 1998 (Mi 1256, SG 1361);* **Fig.481.** *Tanzania, 1999 (Sc 1898n);* **Fig.482.** *Congo, Republic, 2007;* **Figs.483, 484.** *Manama, 1972;* **Fig.485.** *Niger, 2016;* **Fig.486.** *Ukraine, 2009 (Sc 759, Mi 1023;* **Fig.487.** *St. Vincent Grenadines, 2018.*

488

CUBAN PIGMY OWL

(GYMNOLAUX SIJU, GLAUCIDIUM SIJU, SIJÚ PLATANERO).

CUBAN PIGMY OWL — COUNTRY REPRESENTED:

GRENADA GRENADINES-CARRIACOU - 2001 - **Fig.488**

491

489

490

CUBAN TODY

(TODUS MULTICOLOR, CARTACUBA).

CUBAN TODY — COUNTRIES REPRESENTED:

SPAIN - 1990 - **Fig.491**

GRENADA - 1995 - **Fig.490**

ST. VINCENT GRENADINES-MUSTIQUE - 2018 - **Fig.489**

Fig.488. *Grenada Grenadines-Carriacou 2001 (Sc 2290a, Mi 348-94);*
Fig.489. *St. Vincent Grenadines-Mustique, 2018;* **Fig.490.** *Grenada, 1995*
(Sc 2403); **Fig.491.** *Spain, 1990 (Sc 2633, Edifil 3083).*

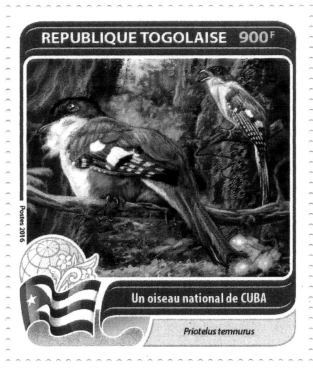

REPUBLIQUE TOGOLAISE 900ᶠ

Postes 2016

Un oiseau national de CUBA

Priotelus temnurus

492

25c

Cuban Trogan

Grenada Grenadines

493

87

CUBAN TROGON

(PRIOTELUS TEMNURUS, TOCORORO).

CUBAN TROGON — COUNTRIES REPRESENTED:

BELARUS - 2012 - **Fig.954, p.173**
GRENADA GRENADINES - 1995 - **Fig.493**
TOGO - 2016 - **Fig.492**

ZAPATA RAIL

(CYANOLIMNAS CERVERAI).

ZAPATA RAIL — COUNTRY REPRESENTED:

IRAN - 2009 - **Fig.966, p.175**

Fig.492. *Togo, 2016;* **Fig.493.** *Grenada Grenadines, 1995 (Sc 1754).*

BUTTERFLIES

Gân cánh

Nervures des ailes

Hệ thống tái sinh sản

Systema Reproducteur

EXPOSITION
PHILATELIQUE
INTERNATIONALE
INDIA'89

495

CUBAN CATTLEHEART

(PARIDES GUNDLACHIANUS,
GUNDLACH'S SWALLOWTAIL).

CUBAN CATTLEHEART – COUNTRIES REPRESENTED:

DOMINICA - 1989 - **Fig.494**
NEVIS - 2018 - **Fig.496**
VIETNAM, DPR - 1989 - **Fig.495**

Fig.494. Dominica, 1989 (Sc 1179, SG 1255-62); **Fig.495.** Vietnam, DPR, 1989 (Sc 1930); **Fig.496.** Nevis, 2018.

494

Beautiful Butterflies

Gundlach's Swallowtail *Parides gundalachianus*

Nevis

$8

496

REPUBLIQUE
de GUINEE
400f

OPG 1998

Dismorphia cubana

497

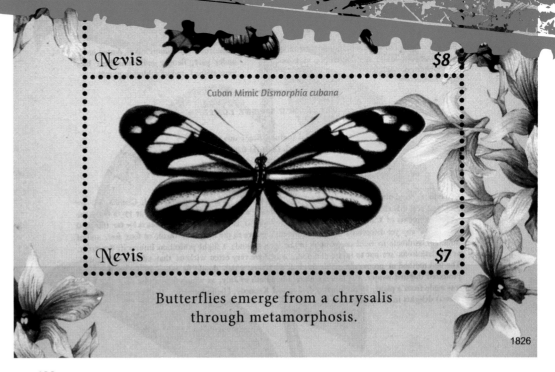

Nevis $8

Cuban Mimic *Dismorphia cubana*

Nevis $7

Butterflies emerge from a chrysalis
through metamorphosis.

1826

498

CUBAN MIMIC

((DISMORPHIA CUBANA).

CUBAN MIMIC — COUNTRIES REPRESENTED:

GUINEA, 1998 - **Fig.497**
NEVIS - 2018 - **Fig.498**
TURKS & CAICOS - 2001 - **Fig.499**

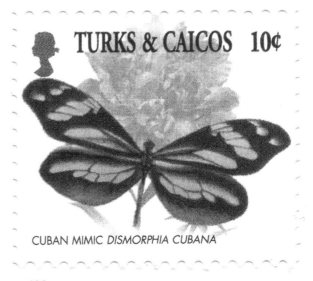

TURKS & CAICOS 10¢

CUBAN MIMIC *DISMORPHIA CUBANA*

499

Fig.497. *Guinea, 1998 (Sc 1427)*; **Fig.498.** *Nevis, 2018*; **Fig.499.** *Turks & Caicos, 2001 (Sc 1351).*

89

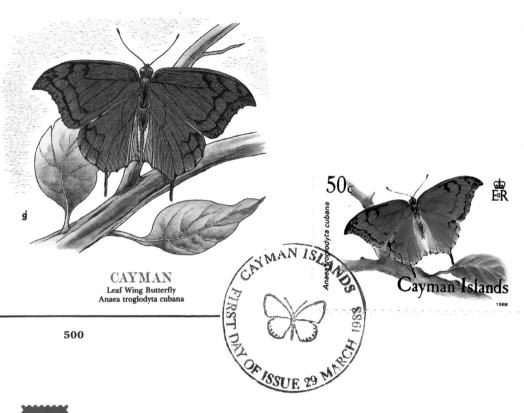

CAYMAN
Leaf Wing Butterfly
Anaea troglodyta cubana

500

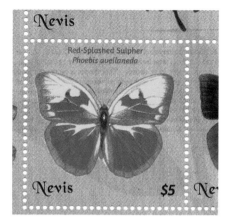

500a

501

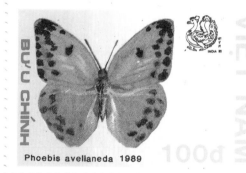

502

LEAF WING BUTTERFLY

(ANAEA TROGLODYTA CUBANA).

LEAF WING BUTTERFLY — COUNTRY REPRESENTED:

CAYMAN - 1988 - Fig.500

PHOEBIS AVELLANEDA

(RED-SPLASHED SULPHUR).

PHOEBIS AVELLANEDA — COUNTRIES REPRESENTED:

DOMINICA - 1989 - Fig.500a
NEVIS - 2018 - Fig.501
ROMANIA - 1992 - Figs.503, 504
TUVALU - 1985 - Fig.505
VIETNAM, DPR - 1989 - Fig.502

Inspired by Cuba! DELIVERING CUBA THROUGH THE MAIL ★ C U E T O

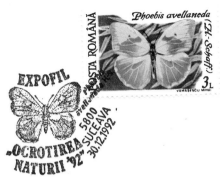

TUVALU
Phoebis avellaneda
Phoebis avellaneda

503



505

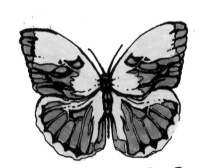

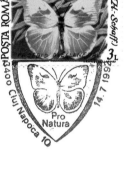

Phoebis avellanoda (H.-Schaff)

91

506

POEY´S BLACK SWALLOWTAIL

(PAPILUS CAIGUANABUS).

POEY'S BLACK SWALLOWTAIL — COUNTRY REPRESENTED:

NEVIS - 2018 - **Fig.506**

504

Fig.500. *Cayman*, 1998; Fig.500a. *Dominica*, 1989 (Sc1183); Fig.501. *Nevis,*
2018; Fig.502. *Vietnam, DPR*, 1989 (Sc 1927, Mi 1994); Figs.503, 504. *Romania,*
1992; Fig.505. *Tuvalu*, 1985 (Sc 41, Mi 51); Fig.506. *Nevis*, 2018.

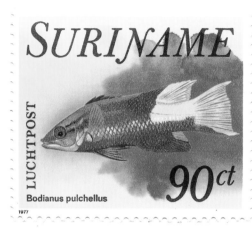

507

CUBAN HOGFISH

(BODIANUS PULCHELLUS).

CUBAN HOGFISH — COUNTRIES REPRESENTED:

BAHAMAS - 1994 - **Fig.508**
SURINAME - 1977 - **Fig.507**

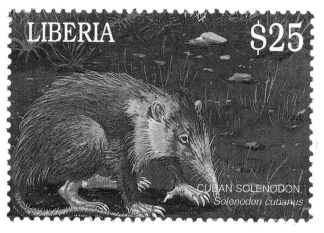

509

ALMIQUI / CUBAN SOLENODON

(SOLENODON CUBANUS).

ALMIQUI/CUBAN SOLENODON — COUNTRIES REPRESENTED:

BURUNDI - 2011 - **Fig.511**
DOMINICA - 2001 - **Fig.510**
LIBERIA - 2001 - **Fig.509**

Fig.507. *Suriname, 1977 (Sc 471-5, C72-4);* **Fig.508.** *Bahamas, 1994 (Sc A139a);* **Fig.509.** *Liberia, 2001.*

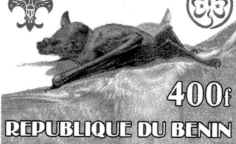

DOMINICA

Commonwealth of
DOMINICA

Cuban Solenodon

$1.45

Commonwealth of
DO

510

RÉPUBLIQUE DU BENIN

PHYLLONYCTERIS POEYI

POSTES 2002

400f

RÉPUBLIQUE DU BENIN

512

Commonwealth of
DOMINICA

$1.45

Cuban Hutia

Commonwealth of
DOMINICA

513

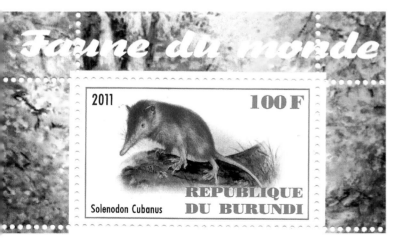

Faune du monde

2011

100 F

Solenodon Cubanus

RÉPUBLIQUE
DU BURUNDI

511

CUBAN FLOWER BAT

(PHYLLONCYTERIS POEYI).

CUBAN FLOWER BAT —
COUNTRY REPRESENTED:

BENIN - 2002 - **Fig.512**

CUBAN HUTIA

(JUTÍA).

CUBAN HUTIA —
COUNTRY REPRESENTED:

DOMINICA - 2001 - **Fig.513**

93

Fig.510. *Dominica, 2001 (Sc 2262d);* **Fig.511.** *Burundi, 2011;* **Fig.512** *Benin, 2002;* **Fig.513.** *Dominica, 2001 (Sc 2262e).*

Havana Brown

St. Vincent & The Grenadines $3

514

HIMALAYAN TORTIE POINT SCOTTISH FOLD BL

ZAMBIA ZAMB

K1000

HAVANA CHOCOLATE RAGDOLL SEAL PO

515

REPUBLIQUE POPULAIRE DU CONGO

30F
POSTES
1974

CHESNUT HAVANE

CHESNOT DELRIEU

516

HAVANA/
HAVANA BROWN/
HAVANA CHOCOLATE/
CHESTNUT HAVANA/
CAT

HAVANA CAT — COUNTRIES REPRESENTED:

BURUNDI - 2017 - Fig.517
CONGO, REPUBLIC - 1974 - Fig.516
DJIBOUTI - 2008 - Fig.521
KOREA, DPR - 1983 - Fig.518
ST. VINCENT - 2003 - Fig.514
SIERRA LEONE - 1993 - Fig.520
TANZANIA - 1992 - Fig.519
ZAMBIA - 1999 - Fig.515

DPR KOREA 1983
DPR KOREA

10 1983
조선우표 DPR KOREA

518

TANZANIA

Havana cat

30/.

1992

519

Havana Brown

Sierra Leone LE 150

520

517

522

524

523

521

HAVANESE/ BICHON HAVANAIS

95

HAVANESE — COUNTRIES REPRESENTED:

GUINEA - 2002 - **Fig.524**
KURIL ISLANDS - 2007 - **Fig.523**
TATARSTAN - 2006 - **Fig.522**

Fig.514. St. Vincent, 2003 (Sc 3158); **Fig.515.** Zambia, 1999 (Sc 800d); **Fig.516.** Congo, Republic, 1974 (YT 351); **Fig.517.** Burundi, 2017; **Fig.518.** Korea, DPR, 1983 (Sc 2347-2351); **Fig.519.** Tanzania, 1992 (Sc 967B, Mi 1406); **Fig.520.** Sierra Leone, 1993 (Sc 1644h); **Fig.521.** Djibouti, 2008. **Fig.522.** Tatarstan, 2006; **Fig.523.** Kuril Islands, 2007; **Fig.524.** Guinea, 2002.

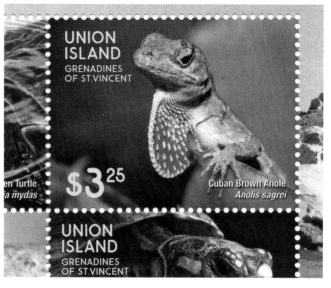

525

526

COLORED LAND SNAIL

(POLYMITA PICTA).

COLORED LAND SNAIL – COUNTRIES &
POSTAL AUTHORITIES REPRESENTED:

GRENADA GRENADINES-CARRIACOU
- 2001 - **Fig.525**
NICARAGUA - 1988 - **Fig.527**
UNITED NATIONS - 2018 - **Fig.526**

527

CUBAN BROWN ANOLE

(ANOLIS SAGREI).

CUBAN BROWN ANOLE – COUNTRY REPRESENTED:

ST. VINCENT GRENADINES-UNION - 2015 - **Fig.528**

528

Fig.525. *Grenada Grenadines-Carriacou, 2001 (Sc 2290, Mi 3489-94);* **Fig.526.** *United Nations, 2018;* **Fig.527.** *Nicaragua, 1988 (Sc 1720) [I wish to thank Yamilet Moya for this information];* **Fig.528.** *St. Vincent Grenadines-Union, 2015.*

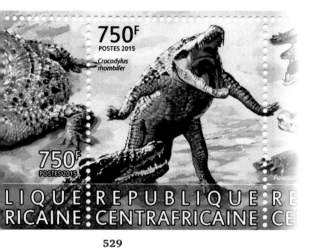

750ᶠ
POSTES 2015

Crocodylus rhombifer

750ᶠ
POSTES 2015

LIQUE REPUBLIQUE R
RICAINE CENTRAFRICAINE CE

529

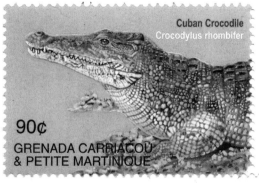

Cuban Crocodile
Crocodylus rhombifer

90¢
GRENADA CARRIACOU
& PETITE MARTINIQUE

530

CUBAN CROCODILE

(CROCODYLUS RHOMBIFER).

CUBAN CROCODILE — COUNTRIES REPRESENTED:

CENTRAL AFRICAN REPUBLIC - 2015 - **Fig.529**
DJIBOUTI - 2016 - **Fig.532**
GRENADA GRENADINES-CARRIACOU - 2001 - **Fig.530**

Continued on page 98

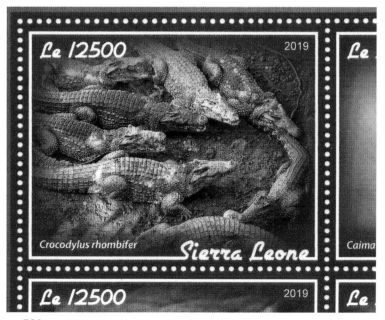

Le 12500 2019

Crocodylus rhombifer *Sierra Leone* Caima

Le 12500 2019

531

260ᶠ
2016

RÉPUBLIQUE DE
Djibouti

Crocodylus rhombifer

532

97

Fig.529. *Central African Republic, 2015;* **Fig.530.** *Grenada Grenadines-Carriacou, 2001 (Sc 2286);* **Fig.531.** *Sierra Leone, 2019 (Sc 3681d).* **Fig.532.** *Djibouti, 2016 (Sc 874c).*

Exposición Filatélica Internacional

ESPAMER '85

NICARAGUA ₡ 10.00 aéreo
Crocodylus rhombifer

ESPAMER '85

533

SIERRA LEONE
Crocodylus rhombifer
2016 Le 6000

534

MOÇAMBIQUE
Crocodylus rhombifer
2007 8.00 Mtn
MOÇAMBIQUE

535

CUBAN CROCODILE

(CROCODYLUS RHOMBIFER).

CUBAN CROCODILE — COUNTRIES REPRESENTED:

Continued from page 97

GUINEA BISSAU - 2015 - Fig.537
MOZAMBIQUE - 2007 - Fig.535
NICARAGUA - 1985 - Fig.533
SIERRA LEONE - 2016 - Fig.534
- 2019 - Fig.531, p.97
TANZANIA - 1996 - Fig.536

TANZANIA 380/.

1996 CROCODYLUS RHOMBIFER

536

GUINÉ - BISSAU 2015 750 FCFA
Crocodylus rhombifer

537

Fig.533. Nicaragua, 1985 (Sc C1050); Fig.534. Sierra Leone, 2016 (Sc 3605?, Sc 3681d);
Fig.535. Mozambique, 2007 (Sc 1764c); Fig.536. Tanzania, 1996 (Sc 1470, Mi 2274-2281);
Fig.537. Guinea Bissau, 2015.

538

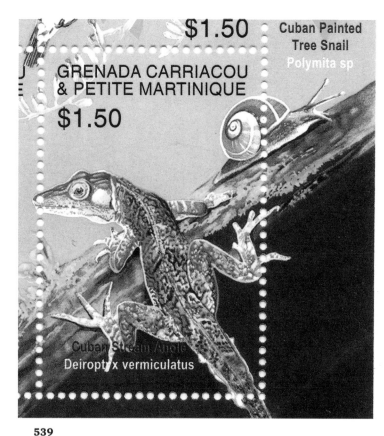

539

CUBAN GROUND IGUANA

CUBAN GROUND IGUANA — COUNTRY REPRESENTED:

DHUFAR - 1972 - **Fig.538**

CUBAN STREAM ANOLE

(DEIROPTYX VERMICULATUS).

CUBAN STREAM ANOLE — COUNTRY REPRESENTED:

GRENADA GRENADINES-CARRIACOU - 2001 - **Fig.539**

Fig.538. *Dhufar, 1972;* **Fig.539.** *Grenada Grenadines-Carriacou, 2001 (Sc 2290f, Mi 3489-94).*

PLACES

MAP OF CUBA WITH POLITICAL SUBDIVISIONS

- **A** Viñales
- **B** Havana
- **C** Bellamar Caves
- **D** Varadero
- **E** Zapata Swamp
- **F** Cienfuegos
- **G** Trinidad
- **H** Camagüey
- **I** Cascorro
- **J** Santiago de Cuba

Havana

Artemisa

Mayabeque

Matanzas

Villa Clara

Pinar del Río

Cienfuegos

Sancti Spíritus

Ciego de Ávila

Isla de la Juventud

Camagüey

Las Tunas

Holguín

Granma

Santiago de Cuba

Guantánamo

REPUBLIQUE CENTRAFR...

CYCLONE MICHELLE
CUBA
27/10/2001

PLACES

HAVANA

ALICIA ALONSO THEATER

(FORMER GALICIAN CENTER).

ALICIA ALONSO THEATER —
COUNTRIES REPRESENTED:

GRENADA - 2016 - Fig.994, p.178
TUVALU - 2016 - Figs.988-991, p.178

ANGEL CHURCH

ANGEL CHURCH — COUNTRY REPRESENTED:

TOGO - 2012 - Fig.1029, p.181

CAPITOL BUILDING

CAPITOL BUILDING — COUNTRIES REPRESENTED:

NETHERLANDS - 2011 - Fig.1167, p.201
RWANDA - 2013 - Fig.963, p.174
 - 2013 - Fig.1007, p.179
SERBIA - 2013 - Fig.974, p.176
SIERRA LEONE - 2017 - Fig.833, p.150
ST. VINCENT - 2016 - Fig.1002, p.178
ST. VINCENT GRENADINES-MYREAU
 - 2007 - Fig.813, p.149

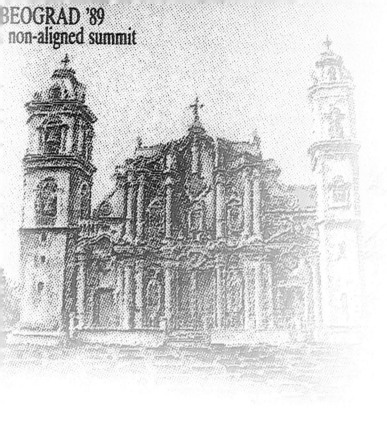

BEOGRAD '89
non-aligned summit

MALECÓN

MALECÓN — COUNTRY REPRESENTED:

SIERRA LEONE - 2017 -

Fig.832, p.150

MARTI'S BIRTHPLACE

MARTI'S BIRTHPLACE — COUNTRY REPRESENTED:

NICARAGUA - 1983 - **Fig.39, p.25**

CATHEDRAL

CATHEDRAL — COUNTRIES REPRESENTED:

BULGARIA - 2010 - **Fig.957, p.173**
SPAIN - 1985 - **Fig.900, p.162**
ST. VINCENT - 2016 - **Fig.948, p.171**
TOGO - 2012 - **Fig.1029, p.181**
YUGOSLAVIA - 1989 - **Fig.1070, p.187**

FUERZA CASTLE

FUERZA CASTLE — COUNTRY REPRESENTED:

BELGIUM - 1976 - **Fig.1161, p.200**

HAVANA | PLACES

MUSEUM OF THE REVOLUTION

(FORMER PRESIDENTIAL PALACE).

MUSEUM OF THE REVOLUTION — COUNTRY REPRESENTED:

ST. VINCENT - 2016 - **Fig.998, p.178**

540

MORRO CASTLE

MORRO — COUNTRIES & POSTAL
AUTHORITIES REPRESENTED:

CAMBODIA - 1986 - **Fig.245, p.52**
ECUADOR - 2015 - **Fig.905, p.164**
NICARAGUA - 1985 - **Fig.533, p.98**
UNITED NATIONS - 2019 - **Fig.540**

Fig.540. *United Nations, 2019;* **Fig.541.** *Israel, 2015.*

OLD HAVANA STREET

OLD HAVANA STREET —
COUNTRY REPRESENTED:

ISRAEL - 2015 - **Fig.541**

Inspired by Cuba! DELIVERING CUBA THROUGH THE MAIL ★ CUETO

541

U.N.E.S.C.O

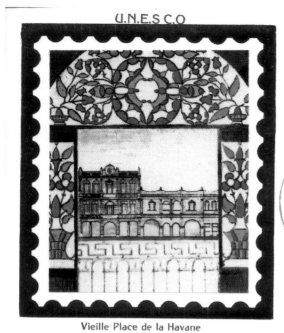

Vieille Place de la Havane

542

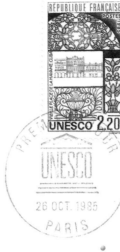

PREMIER JOUR
D'ÉMISSION
FIRST DAY COVER

CEF

OLD SQUARE

(PLAZA VIEJA).

OLD SQUARE — COUNTRY/POSTAL AUTHORITY REPRESENTED:

FRANCE / UN/ UNESCO - 1985 - **Figs.542, 543**

PRINCESS DIANA (1961-1997) GARDEN

PRINCESS DIANA GARDEN — COUNTRY REPRESENTED:

GUINEA - 1998 - **Fig.1019, p.180**

Figs.542, 543. *France/ UN/ UNESCO, 1985 (Sc 2029-2036, SG FR U35, Mi FR U35, YT FR S89).*

543

105

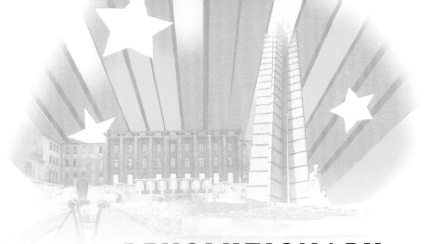

REVOLUTIONARY SQUARE

(PLAZA CÍVICA/ DE LA REVOLUCIÓN).

REVOLUTIONARY SQUARE — COUNTRIES REPRESENTED:

CENTRAL AFRICAN REPUBLIC - 2012 - **Fig.1013, p.179**
GERMANY, DDR - 1978 - **Fig.921, p.168**
GRENADA - 2012 - **Fig.1008, p.179**
INDONESIA - 2008 - **Fig.52, p.26**
RUSSIA - 1974 - **Fig.973, p.176**
TURKEY - 2012 - **Fig.980, p.177**
VATICAN - 1999 - **Fig.1028, p.180**
 - 2015 - **Fig.1034, p.181**
VIETNAM - 1999 - **Fig.708, p.139**

ST. FRANCIS SQUARE

ST. FRANCIS SQUARE —
COUNTRY REPRESENTED:

GRENADA - 2016 - **Fig.946, p.171**

VEDADO SECTION UNDER HURRICANE MICHELLE

(2001).

544

VEDADO SECTION — COUNTRY REPRESENTED:

CENTRAL AFRICAN REPUBLIC - 2002 - **Fig.544**

Fig.544. *Central African Republic, 2002.*

PLACES

CAMAGÜEY CITY

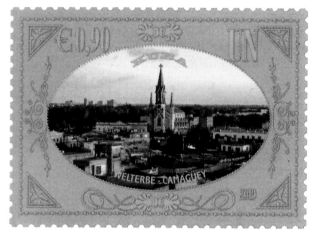

545

CASCORRO, CAMAGÜEY

VEDADO. UNIVERSITY OF HAVANA

VEDADO. UNIVERSITY —
COUNTRY REPRESENTED:

RUSSIA - 1974 - Fig.973, p.176

CAMAGÜEY CITY

CAMAGÜEY CITY —
POSTAL AUTHORITY REPRESENTED:

UNITED NATIONS - 2019 - Fig.545

CASCORRO

CASCORRO — COUNTRY REPRESENTED:

SPAIN - 1971 - Fig.668, p.133

Fig.545. *United Nations, 2019.*

PLACES

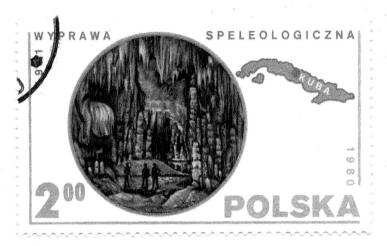

546

GOVERNMENT PALACE

GOVERNMENT PALACE — COUNTRY &
POSTAL AUTHORITY REPRESENTED:

IVORY COAST - 2013 - **Fig.85, p.33**
UNITED NATIONS - 2019 - **Fig.546**

547

BELLAMAR CAVES

BELLAMAR CAVES — COUNTRY &
POSTAL AUTHORITY REPRESENTED:

POLAND - 1980 - **Fig.547**

Fig.546. *United Nations, 2019;* **Fig.547.** *Poland, 1980 (Sc 2390).*

VARADERO, MATANZAS

548

549

ZAPATA SWAMP, MATANZAS

VIÑALES, PINAR DEL RIO

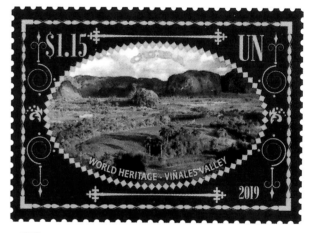

550

VARADERO BEACH

VARADERO BEACH — COUNTRIES REPRESENTED:

CHINA - 2000 - **Fig.548**
GREAT BRITAIN - 2009 - **Fig.549**

ZAPATA SWAMP

ZAPATA SWAMP —
COUNTRY REPRESENTED:

IRAN - 2009 - **Fig.966, p.175**

VIÑALES VALLEY

VIÑALES VALLEY —
POSTAL AUTHORITY REPRESENTED:

UNITED NATIONS - 2019 - **Fig.550**

Fig.548. *China, 2000;* **Fig.549.** *Great Britain, 2009;* **Fig.550.** *United Nations, 2019.*

SANTIAGO DE CUBA

e de la Poste Guinéenne 2012

20000 FG.
2012

CATHEDRAL

CATHEDRAL — COUNTRY REPRESENTED:

GUINEA - 2012 - **Fig.1017, p.180**

EL COBRE SHRINE TO OUR LADY OF CHARITY

EL COBRE SHRINE TO OUR LADY OF CHARITY — COUNTRY REPRESENTED:

MOZAMBIQUE - 2016 - **Fig.1035, p.181**
TOGO - 2012 - **Fig.1031, p.181**

CHURCH

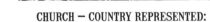

CHURCH — COUNTRY REPRESENTED:

GUINEA - 2002 - **Fig.681, p.135**

PORT OF SANTIAGO ON MAP

PORT OF SANTIAGO ON MAP — COUNTRY REPRESENTED:

URUGUAY - 2003 - **Fig.615, p.125**

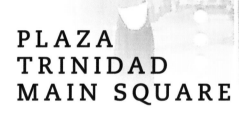

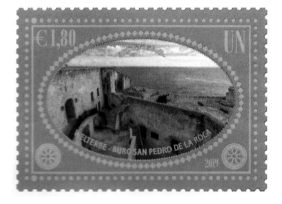

551

552

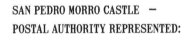

SAN PEDRO MORRO CASTLE

SAN PEDRO MORRO CASTLE —
POSTAL AUTHORITY REPRESENTED:

UNITED NATIONS - 2019 - **Fig.551**

MANACAS SUGAR MILL

MANACAS SUGAR MILL —
POSTAL AUTHORITY REPRESENTED:

UNITED NATIONS - 2019 - **Fig.552**

PLAZA TRINIDAD MAIN SQUARE

(PLAZA MAYOR).

111

TRINIDAD MAIN SQUARE —
COUNTRY REPRESENTED:

GUINEA - 2012 - **Fig.1018, p.180**

Fig.551, 552. *United Nations, 2019.*

$6

ANTIGUA & BARBUDA

SPECIMEN

"REMEMBER THE MAIN"

992

REPUBLIQUE ...ce de la Poste Guinéenne

HISTORICAL & INTERNATIONAL EVENTS

Débarquement de la baie des Cochons

5000 F.G.

1492.
EUROPEAN DISCOVERY OF THE ISLAND BY COLUMBUS

The Island of Cuba, of course, had been discovered by aboriginal people who settled it progressively during the centuries preceding the first sighting of the island on October 27, 1492 by Genoese mariner Christopher Columbus (ca. 1451-1506).

The presence of Columbus in world philately is quite extensive and has been the subject of various monographs, notably, José Luis de Pando Villarroya, *Colón y la filatelia*, Madrid, Pando, 1989; Juan de Linares, *Colón, Barcelona y la filatelia*, Barcelona, Artigas, 1965; and Marcelino González Fernández, "La mar en la filatelia: V Centenario de la muerte de Colón", in *Revista general de marina* (Madrid), Vol. 250, N°. 5 (May), 2006, pp. 751-754.

For purposes of this book I have selected mostly those stamps which deal specifically with Columbus' first voyage and which, quite literally, put Cuba on the map. Cuba's outline (which first appeared in the 1500 Juan de la Cosa manuscript), has, in turn, ended up in many stamps, particularly those issued on the 500th anniversary of the 1492 epic.

1492.

EUROPEAN DISCOVERY OF THE ISLAND BY COLUMBUS

553

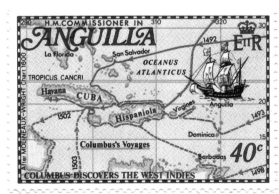

554

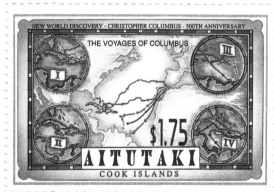

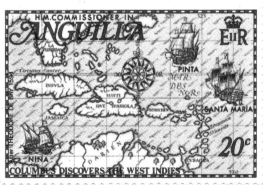

555

1492. EUROPEAN DISCOVERY OF THE ISLAND BY COLUMBUS – COUNTRIES REPRESENTED:

AITUTAKI - 1992 - **Fig.553**

ANGUILLA - 1973 - **Figs.554, 555**

 - 1992 - **Fig.556**

ANTIGUA - 1992 - **Fig.557**

 - 1988 - **Fig.558**

BAHAMAS - 1988 - **Fig.559**

 - 1991 - **Fig.560**

BHUTAN - 1987 - **Figs.561, 562**

BRAZIL - 1992 - **Fig.567**

BULGARIA - 1992 - **Fig.566**

BURKINA FASO - 1992 - **Fig.563**

CAMBODIA - 1992 - **Fig.565**

CAMEROON - 1992 - **Fig.569**

Fig.553. Aitutaki, 1992 (Sc 480, SG 648); **Figs.554, 555.** Anguilla, 1973 (Sc 175, SG 160), (Sc 176, SG 161).

114

Inspired by Cuba! DELIVERING CUBA THROUGH THE MAIL ★ CUETO

CHILE - 1992 - Fig.564

CONGO, REPUBLIC - 1992 - Fig.568

CYPRUS - 1992 - Fig.570

DOMINICAN REPUBLIC - 1982 - Fig.574

EL SALVADOR - 1987 - Fig.577

 - 1990 - Fig.578

FALKLAND ISLANDS - 1992 - Fig.573

FAROE ISLANDS - 1992 - Fig.571

FINLAND - 1992 - Fig.575

GIBRALTAR - 1992 - Fig.576

GREECE - 1992 - Fig.583

GRENADA - 1987 - Figs.579, 580

GUERNSEY - 1992 - Fig.572

GUINEA - 1985 - Fig.582

GUYANA - 1992 - Fig.581

HUNGARY - 1992 - Fig.586

ICELAND - 1992 - Fig.588

ITALY - 1992 - Figs.584, 585

JAMAICA - 1990 - Figs.592-595

LAOS - 1985 - Fig.587

MALAGASY REP. - 1991 - Fig.590

MONGOLIA - 1992 - Fig.597

MONTSERRAT - 1992 - Fig.589

NICARAGUA - 1982 - Fig.596

POLAND - 1992 - Fig.598

ROMANIA - 1992 - Fig.591

ST. KITTS - 1989 - Fig.601

ST. VINCENT - 1986 - Fig.599

 - 1988 - Fig. 600

 - 1989 - Fig.603

 - 1992 - Fig.604

SAMOA - 1992 - Fig.602

SAN MARINO - 1992 - Figs.605, 606

SLOVENIA - 1992 - Fig.608

SOLOMON ISLANDS - 1992 - Fig.607

SURINAME - 1991 - Fig.618

TURKISH REPUBLIC OF
 NORTHERN CYPRUS - 1992 - Fig.611

TURKS & CAICOS - 1984 - Fig.612

URUGUAY - 1992 - Fig.614

 - 2003 - Fig.615

US - 1992 - Fig.610

VATICAN - 1992 - Fig.617

VIETNAM - 1992 - Fig.609

VIRGIN ISLANDS, BRITISH
 - 1992 - Fig.613

WALLIS & FUTUNA - 1992 - Fig.616

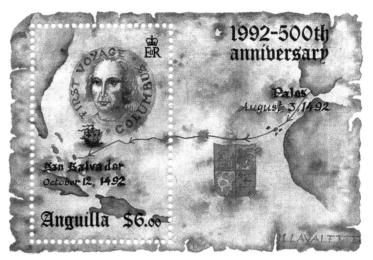

556

557

Fig.556. *Anguilla, 1992 (Sc 866);* **Fig.557.** *Antigua, 1992 (Sc 1660, SG 1654).*

COLUMBUS' FOUR EXPLORATIONS

558

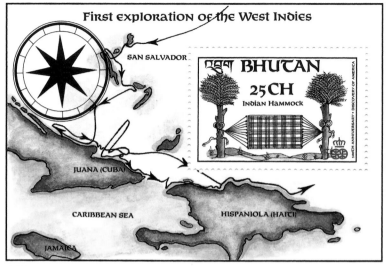

First exploration of the West Indies

561

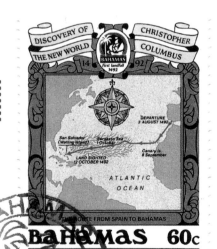

559

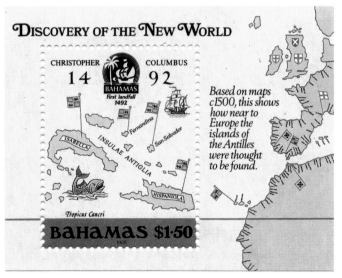

560

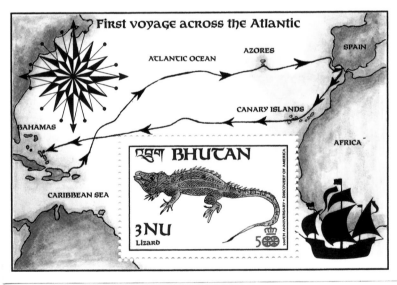

First voyage across the Atlantic

562

Fig.558. Antigua, 1988 (Sc 866, SG 1180); **Fig.559.** Bahamas, 1988 (Sc 644); **Fig.560.** Bahamas, 1991 (Sc 728); **Figs.561, 562.** Bhutan, 1987 (Sc 590-96).

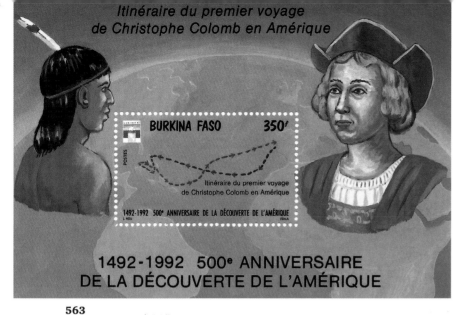

Itinéraire du premier voyage
de Christophe Colomb en Amérique

BURKINA FASO 350F

POSTES

Itinéraire du premier voyage
de Christophe Colomb en Amérique

1492-1992 500ᵉ ANNIVERSAIRE DE LA DÉCOUVERTE DE L'AMÉRIQUE

1492-1992 500ᵉ ANNIVERSAIRE
DE LA DÉCOUVERTE DE L'AMÉRIQUE

563

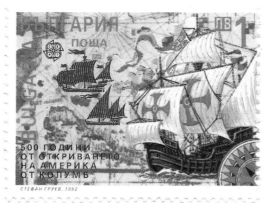

566

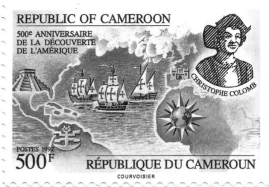

REPUBLIC OF CAMEROON
500ᵉ ANNIVERSAIRE
DE LA DÉCOUVERTE
DE L'AMÉRIQUE
CHRISTOPHE COLOMB

POSTES 1992
500F RÉPUBLIQUE DU CAMEROUN
COURVOISIER

569

CHILE
upaep
$200
$250
CASA DE MONEDA DE CHILE 1992

564

AMÉRICA
upaep
Brasil 92 Cr$ 3.500,00
500 ANOS DO DESCOBRIMENTO DA AMÉRICA

567

EUROPA 1992

10
ΚΥΠΡΟΣ
CYPRUS
KIBRIS

570

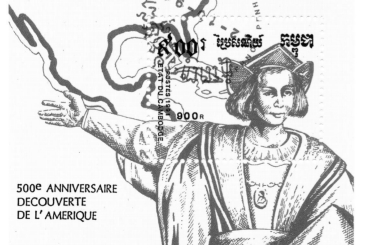

500ᵉ ANNIVERSAIRE
DECOUVERTE
DE L'AMERIQUE

565

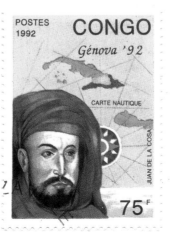

POSTES
1992 CONGO
Génova '92

CARTE NAUTIQUE

JUAN DE LA COSA

75F

568

Fig.563. Burkina Faso, 1992 (Sc 946); Fig.564. Chile, 1992 (Sc 1024, Mi 1529); Fig.565. Cambodia, 1992 (Sc 1174); Fig.566. Bulgaria, 1992 (Sc 3982); Fig.567. Brazil, 1992 (Sc 2361); Fig.568. Congo, Republic, 1992 (Sc 966); Fig.569. Cameroon, 1992 (Sc 881); Fig.570. Cyprus, 1992 (Sc 800).

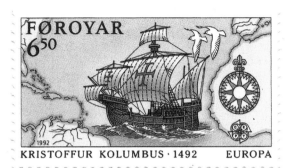

FØROYAR 6,50
KRISTOFFUR KOLUMBUS · 1492 EUROPA

571

Columbus' First Voyage
28 EUROPA 19.92
GUERNSEY

572

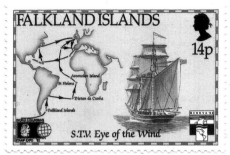

FALKLAND ISLANDS
14p
S.T.V. Eye of the Wind

573

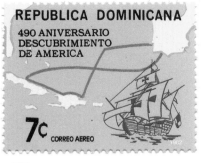

REPUBLICA DOMINICANA
490 ANIVERSARIO DESCUBRIMIENTO DE AMERICA
7¢ CORREO AEREO

574

SUOMI-FINLAND
EUROPA
2,10 2,10

575

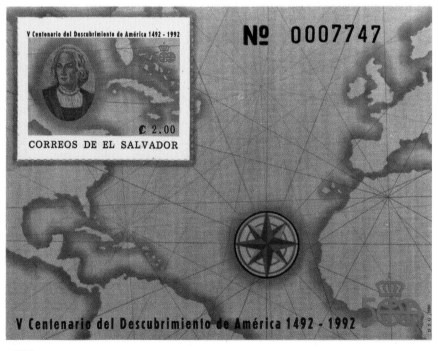

Nº 0007747
V Centenario del Descubrimiento de América 1492 - 1992
¢ 2.00
CORREOS DE EL SALVADOR
V Centenario del Descubrimiento de América 1492 - 1992

578

c1.00 AEREO V CENTENARIO DEL DESCUBRIMIENTO DE AMERICA 1492 - 1992.
CORREOS DE EL SALVADOR
D.S.G. · 1987

577

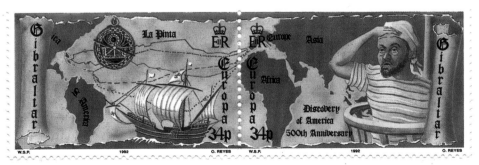

La Pinta Europe Asia
Gibraltar EʳR EʳR Gibraltar
Europa Europa
34p 34p
Discovery of America 500th Anniversary
W.S.P. 1992 O. REYES W.S.P. 1992 O. REYES

576

Fig.571. Faroe Islands, 1992 (Sc 237); Fig.572. Guernsey, 1992 (Sc 470); Fig.573. Falkland Islands, 1992 (Sc 545); Fig.574. Dominican Republic, 1982 (Sc C379); Fig.575. Finland, 1992 (Sc 884-885); Fig.576. Gibraltar, 1992 (Sc 6012, SG 671); Fig.577. El Salvador, 1987 (Sc C543e). Fig.578. El Salvador, 1990 (Sc 1243-1244).

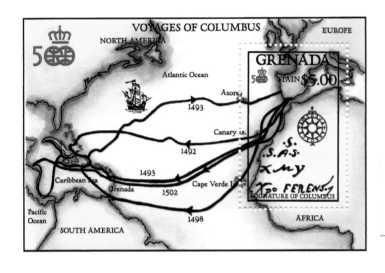

579

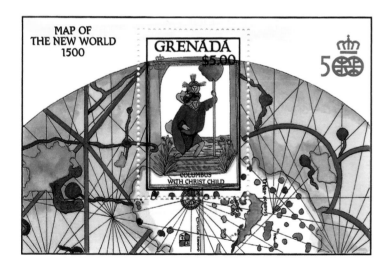

580

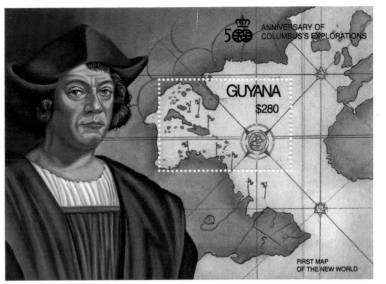

581

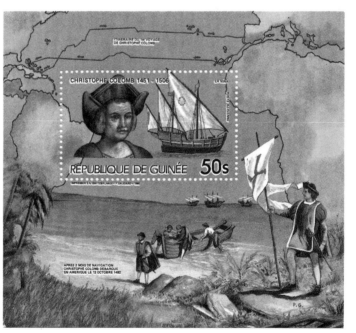

582

583

Fig.579, 580. *Grenada, 1987;* **Fig.581.** *Guyana, 1992 (Sc 2532;* **Fig.582.** *Guinea, 1985 (Sc 978);* **Fig.583.** *Greece, 1992 (Sc 1738).*

AEROGRAMME
PAR AVION
VIA AEREA

LA SCOPERTA DELL'AMERICA

Il primo viaggio 1492-93

ITALIA 850

F. FILANCI M. ANTOMELLI

GENOVA '92
CELEBRAZIONI COLOMBIANE

584

ITALIA 750

OCEANO ATLANTICO

AMERICA DEL NORD

SAN SALVADOR LISBONA
PALOS EUROPA

AMERICA CENTRALE AFRICA

AMERICA DEL SUD

GENOVA '92
CELEBRAZIONI COLOMBIANE

I.P.Z.S. ROMA 1992 E. DONNINI

585

AMERIKA FELFEDEZÉSÉNEK 500 ÉVES ÉVFORDULÓJA

KOLUMBUSZ KRISTÓF

30 Ft

MAGYARORSZÁG

PJ 1991 VARGA PÁL

153765

586

120

POSTES LAO 1985

5.00k

ATLANTIC

PREMIER VOYAGE DE
CHRISTOPHE COLOMB

6,00₭

587

ÍSLAND
55.00

PRÓSTUR MAGNÚSSON 1992

KRISTÓFER KÓLUMBUS · 1492 EUROPA

FUNDUR
AMERÍKU

588

500th ANNIVERSARY + DISCOVERY OF AMERICA

San Salvador

Cuba

West Indies

EₐR

CARIBBEAN SEA

589

Fig.584. Italy, 1992. **Fig.585.** Italy, 1992 (YT 1978); **Fig.586.** Hungary, 1992 (Sc 3319); **Fig.587.** Laos, 1985 (Sc 665 Mi 866-70); **Fig.588.** Iceland, 1992 (Sc 751); **Fig.589.** Montserrat, 1992 (Sc 789).

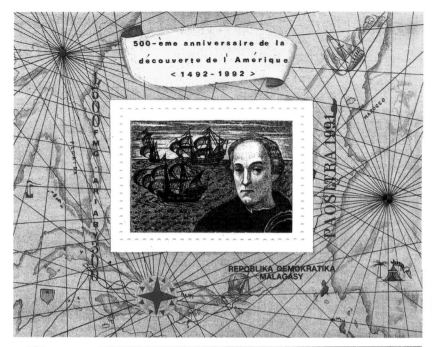

590

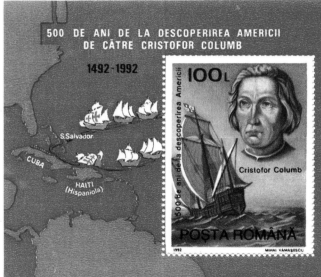

591

592-595

596

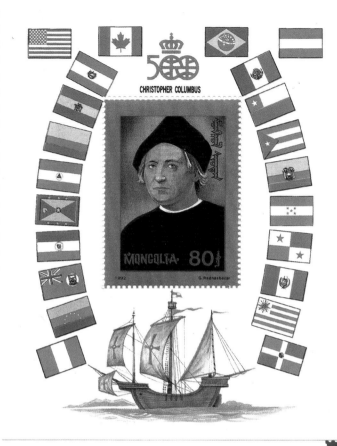

597

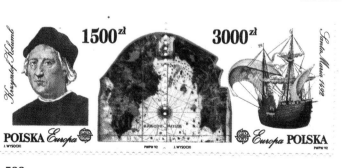

598

Fig.590. *Malagasy Rep., 1991 (Sc 1021);* Fig.591. *Romania, 1992 (Sc 3774);* Figs.592-595. *Jamaica, 1990 (Sc 741, SG 774), (Sc 742-4);* Fig.596. *Nicaragua, 1982 (Sc C1027-C1029, Mi 2324, SG 2411);* Fig.597. *Mongolia, 1992 (Sc 2103);* Fig.598. *Poland, 1992 (Sc 3034-3035 SG 3403-4).*

599

600

Fig.599. St. Vincent, 1986 (Sc 937);
Fig.600. St. Vincent, 1988 (Sc 1093A);
Fig.601. St. Kitts, 1989 (Sc 272, SG 294); Fig.602. Samoa, 1992 (Sc 810, SG 881).

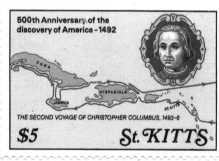

601

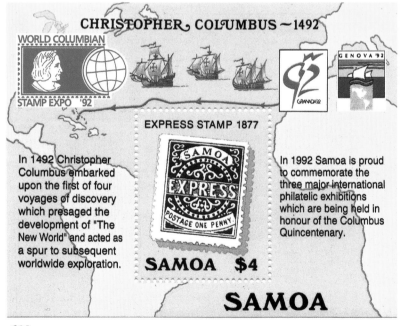

602

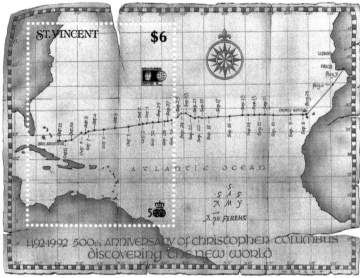

Fig.603. *St. Vincent, 1989 (Sc 1233);* **Fig.604.** *St. Vincent, 1992 (Sc 1638-1639);*
Figs.605, 606. *San Marino, 1992 (Sc 1249, 1250).*

603

604

605, 606

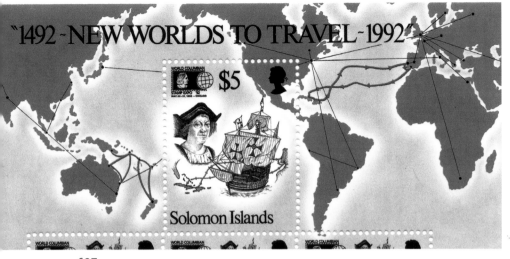

"1492 ~ NEW WORLDS TO TRAVEL ~ 1992"

$5

Solomon Islands

607

SLOVENIJA

PTT

OCEANUS OCCIDENTALIS

KRISTOF KOLUMB

47.00

608

BƯU CHÍNH

MIAMI

Bahamas

S.Salvador

CUBA

300

Antilles

PORTO R

HAITI

500

1492-1992

12-10-1492
C. Colomb
đặt chân lên châu Mỹ

HONDURAS

BƯU CHÍNH

Kỷ niệm 50

609

124

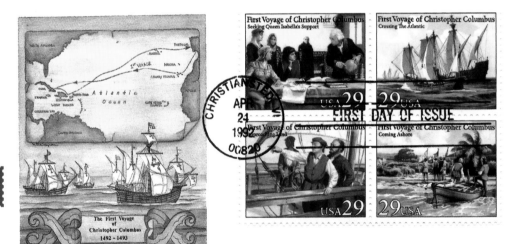

The First Voyage of Christopher Columbus 1492-1493

Columbus was determined that one could reach Asia by sailing west from Europe. The expedition upon which he embarked was known as The Enterprise of the Indies.

FIRST DAY OF ISSUE

610

First Voyage of Christopher Columbus — Seeking Queen Isabella's Support

First Voyage of Christopher Columbus — Crossing The Atlantic

USA 29 USA 29

FIRST DAY OF ISSUE

First Voyage of Christopher Columbus — Approaching Land

First Voyage of Christopher Columbus — Coming Ashore

USA 29 29 USA

CHRISTIANSTED APR 21 199_ 00820

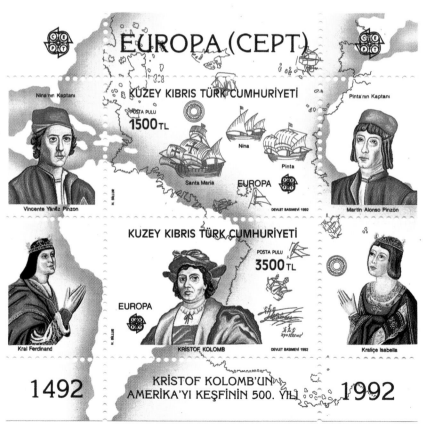

EUROPA (CEPT)

Nina'nin Kaptanı

KUZEY KIBRIS TÜRK CUMHURİYETİ

POSTA PULU
1500 TL

Nina

Pinta

Santa Maria EUROPA

Vincente Yáñez Pinzón

Pinta'nin Kaptanı

Martin Alonso Pinzón

Kral Ferdinand

KUZEY KIBRIS TÜRK CUMHURİYETİ

POSTA PULU
3500 TL

EUROPA

KRİSTOF KOLOMB

Kraliçe Isabella

1492

KRİSTOF KOLOMB'UN
AMERİKA'YI KEŞFİNİN 500. YILI

1992

611

Fig.607. Solomon Islands, 1992 (Sc 723-726, SG 732); **Fig.608.** Slovenia, 1992 (Sc 137); **Fig.609.** Vietnam, 1992 (Sc 2329); **Fig.610.** US, 1992 (Sc 2620-2623); **Fig.611.** Turkish Republic of Northern Cyprus, 1992 (Sc 326, Mi 332).

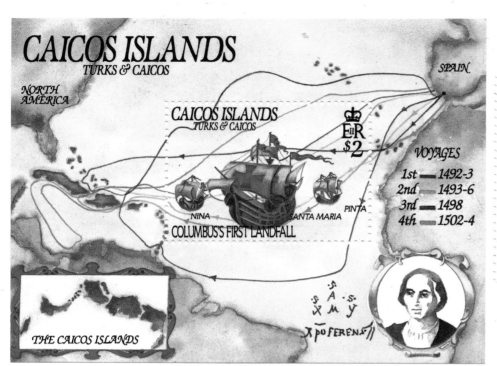

CAICOS ISLANDS
TURKS & CAICOS

NORTH AMERICA

CAICOS ISLANDS
TURKS & CAICOS

EⅡR $2

NINA SANTA MARIA PINTA

COLUMBUS'S FIRST LANDFALL

VOYAGES
1st — 1492-3
2nd — 1493-6
3rd — 1498
4th — 1502-4

SPAIN

THE CAICOS ISLANDS

612

MONUMENTO A CRISTOBAL COLON
DURAZNO 1892 - 1992

URUGUAY CORREOS N$ 700

614

POSTE VATICANE 1500 1492 - 1992

492 - 1992

POSTE VATIC 25

617

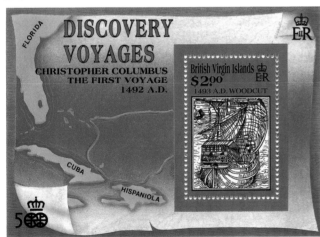

DISCOVERY VOYAGES
CHRISTOPHER COLUMBUS
THE FIRST VOYAGE
1492 A.D.

FLORIDA

CUBA

HISPANIOLA

British Virgin Islands
$2.00
1493 A.D. WOODCUT

EⅡR

613

500 años 4º Viaje Cristóbal Colón
1502-2002 Jua

FERNANDINA
SANTIAGO
LA ESPAÑOLA

Uruguay Correos
imprimex 2003 $12 $1

C. MENCK FREIRE C. MENCK F

615

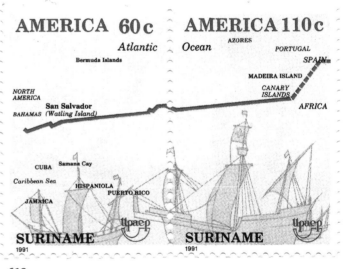

AMERICA 60 c AMERICA 110 c
Atlantic Ocean

AZORES
PORTUGAL
SPAIN

BERMUDA Islands

MADEIRA ISLAND
CANARY ISLANDS
AFRICA

NORTH AMERICA
BAHAMAS San Salvador
(Watling Island)

CUBA Samana Cay
Caribbean Sea
HISPANIOLA
PUERTO RICO
JAMAICA

Upaep Upaep

SURINAME SURINAME
1991 1991

618

Wallis et Futuna 100 F

POSTE AÉRIENNE

WORLD COLUMBIAN
STAMP EXPO '92
22-31 MAI 1992 - CHICAGO

CHRISTOPHE COLOMB
1492-1992
Découverte de l'Amérique

RF

VERET - LEMARINIER

616

Fig.612. *Turks and Caicos, 1984 (Sc C53, YT 44-46);* **Fig.613.** *Virgin Islands, British, 1992 (Sc 721-725);* **Fig.614.** *Uruguay, 2003 (Mi 1959, YT 1410);* **Fig.615.** *Uruguay, 2003 (Sc 1996);* **Fig.616.** *Wallis & Futuna, 1992 (Sc C170, SG 605);* **Fig.617.** *Vatican, 1992 (Sc 903);* **Fig.618.** *Suriname, 1991 (Sc 899a, SG 1490-1491).*

HISTORICAL & INTERNATIONAL EVENTS

1895-1898.
SPANISH-CUBAN-AMERICAN WAR

For several decades since the 1820s, Cubans had tried, without success, to free themselves from the yoke of the Spanish Government and become an independent nation like the rest of the former Spanish colonies in Latin America. Finally, in February 1895, a new struggle began in opposition to the Spaniards. While Cubans won many important battles, there were some defeats: in 1896 spanish soldier Eloy Gonzalo (1868-1897) attacked and burnt the town of Cascorro in the province of Camagüey.

n February 1898 the US warship *Maine*, exploded in Havana Bay and the US declared war against Spain, which ended with Spanish defeat in Santiago de Cuba in July of that year.

The postal history of the war has recently been superbly researched and illustrated in the book by Yamil H. Kouri Jr, mentioned before. As the 733-page book makes abundantly clear, patriotic envelopes, postal stationery and labels were printed during the war both in Spain and the US.

Among the most celebrated US heroes depicted in the American materials were Teddy Roosevelt (1858-1919), founder of a voluntary cavalry unit called the Rough Riders; William "Buckey" O'Neill (1860-1898), a Rough Rider who died in Cuban soil; Richmond P. Hobson (1870-1937), who sank the *Merrimac* in Santiago harbor; Fitzugh Lee (1835-1905), US consul in Havana; and Rear Admirals William Sampson (1840-1902) and Winfield Schley (1839-1911), who defeated the Spanish fleet of Admiral Pascual Cervera (1839- 1909).

619

While Cubans and Americans celebrated victory, Spain had to face the task of repatriating its military personnel. On August 19, 1898, 1,108 soldiers arrived in the Galician port of La Coruña on board the ship *Alicante*.

On the 50th and 100th anniversaries of the war (1948 and 1898, respectively), the US issued commemorative stamps, and several First Day Covers were also printed, then and later, to illustrate the event and honor the victorious leaders. I am also aware of a few commemorative envelopes printed in Spain in 1971 and 1998.

We should also take note that, during the first two years of the US occupation of the island, from 1898 until September 1900, the American authorities, instead of issuing new Cuban stamps, used US stamps overprinted with the word "Cuba". The originals can be traced to the US First Bureau Issue of 1894 featuring Benjamin Franklin (one cent), George Washington (two cents in two different colors, one of which would be overprinted with 2½ cents), Andrew Jackson (3 cents), Ulysses Grant (5 cents) and Daniel Webster (10 cents). A 10-cent special delivery stamp depicting a mailman was also used.

1895-1898.

SPANISH-CUBAN-AMERICAN WAR

1895-1898. SPANISH-CUBAN-AMERICAN WAR — COUNTRIES REPRESENTED:

1896-1899 COVERS & STATIONERY -
 SPAIN - 1896-1898 - **Figs.620-622** - *Many more, not illustrated*
 US - 1898-1899 - **Figs.619, 623-656** - *Many more, not illustrated*

1898-1900 US "CUBA" OVERPRINTS -
 US - 1898-1900 - 1-10 CENTS - **Figs.657-662**
 - 1898-1900 - 10 CENTS SPECIAL DELIVERY - *not illustrated*

LATER COMMEMORATIVE PIECES -
 GUINEA - 2002 - **Figs.680, 681**
 SPAIN - 1971 - **Fig.668**
 - 1998 - **Figs.664, 667**
 US - 1934 - **Fig.662a**
 - 1937 - **Fig.663**
 - 1948 - **Figs.669-677**
 - 1986 - **Fig.678**
 - 1998 - **Figs.665, 679**
 - 2015 - **Fig.666**

Fig.619. *US, 1898-1899.*

620

621

622

623

625

624

626

627

628

128

629

631

632

633

634

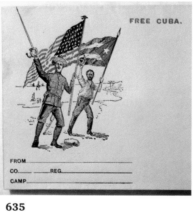

635

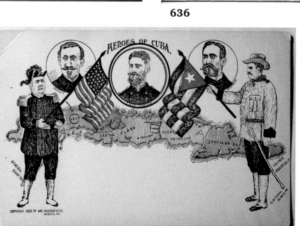

636

129

637

638

Fig.629, US, 1898-1899; Fig.630. *not assigned*;
Figs.631-638. US, 1898-1899.

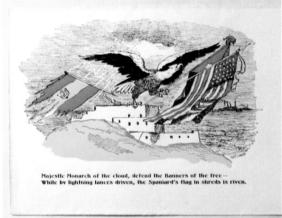

Majestic Monarch of the cloud, defend the Banners of the free—
While by lightning lances driven, the Spaniard's flag in shreds is riven.

639

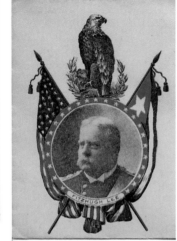

640

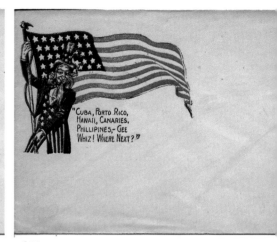

Taking Toral's Army back to Spain

SPAIN

SANTIAGA SPANISH FLEET

After 5 days come back to

641

"CUBA, PORTO RICO, HAWAII, CANARIES, PHILLIPINES,- GEE WHIZ! WHERE NEXT?"

642

Now run along home Sonny and don't monkey again with your Uncle Samuel

643

RICHARD PEARSON HOBSON

644

SPANISH HONOR

CUBA

RETURN TO

COMPANY _____

_____ REGIMENT,

_____ VOLUNTEERS.

645

"HOLD THE FORT BOYS WE ARE COMING TO HELP YOU"

PHILLIPINE IS. SAN FRANCISCO WASHINGTON
CHICKAMAUGA TAMPA CUBA

COPYRIGHTED

Return to

Company _____

_____ Regiment,

_____ Volunteers

CAMP _____

646

SCHLEY TRAPPING CERVERA.

Co. , 1st N. H., Volunteers.

647

Figs.639-647. US, 1898-1899.

130

The New Bird in Havana Harbor.

648

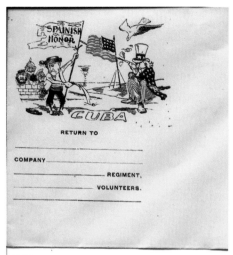

SPANISH HONOR

CUBA

RETURN TO

COMPANY _____

_____ REGIMENT,

_____ VOLUNTEERS.

649

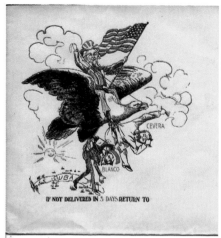

CEVERA

BLANCO

CUBA

IF NOT DELIVERED IN 5 DAYS RETURN TO

650

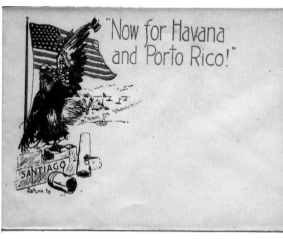

"Now for Havana and Porto Rico!"

SANTIAGO

Return to

651

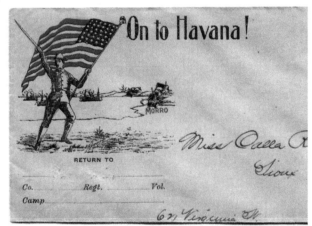

"On to Havana!"

MORRO

Miss Oula R...

Sioux

RETURN TO

Co. _____ Regt. _____ Vol. _____

Camp _____

6 N Virginia N...

652

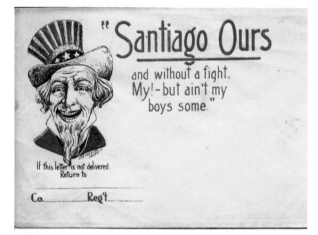

"Santiago Ours

and without a fight.
My!- but ain't my
boys some."

If this letter is not delivered.
Return to

Co. _____ Reg't _____

653

IF YOU DON'T
CATCH HIM
IN 10 DAYS

Return to

Co. _____ Regiment

_____ Vol.

Camp _____

654

J. L. SMITH
MAP PUBLISHER
27 S. 6TH STREET, PHILAD'A, PA.

655

WAVE ON WAVE EVER

"Victors o'er land
and sea"

Return to

656

Figs.648-656. US, 1898-1899.

657

658

659

660

661

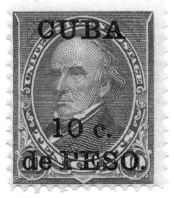

662

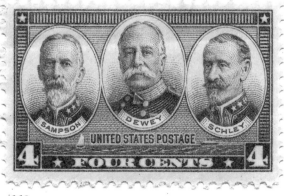

663

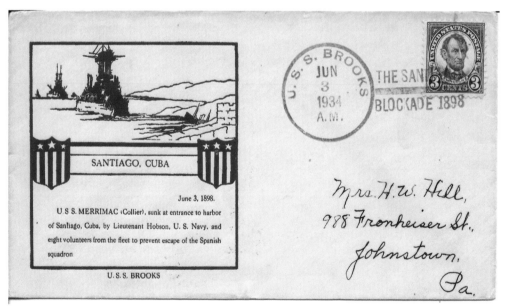

662a

Figs.657-662. US, 1898-1900 (Original issues, Sc 267, 248, 267A, 268, 270, 273); **Fig.662a.** US, 1934; **Fig.663.** US, 1937 (Sc 793).

FERIA Y EXPOSICIÓN FILATÉLICA

LA CORUÑA 1998
CENTENARIO DEL 98
— 28 - 31 MAYO —

APF

Vapor "Alicante"

CENTENARIOS 1998

RICARDO OLIVART-F
Pau Claris, 115
08009 BARCELONA
BARCELONA

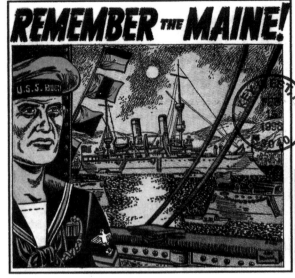

REMEMBER THE MAINE!

U.S.S. BUG

"REMEMBER THE MAINE"
32 UNITED STATES OF AMERICA 32

FIRST DAY OF ISSUE

USS Maine, commissioned in 1895, was the first US Navy ship named after the state of Maine. The Maine is best known for her loss in Havana Harbor on the evening of February 15, 1898. Sent to protect U.S. interests during the Cuban revolt against Spain, she exploded suddenly, without warning, and sank quickly, killing nearly 75% of her crew. Nevertheless, popular opinion in the U.S. blamed Spain. The phrase, "remember the Maine, to Hell with Spain", became a rallying cry for action, which came with the Spanish–American War later that year.

664

665

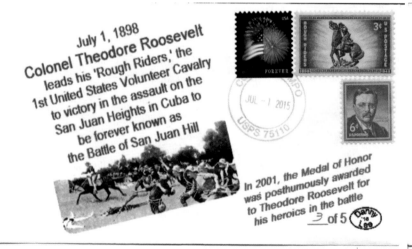

July 1, 1898
Colonel Theodore Roosevelt
leads his 'Rough Riders,' the
1st United States Volunteer Cavalry
to victory in the assault on the
San Juan Heights in Cuba to
be forever known as
the Battle of San Juan Hill

In 2001, the Medal of Honor
was posthumously awarded
to Theodore Roosevelt for
his heroics in the battle
≡ of 5

SOCIETAT FILATÈLICA I NUMISMÀTICA
XXIX EXPOSICIÓ FILATÈLICA

CENTENARI DE LA DESFETA DEL
MAINE I LA GUERRA DE CUBA

BLANES, DEL 29 DE JULIOL AL
5 D'AGOST DE 1998

1998 aniversaris
XXIX EXPOSICIÓ
SOCIETAT FIL. i NUM.
BLANES 29-7-98

EXPOSICION HISTORICO-MILITAR

EJÉRCITO EN OPERACIONES DE LA ISLA DE CUBA

CASCORRO
EL SOLDADO
Eloy Gonzalo García,
prende fuego a una casa de Cascorro ocupada por los insurrectos.

133

SEVILLA, 3-5 MAYO 1971

Sr.D.
Héctor L. YU
Av.Madrid,
BARCELONA

666

667

668

Fig.664. *Spain, 1998;* **Fig.665.** *US, 1998 (Sc 3192);* **Fig.666.** *US, 2015;* **Fig.667.** *Spain, 1998;* **Fig.668.** *Spain, 1971.*

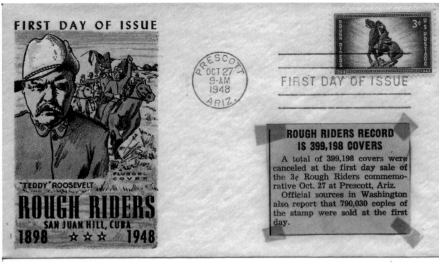

FIRST DAY OF ISSUE

"TEDDY" ROOSEVELT
ROUGH RIDERS
SAN JUAN HILL, CUBA
1898 ★★★ 1948

FIRST DAY OF ISSUE

ROUGH RIDERS RECORD
IS 399,198 COVERS
A total of 399,198 covers were
canceled at the first day sale of
the 3¢ Rough Riders commemo-
rative Oct. 27 at Prescott, Ariz.
Official sources in Washington
also report that 790,030 copies of
the stamp were sold at the first
day.

669

ROUGH RIDERS

670

50th
Anniversary
FIRST U.S. VOLUNTEER
Cavalry
ROUGH RIDERS
SPANISH AMERICAN WAR
1898 1908 1948

671

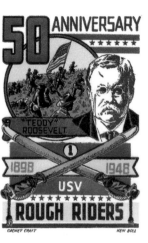

50 ANNIVERSARY

"TEDDY" ROOSEVELT
1898 1948
USV
ROUGH RIDERS

672

134

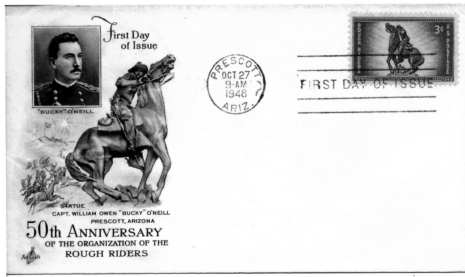

First Day of Issue

"BUCKY" O'NEILL

FIRST DAY OF ISSUE

STATUE
CAPT. WILLIAM OWEN "BUCKY" O'NEILL
PRESCOTT, ARIZONA
50th ANNIVERSARY
OF THE ORGANIZATION OF THE
ROUGH RIDERS

673

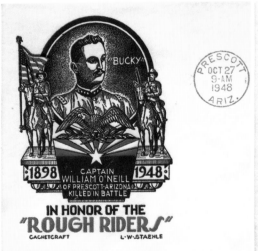

"BUCKY"
1898 1948
CAPTAIN
WILLIAM O'NEILL
OF PRESCOTT-ARIZONA
KILLED IN BATTLE
IN HONOR OF THE
"ROUGH RIDERS"
CACHETCRAFT L·W·STAEHLE

674

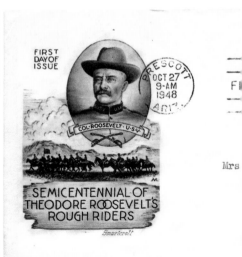

FIRST DAY OF ISSUE

COL·ROOSEVELT·U·S·V·
SEMICENTENNIAL OF
THEODORE ROOSEVELT'S
ROUGH RIDERS

675

Figs.669-677. US, 1948 (Sc 973).

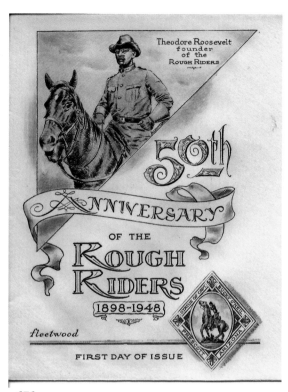

676

FIRST DAY OF ISSUE

677

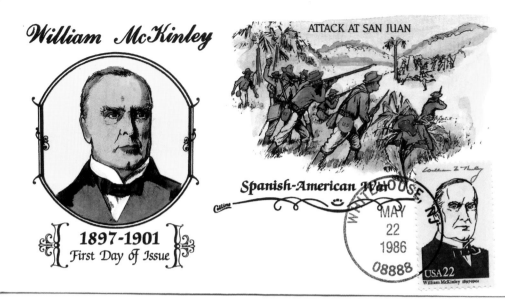

678

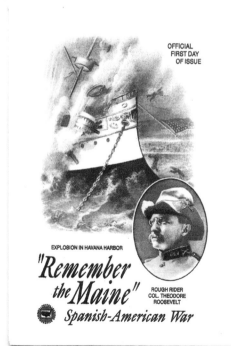

679

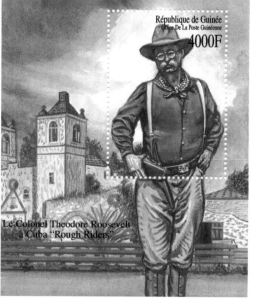

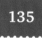

681

Fig.678. US, 1986; **Fig.679.** US, 1998 (Sc 3192); **Figs.681.** *Guinea, 2002.*

HISTORICAL & INTERNATIONAL EVENTS

1959.
CUBAN REVOLUTION

Outraged by the March 1952 unconstitutional coup d'etat by General Fulgencio Batista (1901-1973), the Cuban people began a 7-year struggle to overthrow his regime.

On July 26, 1953, a group of revolutionaries under the leadership of Fidel Castro (1926-2016) attacked the Moncada Barracks in Santiago de Cuba. Several years of guerrilla and urban fighting followed, culminating in the flight of Batista and the victory of the armed rebels on January 1, 1959. Several countries ideologically close to the Cuban regime have issued stamps to commemorate various anniversaries of this most significant event.

1959.
CUBAN REVOLUTION

1959. CUBAN REVOLUTION — COUNTRIES REPRESENTED:

CHINA - 1962 - **Figs.684-686**
 - 1963 - **Figs.687-692**
 - 1964 - **Figs.693, 694**
HUNGARY - 1983 - **Fig.683**
LAOS - 1989 - **Figs.695, 696**
MONGOLIA - 1983 - **Fig.682**
NICARAGUA - 1984 - **Figs.697, 698**
 - 1989 - **Fig.40, p.25**
RUSSIA - 1963 - **Figs.701-703**
 - 1964 - **Fig.700**
 - 1979 - **Fig.699**
 - 1984 - **Fig.707**
VIETNAM - 1965 - **Figs.704, 705**
 - 1968 - **Fig.706**
 - 1978 - **Figs.710, 711**
 - 1979 - **Fig.709**
 - 1989 - **Figs.712, 713**
 - 1999 - **Fig.708**

682

683

Fig.682. *Mongolia, 1983 (Sc 1378A, Mi 1624, YT 1298);* **Fig.683.** *Hungary, 1983.*

684-686

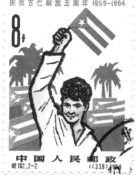
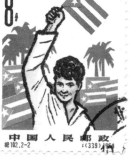
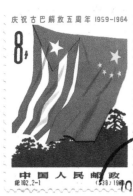

693, 694

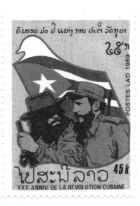

695, 696

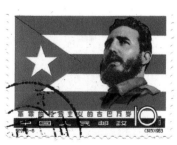

687-692

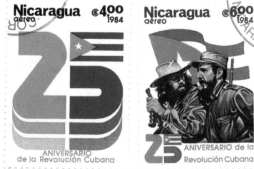

697, 698

Figs.684-686. *China, 1962 (Sc 615-617);* **Figs.687-692.** *China, 1963 (Sc 655-660);* **Figs.693, 694.** *China, 1964 (Sc 748-749);*
Figs.695, 696. *Laos, 1989 (Sc 940, Mi 1146, Sc 941, Mi 1147);* **Figs.697, 698.** *Nicaragua, 1984 (Sc C1043 A, B).*

699

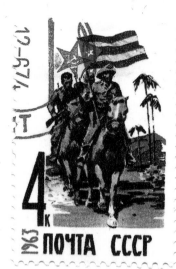

701-703

700

 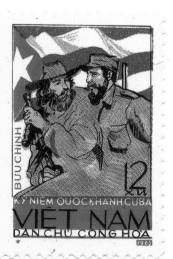

704, 705

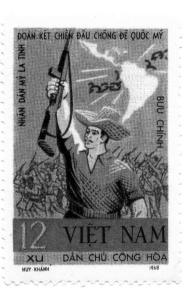

706

Fig.699. Russia, 1979 (Sc 4728); **Fig.700.** Russia, 1964; **Figs.701-703.** Russia, 1963 (Sc 2736-2738); **Figs.704, 705.** Vietnam, 1965 (Sc 332, SG N342, Sc 333, SG N343); **Fig.706.** 1968 (Sc 529).

707

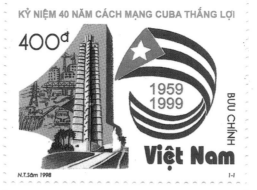

708

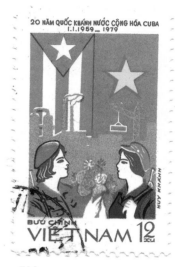

709

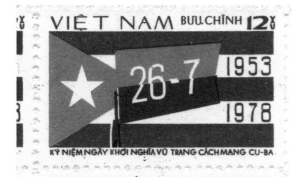

710, 711

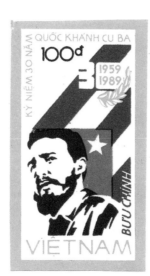

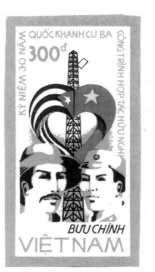

712, 713

Fig.707. *Russia, 1984;* **Fig.708.**
Vietnam, 1999 (Sc 2864, SG 2222);
Fig.709. *Vietnam, 1979 (Sc 980, SG 251),* **Figs.710, 711.** *Vietnam, 1978 (Sc 949- SG 220-, Sc 950, SG 221);*
Fig.712, 713. *Vietnam, 1989 (Sc 1883, SG 1248, Sc 1884, SG 1249).*

1961.
BAY OF PIGS

COMMEMORATING INTERNATIONAL **RED CROSS** *Centennial*

1863 · 1963

CUBAN REFUGEES FROM THE CASTRO REGIME DISEMBARK FROM A RED CROSS MERCY VESSEL

FIRST DAY OF ISSUE

1863 INTERNATIONAL RED CROSS 1963

5c UNITED STATES POSTAGE

WASHINGTON OCT 29 9-AM 1963 D.C.

FIRST DAY OF ISSUE

714

In April 1961, a group of over one thousand Cuban exiles, backed by the American government, landed in Cuba in an attempt to overthrow the Communist government.

The operation failed, the invaders were sentenced to prison and, eventually, exchanged for a sum of money and food. Mercy ships from the International Red Cross were involved in the logistics of the transfer of the prisoners, their families and other refugees. A US stamp was issued depicting a photograph of the freighter S.S. *Morning Light* arriving at Port Everglades, Florida, on May 24, 1963.

1961.
BAY OF PIGS

1961. BAY OF PIGS — COUNTRIES REPRESENTED:

GUINEA - 2012 - **Fig.720**

KOREA, DPR - 1971 - **Fig.719**

LIBERIA - 2009 - **Figs.715-718**

US - 1963 - **Fig.714**

VIETNAM - 1982 - **Fig.721**

Fig.714. US, 1963 (Sc 1239).

JFK
Bay of Pigs
John F. Kennedy

" Those who dare to fail miserably can achieve greatly "

715-718

721

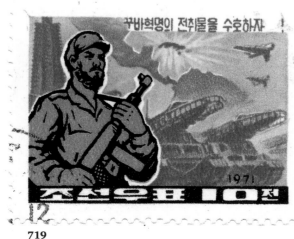

719

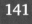

Figs.715-718. *Liberia, 2009;* **Fig.719.**
Korea, DPR, 1971 (Sc 988); **Fig.720.**
Guinea, 2012 (Gu 12114a); **Fig.721.**
Vietnam, 1982 (Sc 1217).

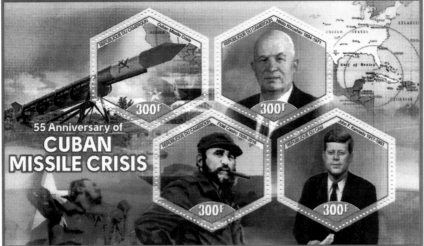

722

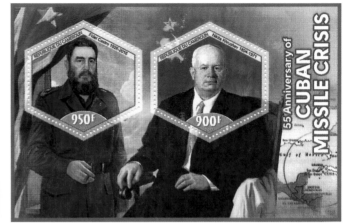

723

1962.
OCTOBER MISSILE CRISIS

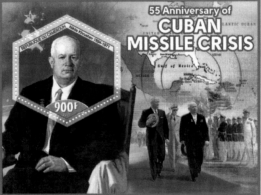

724

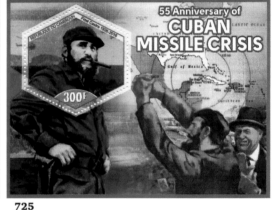

725

In the Fall of 1962 US spy planes discovered the installation of nuclear weapons in the island of Cuba.

United States President John F. Kennedy (1917-1963) declared a quarantine over Cuba and ordered the interception of Soviet ships heading for Cuba. Negotiations, which also involved the United Nations, took place during those tense 13 days in October 1962 and, eventually the Soviet Union backed down and sent the weapons back to the USSR. Various countries have issued stamps to remember the peaceful resolution to one of the most dangerous conflicts the world has ever experienced.

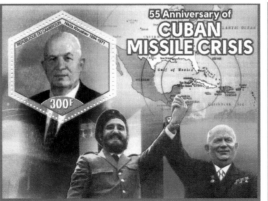

726

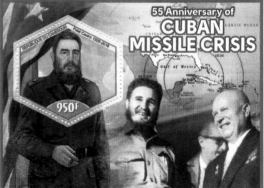

727

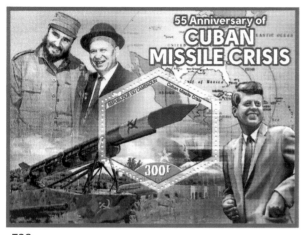

728

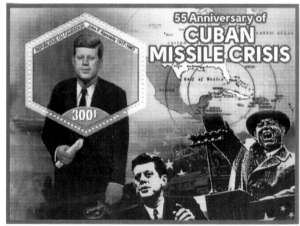

729

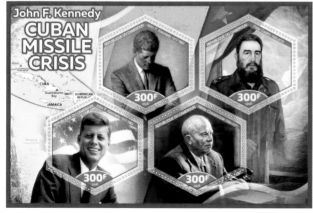

730

1962.
OCTOBER
MISSILE CRISIS

1962. OCTOBER MISSILE CRISIS — COUNTRIES REPRESENTED:

CAMEROON - 2017 - **Figs.722-729**

 - 2018 - **Fig.730**

CENTRAL AFRICAN REPUBLIC - 2017 - **Figs.748, 749-752**

CONGO, DEMOCRATIC REPUBLIC - 2017 - **Figs.732-743**

GABON - 2017 - **Figs.765-768**

GIBRALTAR - 2008 - **Fig.769**

GRENADA - 2006 - **Figs.744-747**

GUINEA - 2017 - **Figs.753-764**

LAOS - 2017 - **Figs.770-779**

MALAGASY REP. - 2020 - **Fig.731**

MALDIVES - 2017 - **Figs.781-789**

MARSHALL ISLANDS - 1995 - **Fig.792**

 - 1999 - **Fig.780**

MOZAMBIQUE - 2009 - **Figs.790, 791**

NIGER - 2016 - **Figs.793-804**

ST. THOMAS AND PRINCE - 2013 - **Figs.806, 807**

 - 2017 - **Fig.805**

Figs.722-729. Cameroon, 2017; **Fig.730.**
Cameroon, 2018; **Fig.731.** *Malgasy Rep., 2020.*

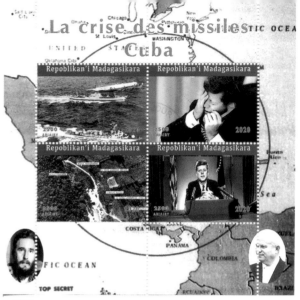

731

ST. VINCENT GRENADINES
 - CANOUAN - 2008 - **Figs.828-831**

ST. VINCENT GRENADINES - MYREAU ISLAND
 - 2007 - **Figs.812-815**

ST. VINCENT GRENADINES - UNION
 ISLAND - 2006 - **Figs.816-819**

ST. VINCENT GRENADINES
 - YOUNG - 2006 - **Figs.820-823**

SIERRA LEONE - 2006 - **Figs.808-811**

 - 2010 - **Figs.824-827**

 - 2017 - **Figs.832, 833-836**

TOGO - 2017 - **Fig.837**

US - 1962 - **Figs.840, 1144, p.196**

 - 1979 - **Fig.841**

 - 1991 - **Fig.839**

 - 2014 - **Fig.838**

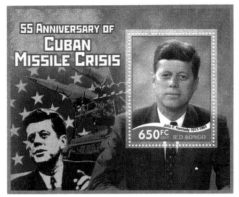

732

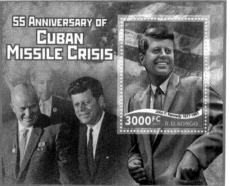

733

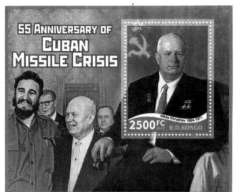

734

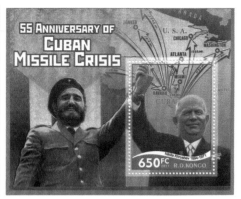

735

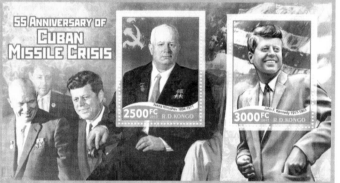

736, 737

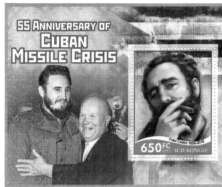

738

The Cuban Missile Crisis - 1962

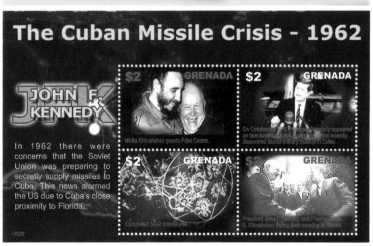

744-747

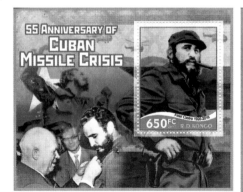

739

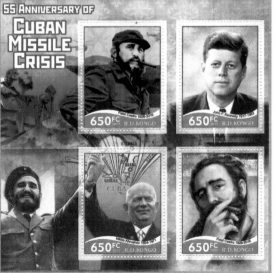

740-743

Figs.732-743. *Congo, Democratic Republic, 2017;* **Figs.744-747.** *Grenada, 2007 (Sc 3635, Mi 5831-5834KB).*

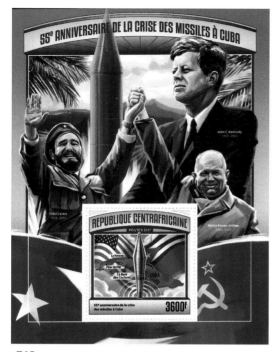

748

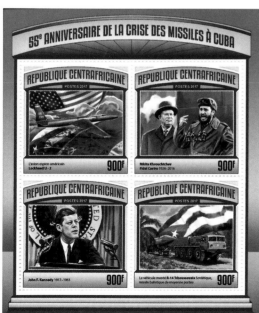

749-752

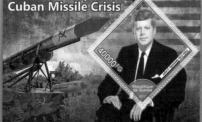

753

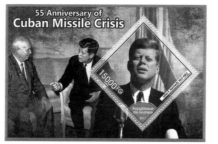

754

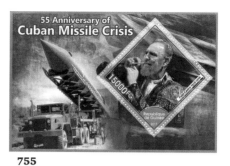

755

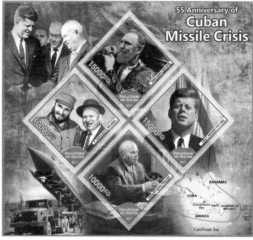

756-759

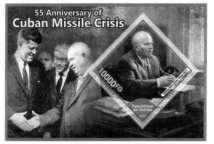

760

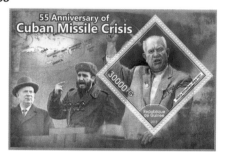

761

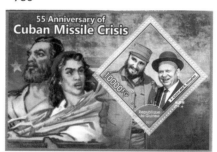

764

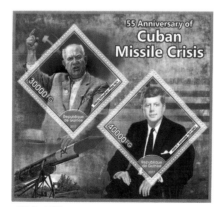

762, 763

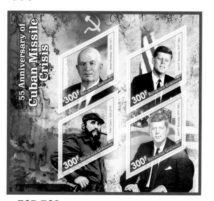

765-768

769

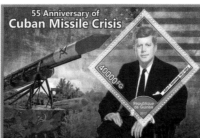

145

Figs.748-752. *Central African Republic, 2017;* **Figs.753-764.** *Guinea, 2017;* **Figs.765-768.** *Gabon, 2017;* **Fig.769.** *Gibraltar, 2008 (Sc 1144).*

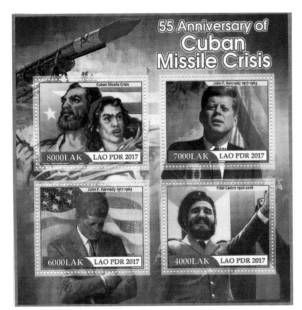

770-773

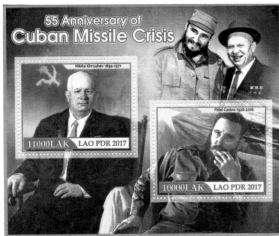

774, 775

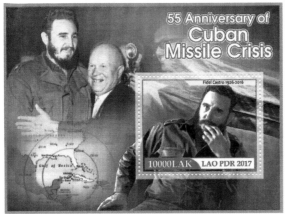

776

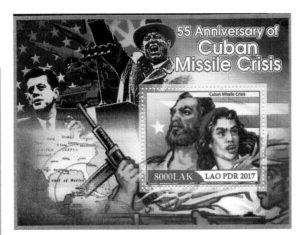

777

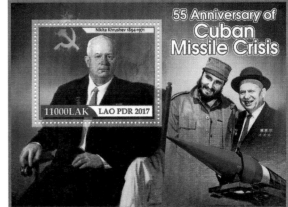

778

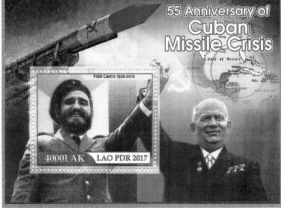

779

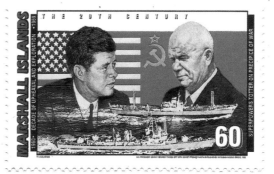

780

Figs.770-779. *Laos, 2017;*
Fig.780. *Marshall Islands,
1999 (Sc 711f).*

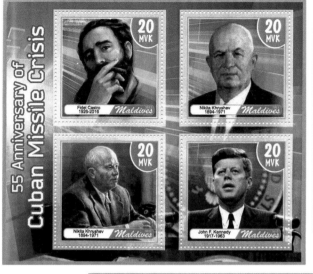

781-784

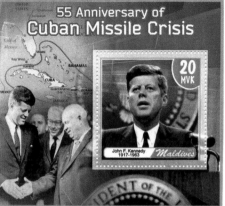

787

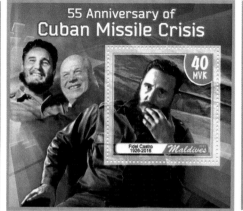

788

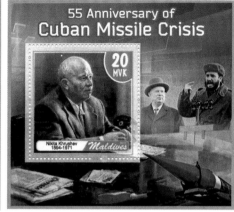

789

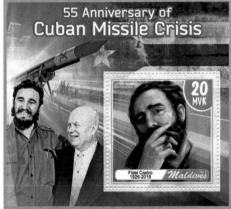

785

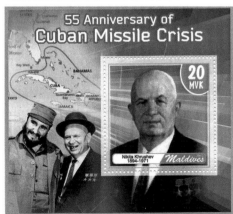

786

790, 791

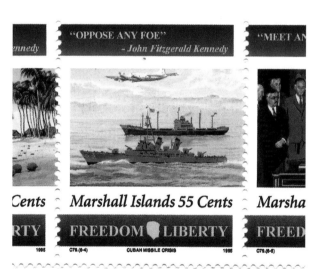

792

Figs.781-789. *Maldives, 2017;* Figs.790, 791.
Mozambique, 2009 (Sc 1829, Mi 3107-3112, YT 2578-2583); Fig.792. *Marshall Islands, 1995 (Sc 591d).*

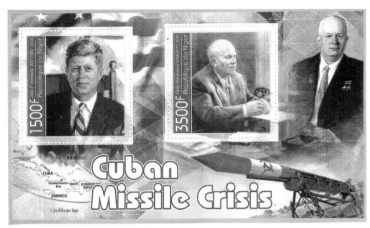

793, 794

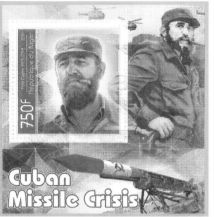

795

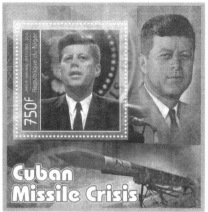

796

Cuban Missile Crisis

797

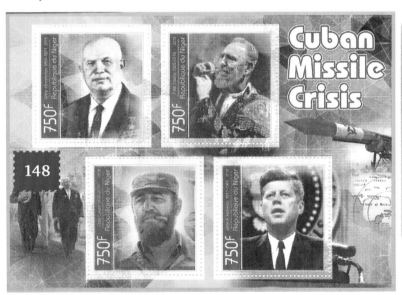

148

Cuban Missile Crisis

798-801

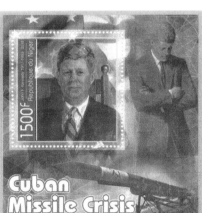

Cuban Missile Crisis

802

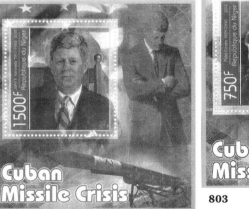

Cuban Missile Crisis

803

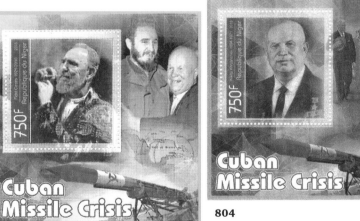

Cuban Missile Crisis

804

Figs.793-804. *Niger, 2016.*

HISTORICAL & INTERNATIONAL EVENTS

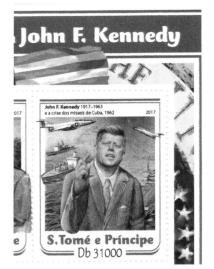

805

806

807

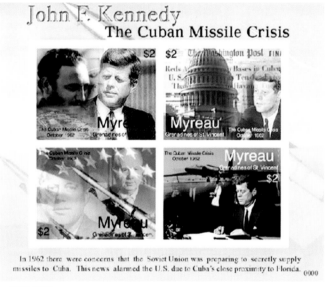

808-811

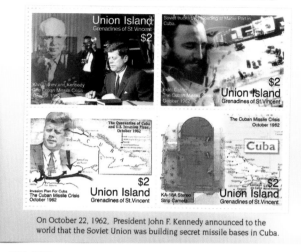

816-819

812-815

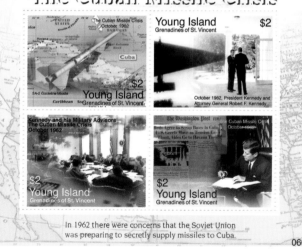

820-823

149

Fig.805. St. Thomas and Prince, 2017; **Fig.806-807.** St. Thomas and Prince, 2013 (Mi 5016-5019); **Figs.808-811.** Sierra Leone, 2006 (Sc 2688a-d, Mi 4955, 4956, 4957, 4958); **Figs.812-815.** St. Vincent Grenadines - Myreau Island, 2007 (Sc 1, 2); **Figs.816-819.** St. Vincent Grenadines - Union Island, 2006 (Sc 319); **Figs.820-823.** St. Vincent Grenadines - Young, 2006.

PORTANT STRATEGIC BASE CONSTITUTES AN EXPLICIT

THIS URGENT TRANSFORMATION OF CUBA INTO AN IM

THE WORLD ON THE BRINK

PRESIDENT KENNEDY

NIKITA S. KHRUSHCHEV · JOHN F. KENNEDY

SIERRA LEONE Le 2000 · SIERRA LEONE Le 2000

22 OCT 1962 CUBA CRISIS · JOHN F. KENNEDY

SIERRA LEONE Le 2000 · SIERRA LEONE Le 2000

THREAT TO THE PEACE AND SECURITY OF ALL THE AMERICAS

OF NUCLEAR DESTRUCTION

CUBAN MISSILE CRISIS

PRESIDENTIAL ADDRESS TO THE PEOPLE, 22-X-1962

824-827

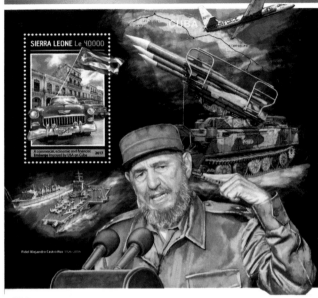

55th ANNIVERSARY OF **CUBAN MISSILE CRISIS**

SIERRA LEONE Le 40000

Fidel Alejandro Castro Ruz 1926–2016

832

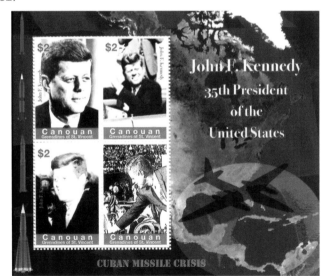

$2 · $2 · $2

John F. Kennedy
35th President
of the
United States

Canouan Grenadines of St. Vincent

CUBAN MISSILE CRISIS

828-831

55th ANNIVERSARY OF **CUBAN MISSILE CRISIS**

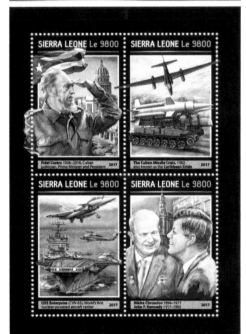

SIERRA LEONE Le 9800 · SIERRA LEONE Le 9800

SIERRA LEONE Le 9800 · SIERRA LEONE Le 9800

Fidel Castro 1926–2016, Cuban politician, Prime Minister and President 2017 · The Cuban Missile Crisis, 1962 also known as the Caribbean Crisis 2017

USS Enterprise (CVN 65), World's first nuclear-powered aircraft carrier 2017 · Nikita Chruschov 1894–1971 John F. Kennedy 1917–1963 2017

833-836

800F POSTES 2017

U-2 avion d'espionnage de la CIA frappé par le S-75 Dvina

Fidel Castro 1926–2016 · Nikita Khrushchev 1894–1971

REPUBLIQUE TOGOLAISE

837

Figs.824-827. *Sierra Leone, 2010;*
Figs.828-831. *St. Vincent Grenadines -
Canouan, 2008;* **Fig.832.** *Sierra Leone,
2017;* **Figs.833-836.** *Sierra Leone, 2017;*
Fig.837. *Togo, 2017.*

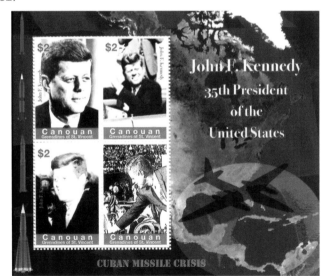

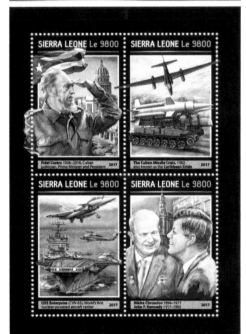

150

Inspired by Cuba! **DELIVERING CUBA THROUGH THE MAIL** ⋆ C U E T O

October 22, 1962
In a live television address,
President John Kennedy
informed the nation of the
Cuban Missile Crisis

and announced a strict
naval quarantine of
the island of Cuba

838

Cuban Missile Crisis

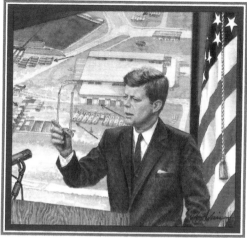

October 22, 1962
Washington, D.C.

839

WELCOME HOME

U. S. S. WALLACE L. LIND
CUBAN BLOCKADE DUTY

840

Cuban Missile Crisis

Washington, D.C.
October 22, 1962

Mr. Jack E. Wilmot, Jr.
RD #5, Box 33
Apollo, Pennsylvania 15613

841

Fig.838. US, 2014; **Fig.839.** US, 1991; **Fig.840.** US, 1962; **Fig.841.** US, 1979.

INTERNATIONAL GAMES, PHILATELIC EVENTS, CONGRESSES, FAIRS, MEETINGS & PROGRAMS

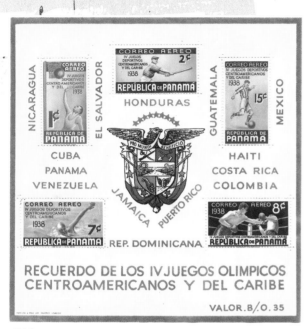

842

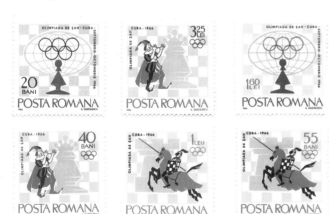

843-848

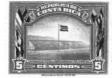

842a-h

Fig.842. *Panama, 1938 (Sc C43-47 Mi 246-250);*
Figs.842a-h. *Costa Rica, 1938 (Sc 201-208);* **Figs.843-848.**
Romania, 1966 (Sc 1815-1820, Mi 2479, SG 3346).

GAMES & SPORTS

For individual athletes, see chapter on People.

1938. CENTRAL AMERICAN & CARIBBEAN GAMES (PANAMA).

CENTRAL AMERICAN & CARIBEEAN GAMES — COUNTRY REPRESENTED:

PANAMA - 1938 - Fig.842

1941. CENTRAL AMERICAN & FOOTBALL CHAMPIONSHIP (COSTA RICA).

CENTRAL AMERICAN & FOOTBALL CHAMPIONSHIP — COUNTRY REPRESENTED:

COSTA RICA - 1938 - Figs.842a-h

1966. CHESS OLYMPIAD (HAVANA).

CHESS OLYMPIAD — COUNTRY REPRESENTED:

ROMANIA - 1966 - Figs.843-848

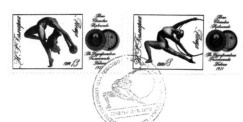

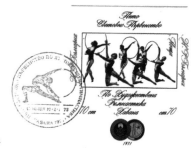

1971.
ARTISTIC GYMNASTIC CHAMPIONSHIP
(HAVANA).

ARTISTIC GYMNASTIC CHAMPIONSHIP –
COUNTRY REPRESENTED:

BULGARIA - 1971 - Figs.849-851

Пето
Световно Първенство
По Художествена
Гимнастика
Хавана
1971

849, 850

Пето
Световно Първенство
По Художествена
Гимнастика
Хавана
1971

851

1973.
WORLD WEIGHTLIFTING CHAMPIONSHIP
(HAVANA).

WORLD WEIGHTLIFTING CHAMPIONSHIP –
COUNTRY REPRESENTED:

ALBANIA - 1973 - Figs.852-857

Figs.849-851. *Bulgaria, 1971 (Sc 2004-2006, Mi 2142-2143, YT 1918-1919);* **Figs.852-857.** *Albania, 1973 (Sc 1536-1541).*

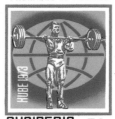
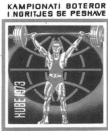
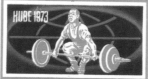
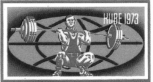

852-857

1977.
FOURTH SPARTAKIADE OF FRIENDLY ARMIES
(HAVANA).

FOURTH SPARTAKIADE OF FRIENDLY ARMIES — COUNTRY REPRESENTED:

RUSSIA - 1977 - Fig.858

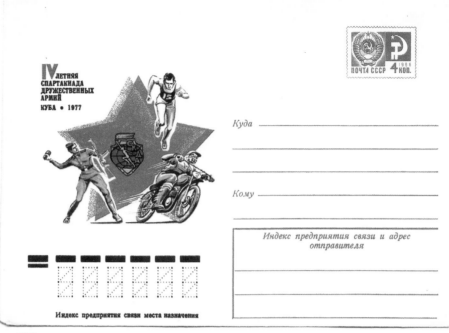

858

1981.
CONFEDERATION OF NORTH, CENTRAL AMERICAN AND CARIBBEAN ASSOCIATION FOOTBALL (CONACAF) '81 SOCCER CUP
(TEGUCIGALPA, HONDURAS).

CONACAF — COUNTRY REPRESENTED:

HONDURAS - 1981 - Figs.859-862

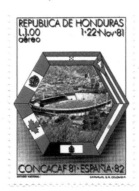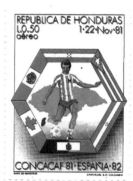

859-862

Fig.858. *Russia, 1977;* **Figs.859-862.**
Honduras, 1981(Sc C703-6).

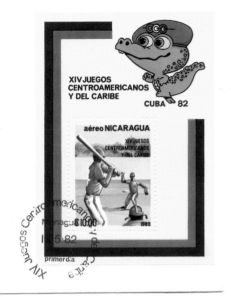

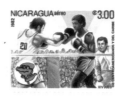

864-870

863

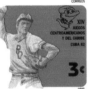
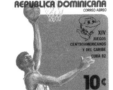
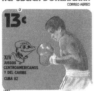

871-874

1982. CENTRAL AMERICAN & CARIBBEAN GAMES (HAVANA).

CENTRAL AMERICAN & CARIBBEAN GAMES — COUNTRIES REPRESENTED:

DOMINICAN REPUBLIC - 1982 - **Figs.871-874**

NICARAGUA - 1982 - **Figs.863-870**

1987. PAN AMERICAN GAMES

(INDIANAPOLIS, US).

875

PAN AMERICAN GAMES —

COUNTRY REPRESENTED:

MEXICO - 1987 - **Fig.875**

1998. WORLD VOLLEYBALL CHAMPIONSHIP

(JAPAN).

WORLD VOLLEYBALL CHAMPIONSHIP —

COUNTRY REPRESENTED:

YUGOSLAVIA - 1998 - **Fig.876**

876

Figs.863-870. *Nicaragua, 1982 (Sc 1159-1162, C1007-C1009);* **Figs.871-874.** *Dominican Republic, 1982 (Sc 866, C368-370);* **Fig.875.** *Mexico, 1987 (Sc 1506);* **Fig.876.** *Yugoslavia, 1998 (Sc 2430).*

CEREMONIA DE CLAUSURA
26 de Marzo

XIII Juegos Deportivos Panamericanos

bienvenida a Winnipeg '99.

ODEPA
ORGANIZACIÓN DEPORTIVA PANAMERICANA

COMITÉ OLIMPICO ARGENTINO
ARGENTINE OLYMPIC COMMITTEE

WINNIPEG 1967 (CANADA)
CHICAGO 1959 (U.S.A.)
INDIANAPOLIS 1987 (U.S.A.)
LA HABANA 1991 (CUBA)
SAN JUAN DE PUERTO RICO 1979 (PUERTO RICO)
MÉXICO 1955 (MÉXICO)
MÉXICO 1975 (MÉXICO)
CARACAS 1983 (VENEZUELA)
SAN PABLO 1967 (BRASIL)
BUENOS AIRES 1951 (ARGENTINA)
1995 MAR DEL PLATA

DEPORTES
GRUPO TEMATICO
" PODIUM "

877

REPUBLICA DOMINICANA CORREOS 50¢
XI JUEGOS DEPORTIVOS PANAMERICANOS
LA HABANA-CUBA
1991

878

REPUBLICA DOMINICANA CORREOS 30¢
XI JUEGOS DEPORTIVOS PANAMERICANOS
LA HABANA-CUBA
1991

879

REPUBLICA DOMINICANA CORREOS $1.00
XI JUEGOS DEPORTIVOS PANAMERICANOS
LA HABANA-CUBA
1991

879a

Eventos Deportivos
XI JUEGOS PANAMERICANOS HABANA '91
Chile $100
CASA DE MONEDA DE CHILE 1991

Eventos Deportivos
XI JUEGOS PANAMERICANOS HABANA '91
Chile $100
CASA DE MONEDA DE CHILE 1991

880, 881

1991.
PAN AMERICAN GAMES
(HAVANA).

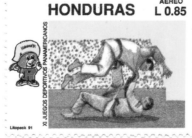

HONDURAS AEREO L 0.30
Habana'91
XI JUEGOS DEPORTIVOS PANAMERICANOS
Litopack 91

882

HONDURAS AEREO L 0.85
Habana'91
XI JUEGOS DEPORTIVOS PANAMERICANOS
Litopack 91

883

HONDURAS AEREO L 0.95
Habana'91
XI JUEGOS DEPORTIVOS PANAMERICANOS
Litopack 91

884

HONDURAS AEREO L 5.00
Habana'91
XI JUEGOS DEPORTIVOS PANAMERICANOS
05430

885

Fig.877. *Argentina, 1995;* **Figs.878, 879, 879a.** *Dominican Republic, 1991 (Sc 1100-1102);* **Figs.880, 881.** *Chile, 1991 (Sc 964, 965);* **Figs.882-885.** *Honduras, 1991 (Sc C826-C829).*

2010.
CAPABLANCA MEMORIAL
(IN MEMORIAM)
(HAVANA).

This international chess tournament has been held in Havana since 1962.

CAPABLANCA MEMORIAL —
COUNTRY REPRESENTED:

GUINEA BISSAU - 2010 - Figs.886, 887

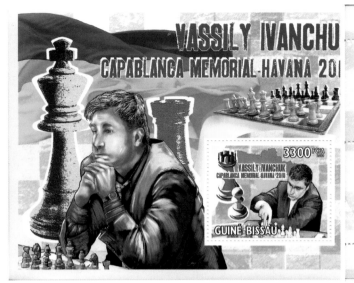

886

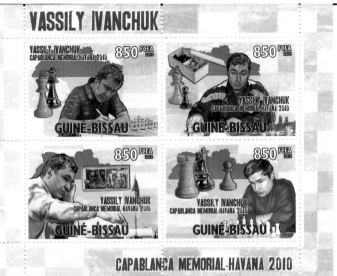

887

1999.
PAN AMERICAN GAMES
(WINNIPEG, CANADA).

PAN AMERICAN GAMES — COUNTRY REPRESENTED:

CANADA - 1999 - Fig.888

Figs.886, 887. *Guinea Bissau, 2010;* **Fig.888.** *Canada, 1999 (Sc 1804a).*

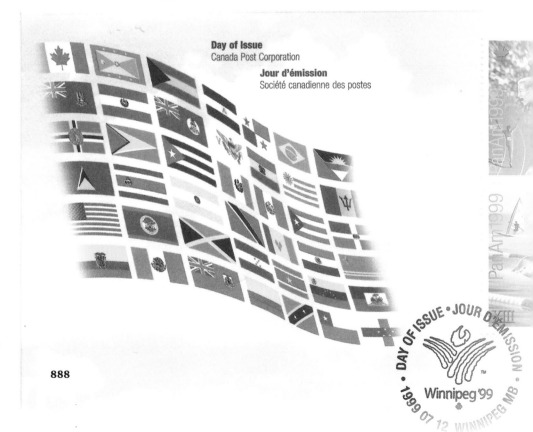

888

Inspired by Cuba! **DELIVERING CUBA THROUGH THE MAIL** ★ C U E T O

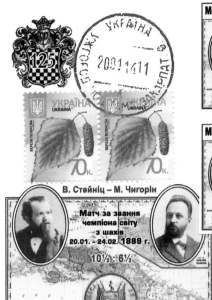

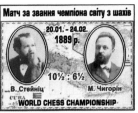

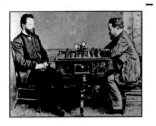

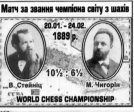

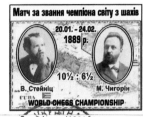

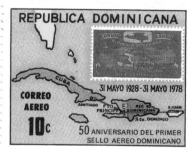

890

891

889

1889.
STEINITZ CHAGRIN MATCH

(HAVANA).

STENINITZ CHAGRIN MATCH — COUNTRY REPRESENTED:

UKRAINE - 2014 - Fig.889

Fig.889. *Ukraine, 2014;* **Figs.890, 891.** *Dominican Republic, 1929 (Sc C6), 1978 (Sc C 270).*

1929.
FIRST DOMINICAN AIR MAIL STAMP. FLIGHT TO SANTIAGO DE CUBA, 1928.

159

FIRST DOMINICAN AIR MAIL STAMP — COUNTRY REPRESENTED:

DOMINICAN REPUBLIC - 1929 - Fig.890

- 1978 - Fig.891

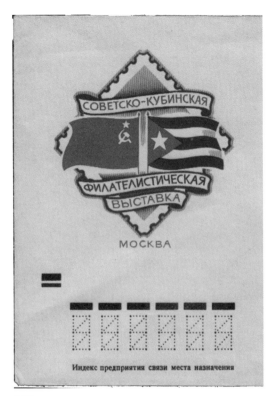

892

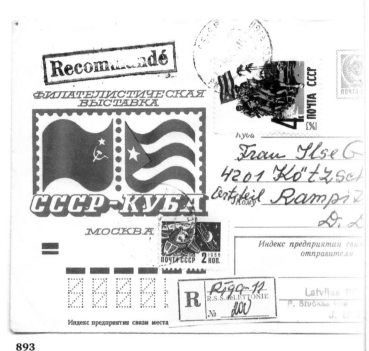

893

894

1972.
SOVIET-CUBAN PHILATELIC EXHIBITION

(MOSCOW).

SOVIET-CUBAN PHILATELIC EXHIBITION —
COUNTRY REPRESENTED:

RUSSIA - 1972 - Fig.892

1974.
PHILATELIC EXHIBITION

(MOSCOW).

PHILATELIC EXHIBITION —
COUNTRY REPRESENTED:

RUSSIA - 1974 - Fig.893

1976.
PHILATELIC EXHIBITION

(BAKU, SOVIET AZERBAIJAN).

PHILATELIC EXHIBITION —
COUNTRY REPRESENTED:

RUSSIA - 1976 - Fig.894

Inspired by Cuba! DELIVERING CUBA THROUGH THE MAIL ★ CUETO

Fig.892. Russia, 1972; Fig.893. Russia, 1974; Fig.894. Russia, 1976.

Licht soll es werden ringsum auf Erden!
Zukunft, wir grüßen dich!
Unser Lied die Ländergrenzen überfliegt.

Freundschaft siegt!
Freundschaft siegt!

PHILATELISTENVERBAND IM KULTURBUND DER DDR

LA HABANA

CUBA

6. BEZIRKSBRIEFMARKENAUSSTELLUNG
JUNGER PHILATELISTEN KARL-MARX-STADT
1978 IM JAHR DER XI. WELTFESTSPIELE

895

PŘÍLEŽITOSTNÁ POŠTOVNÍ DOPISNICE

ČESKOSLOVENSKÁ POŠTA

Mezinárodní výstava
poštovních známek
ČSSR - Kuba
Gottwaldov '79

Kčs 4:40
ČESKOSLOVENSKO

896

СССР
КУБА

МЕЖДУНАРОДНАЯ ФИЛАТЕЛИСТИЧЕСКАЯ
ВЫСТАВКА
г. Одесса · 1981

Куда

Кому

897

СССР
СР

161

1978.
PHILATELIC
EXHIBITION

(KARL-MARX STADT).

PHILATELIC EXHIBITION —
COUNTRY REPRESENTED:

GERMANY - 1978 - Fig.895

1979.
INTERNATIONAL
PHILATELIC
EXHIBITION

(GOTTWALDOV/ ZLÍN, MORAVIA).

INTERNATIONAL PHILATELIC EXHIBITION —
COUNTRY REPRESENTED:

CZECHOSLOVAKIA - 1979 - Fig.896

1981.
INTERNATIONAL
PHILATELIC
EXHIBITION

(ODESSA).

INTERNATIONAL PHILATELIC EXHIBITION —
COUNTRY REPRESENTED:

RUSSIA - 1981 - Fig.897

Fig.895. *Germany, 1978;* **Fig.896.**
Czechoslovakia, 1979; **Fig.897.** *Russia, 1981.*

898

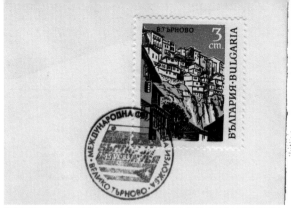

899

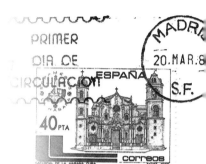

900

1984.
INTERNATIONAL PHILATELIC EXHIBITION

(EREVAN, ARMENIA).

INTERNATIONAL PHILATELIC EXHIBITION – COUNTRY REPRESENTED:

RUSSIA - 1984 - Fig.898

1985.
INTERNATIONAL PHILATELIC EXHIBITION

(VELIKO TARNOVO).

INTERNATIONAL PHILATELIC EXHIBITION – COUNTRY REPRESENTED:

BULGARIA - 1985 - Fig.899

1985.
PHILATELIC EXHIBITION, AMERICA & EUROPE/ EXPOSICIÓN FILATÉLICA DE AMERICA Y EUROPA ESPAMER

(MADRID).

PHILATELIC EXHIBITION AMERICA & EUROPE – COUNTRY REPRESENTED:

SPAIN - 1985 - Fig.900

Fig.898. *Russia, 1984;* Fig.899. *Bulgaria, 1985;* Fig.900. *Spain, 1985.*

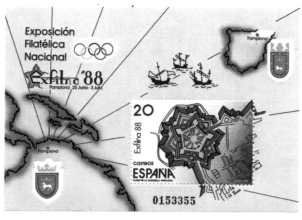

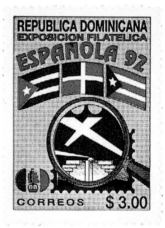

901

1987.
PHILATELIC EXHIBITION
(SCHWERIN).

PHILATELIC EXHIBITION –
COUNTRY REPRESENTED:

GERMANY - 1987 - **Fig.901**

902

1988.
PHILATELIC EXHIBITION
(TOLBUHIN).

PHILATELIC EXHIBITION –
COUNTRY REPRESENTED:

BULGARIA - 1988 - **Fig.902**

903

1988.
NATIONAL PHILATELIC EXHIBITION, EXFILNA
(MADRID).

NATL. PHILATELIC EXHIBITION –
COUNTRY REPRESENTED:

SPAIN - 1988 - **Fig.903**

904

1992.
ESPAÑOLA 92 PHILATELIC EXHIBITION
(SANTO DOMINGO, D. R.).

ESPAÑOLA 92 PHILATELIC EXHIBITION –
COUNTRY REPRESENTED:

DOMINICAN REPUBLIC - 1992 - **Fig.904**

163

Fig.901. *Germany, 1997;* **Fig.902.** *Bulgaria, 1988;* **Fig.903.** *Spain, 1988 (Sc 2562);* **Fig.904.** *Dominican Republic, 1992 (Sc 1112).*

905

906

OTHER

2015.
150TH ANNIVERSARY OF FIRST POSTAGE STAMP IN ECUADOR

150TH ANNIVERSARY 1ST POSTAGE STAMP IN ECUADOR —
COUNTRY REPRESENTED:

ECUADOR - 2015 - **Fig.905**

1929.
IBERO-AMERICAN UNION EXHIBITION / PRO UNION IBEROAMERICANA
(SEVILLE).

IBERO-AMERICAN UNION EXHIBITION — COUNTRY REPRESENTED:

SPAIN - 1930 - **Fig.906**

Fig.905. *Ecuador, 2015 (Sc 2163h);*
Fig.906. *Spain, 1930 (Sc 443, Mi 537-553).*

907

908

909

910

911

912

1939.
NEW YORK WORLD´S FAIR

NEW YORK WORLD'S FAIR —
POSTAL ENTITY REPRESENTED:

US, NEW YORK WORLD'S FAIR -
1940 - **Fig.907**

1975.
IBERO AMERICAN DERMATOLOGICAL CONGRESS

(SAN SALVADOR, EL SALVADOR).

IBERO AMERICAN DERMATOLOGICAL CONGRESS —
COUNTRY REPRESENTED:

EL SALVADOR - 1975 - **Figs.908-911**

1976.
150TH ANNIVERSARY OF PANAMA CONGRESS CONVENED BY SIMÓN BOLÍVAR

(1826).

150TH ANNIVERSARY OF PANAMA CONGRESS —
COUNTRY REPRESENTED:

PANAMA - 1976 - **Fig.912**

165

Fig.907. *US, New York World´s Fair, 1940. "Cuban Village" Cinderella;* **Figs.908-911.** *El Salvador* (Sc 895-896, C366-367); **Fig.912.** *Panama, 1976* (Sc 583a, Mi 1335-1364).

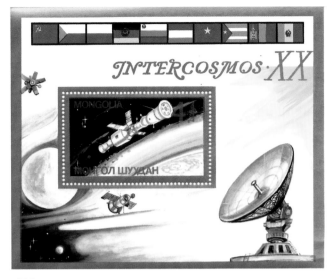

913

914

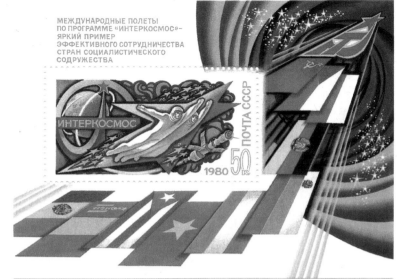

915

1977-1988.
INTERKOSMOS SPACE PROGRAM

(USSR).

Soviet program which included the participation of cosmonauts from USSR´s allies, including Cuba (1980 mission). See Arnaldo Tamayo and José Armando López Falcón in People´s section, above.

INTERKOSMOS SPACE PROGRAM — COUNTRIES REPRESENTED:

CZECHOSLOVAKIA - 1984 - Fig.914

MONGOLIA - 1987 - Fig.913

RUSSIA - 1980 - Fig.915

- 1983 - Fig.917

- 1987 - Fig.916

XX-летие сотрудничества социалистических стран по программе „ИНТЕРКОСМОС"

916

917

Fig.913. Mongolia, 1987 (Sc 1658); Fig.914. Czechoslovakia, 1984 (Sc 2503-2507); Fig.915. Russia, 1980 (Sc 4820); Fig.916. Russia, 1987; Fig.917. Russia, 1983 (Sc 5135).

1978.
HAVANA WORLD YOUTH FESTIVAL
(HAVANA).

The World Festival of Youth and Students was first held in Czechoslovakia in 1947, organized by the left-leaning World Federation of Democratic Youth (WFDY). Havana hosted the 11th such gathering in 1978, and several countries, mostly communist-oriented, celebrated that event in their stamps.

HAVANA WORLD YOUTH FESTIVAL — COUNTRIES REPRESENTED:

ALGERIA - 1978 - **Fig.919**
BULGARIA - 1978 - **Fig.918**
CONGO, REPUBLIC - 2010 - **Fig.920**
GERMANY - 1978 - **Fig.921**
HUNGARY - 1978 - **Figs.923, 924**
MONGOLIA - 1978 - **Fig.925**
MOZAMBIQUE - 1978 - **Figs.930-932**
POLAND - 1978 - **Fig.922**
RUSSIA - 1978 - **Fig.933**
 - 2017 - **Fig.934**
YEMEN - 1978 - **Figs.926-929**

918

919

920

Fig.918. *Bulgaria, 1978 (Sc 2502);* **Fig.919.** *Algeria, 1978 (Sc 866);* **Fig.920.** *Congo, Republic, 2010 (Sc 459).*

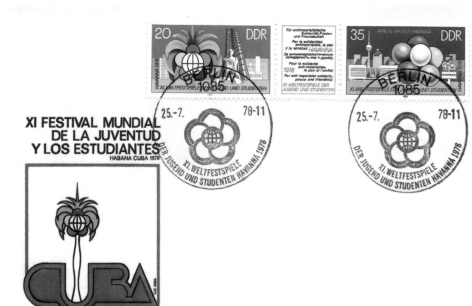

XI FESTIVAL MUNDIAL DE LA JUVENTUD Y LOS ESTUDIANTES
HABANA CUBA 1978

XI. WELTFESTSPIELE DER JUGEND UND STUDENTEN

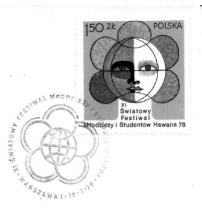

921

923, 924

922

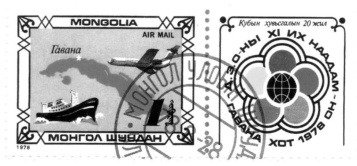

925

Fig.921. *Germany, 1978 (Sc 1933-934a);* Fig.922. *Poland, 1978 (Sc 2272);* Figs.923, 924. *Hungary, 1978 (Sc 2536-2537, Mi 3303A-3304A, SG 3198-9, YT 2620-2621);* Fig.925. *Mongolia, 1978.*

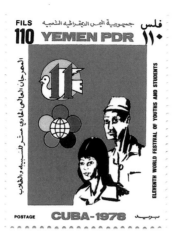

930-932

926-929

933

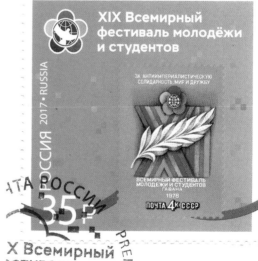

934

Figs.926-929. *Yemen, 1978 (Sc 196-198, Mi 212-215, YT 193-196);*
Figs.930-932. *Mozambique, 1978 (Sc 603-605, Mi 666-668);* **Fig.933.**
Russia, 1978. (Sc 4648); **Fig.934.** *Russia, 2017 (Sc 7840).*

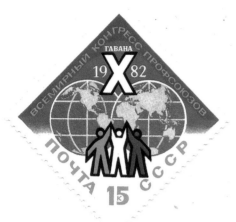

935

936, 937

938

939

941

1982.
HAVANA TRADE UNIONS CONGRESS
(HAVANA).

The World Federation of Trade Unions (WFTU) was founded in Paris on October 3, 1945. Closely allied to socialist ideology, their 1982 Congress was held in Havana. Several participating communist countries issued stamps to commemorate the event.

HAVANA TRADE UNIONS CONGRESS — COUNTRIES REPRESENTED:

BULGARIA - 1982 - **Fig.940**
CZECHOSLOVAKIA - 1982 - **Fig.938**
HUNGARY - 1982 - **Fig.939**
RUSSIA - 1982 - **Fig.935**
VIETNAM - 1982 - **Figs.936, 937**

940

1989.
INTERNATIONAL SCIENCE FAIR
(PLOVDIV).

INTERNATIONAL SCIENCE FAIR — COUNTRY REPRESENTED:

BULGARIA - 1989 - **Fig.941**

Fig.935. *Russia, 1982 (Sc 5013);* **Figs.936, 937.** *Vietnam, 1982 (Sc 1165-1166);* **Fig.938.** *Czechoslovakia, 1982 (Sc 2396);* **Fig.939.** *Hungary, 1982 (Sc 2723, Mi 3534, YT 2794);* **Fig.940.** *Bulgaria, 1982;* **Fig.941.** *Bulgaria, 1989 (Sc 3497).*

2010. 14TH IBERO AMERICAN NOTARIES MEETING

(SANTO DOMINGO, D.R.).

942

14TH IBERO AMERICAN NOTARIES MEETING — COUNTRY REPRESENTED:

DOMINICAN REPUBLIC - 2010 - Fig.942

2012. ROMANIAN CULTURE WEEK IN HAVANA

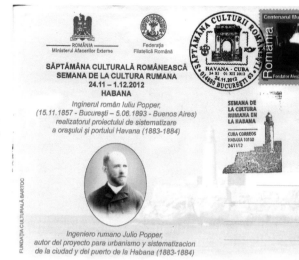

943

ROMANIAN CULTURE WEEK IN HAVANA — COUNTRY REPRESENTED:

ROMANIA - 2012 - Fig.943

2016. MEETING BETWEEN CATHOLIC POPE FRANCIS & PATRIARCH OF THE RUSSIAN ORTHODOX CHURCH KIRILL

MEETING POPE FRANCIS & KIRILL — COUNTRIES REPRESENTED:

GRENADA - 2016 - Figs.944-947 ST. VINCENT - 2016 - Figs.948-951

944-947

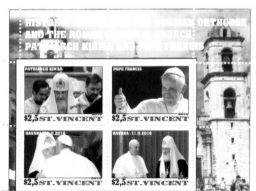

948-951

2017. WORLD SCOUTING MOVEMENT

WORLD SCOUTING MOVEMENT — COUNTRY REPRESENTED:

PERU - 2007 - Fig.952

952

Fig.942. Dominican Republic, 2010 (Sc 1481); Fig.943. Romania, 2012; Figs.944-947. Grenada, 2016; Figs.948-951. St. Vincent, 2016; Fig.952. Peru, 2007 (Sc 1571a, b).

FOREIGN RELATIONS

10 F

POSTES 1998

PERSAHABATAN INDONESIA CUBA

CENTRAFRICAINE

REPUBLIQUE

Fidel Castro

INDIVIDUAL COUNTRIES

ANGOLA

ANGOLA — COUNTRY REPRESENTED:

ANGOLA - 1974 - **Fig.953**

Fig.953. *Angola, 1974*

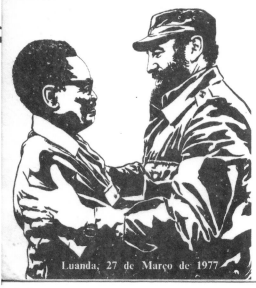

Fidel de Castro na R. P. A.

Luanda, 27 de Março de 1977

953

20-ГОДДЗЕ

ЎСТАЛЯВАННЯ
ДЫПЛАМАТЫЧНЫХ АДНОСІН
ПАМІЖ РЭСПУБЛІКАЙ БЕЛАРУСЬ
І РЭСПУБЛІКАЙ КУБА

БЕЛАРУСЬ BELARUS 2012 15.00

20-ГОДДЗЕ ЎСТАЛЯВАННЯ ДЫПЛАМАТЫЧНЫХ АДНОСІН
ПАМІЖ РЭСПУБЛІКАЙ БЕЛАРУСЬ І РЭСПУБЛІКАЙ КУБА

20 ANIVERSARIO DEL ESTABLECIMIENTO DE LAS RELACIONES
DIPLOMÁTICAS ENTRE LA REPUBLICA DE BELARUS
Y LA REPUBLICA DE CUBA

ПЕРШЫ ДЗЕНЬ PREMIER JOUR

954

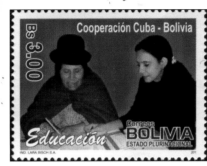

955

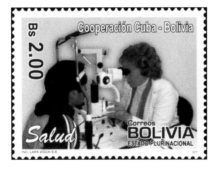

956

COMMON ISSUE BULGARIA - CUBA

EDICIÓN COMÚN BULGARIA - CUBA

Пощенски марки – „50 години от установяване на дипломатически отношения между
България и Куба"
Стойности 0,65 лв.; 1,40 лв. Поръчани с възлагателно писмо № 11-02-205 от 05.11.2010 г. на
Министерство на транспорта, информационните технологии и съобщения по поръчка № 53-Ф-040
от 15.11.2010 г. на БП-ЕАД.
Технологична поръчка № 83 от 16.11.2010 г. на БФН. Офсетов печат. БДС 2218-87.

173

957

BELARUS

BOLIVIA

BULGARIA

BELARUS — COUNTRY REPRESENTED:

BOLIVIA — COUNTRY REPRESENTED:

BULGARIA — COUNTRY REPRESENTED:

BELARUS - 2012 - Fig.954

BOLIVIA - 2011 - Figs.955, 956

BULGARIA - 2010 - Figs.957

Fig.954. *Belarus, 2012 (Sc 826);* **Figs.955, 956.** *Bolivia, 2011;* **Fig.957.** *Bulgaria, 2010 (Sc 4560a).*

中國著名指揮家姚笛

958

959

PERSAHABATAN INDONESIA CUBA

AMISTAD INDONESIA CUBA

03708

960

961, 962

中古友好

Amistad entre China y Cuba

174

962a

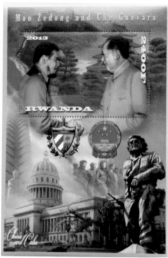

Mao Zedong and Che Guevara

2013

2100F

RWANDA

China and Cuba

963

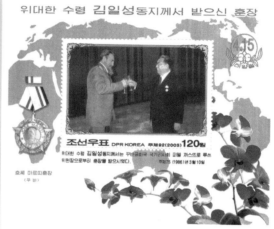

964

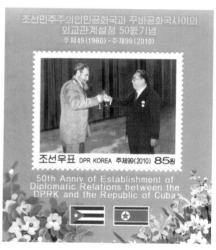

965

CHINA

CHINA – COUNTRIES REPRESENTED:

CHINA - 2006 - **Figs.959, 962a**

EASDALE ISLAND - 1990s? - **Fig.958**

RWANDA - 2013 - **Fig.963**

INDONESIA

INDONESIA – COUNTRY REPRESENTED:

INDONESIA - 1965 - **Fig.960**

- 2008 - **Figs.961, 962**

IRAN

IRAN – COUNTRY REPRESENTED:

IRAN - 2009 -

Figs.966, p.175

KAZAKHSTAN

KAZAKHSTAN – COUNTRY REPRESENTED:

KAZAKHSTAN - 2013 - **Fig.970a**

Fig.958. Easdale Island (Scotland), 1990s?; **Figs.959.** *China, 2006;* **Fig.960.** *Indonesia, 1965;* **Figs.961, 962.** *Indonesia, 2008;* **Fig.962a.** *China, 2006;* **Fig.963.** *Rwanda, 2013;* **Fig.964.** *Korea, DPR, 2003 (Sc 4647);* **Fig.965.** *Korea, DPR, 2010 (Sc 4937).*

1500 Rls.

Ramsar Convention

Ciénaga de Zapata

Cyanolimnas cerverai Nymphaea ampia

970a

966

967

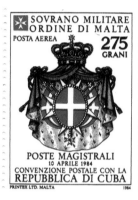

969

970

971

175

KOREA

KOREA – COUNTRY REPRESENTED:

KOREA, DPR - 2003 - **Fig.964**
- 2010 - **Fig.965**

MALI

MALI – COUNTRY REPRESENTED:

MALI - 1999 -
Fig.967

NICARAGUA

NICARAGUA – COUNTRY REPRESENTED:

NICARAGUA - 1983 -
Figs.38, p.25, 968

ORDER OF MALTA

ORDER OF MALTA –
POSTAL AUTHORITY REPRESENTED:

ORDER OF MALTA - 1984 -
Figs.969, 970

PERU

PERU – COUNTRY REPRESENTED:

PERU - 2000 - **Fig.971**

Fig.966. *Iran, 2009 (Sc 3003);* **Fig.967.** *Mali, 1999 (Sc 1061k);* **Fig.968.** *Nicaragua, 1983 (Sc 1313);*
Figs.969, 970. *Order of Malta, 1984;* **Figs.970a.** *Kazakhstan, 2013;* **Fig.971.** *Peru, 2000 (Sc 1250).*

FOREIGN RELATIONS

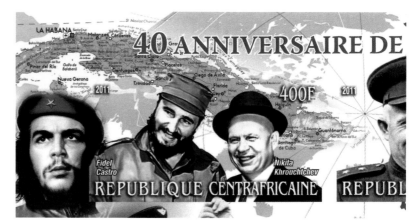

972

RUSSIA

RUSSIA — COUNTRIES EPRESENTED:

CENTRAL AFRICAN REPUBLIC - 2011 - Fig.972
RUSSIA - 1974 - Fig.973

SERBIA

SERBIA — COUNTRY REPRESENTED:

SERBIA - 2013 - Fig.974

Fig.972. *Central African Republic, 2011;*
Fig.973. *Russia, 1974 (Sc 4161-4162, Mi 4213);* **Fig.974.** *Serbia, 2013 (Sc 631).*

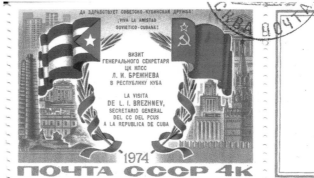

973

974

SOUTH AFRICA

SOUTH AFRICA — COUNTRIES REPRESENTED:

BENIN - 2016 - **Fig.979**

CENTRAL AFRICAN REPUBLIC - 2013 - **Fig.976**

MALDIVES - 2014 - **Fig.975**

MALI - 2013 - **Fig.977**

SRI LANKA

SRI LANKA — COUNTRY REPRESENTED:

SRI LANKA - 2009 - **Fig.978**

TURKEY

TURKEY — COUNTRY REPRESENTED:

TURKEY - 2012 - **Fig.980**

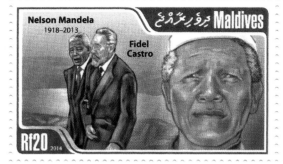

975

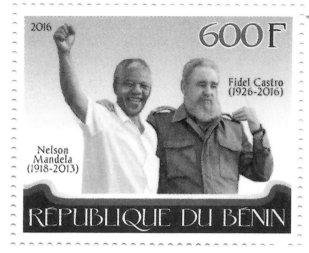

979

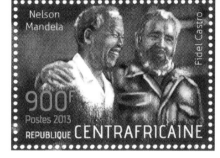

976

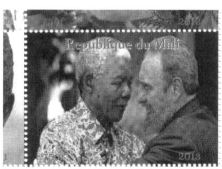

977

978

980

Fig.975. *Maldives, 2014 (Sc 3104c, Mi 5080)*; **Fig.976.** *Central African Republic, 2013 (Mi 4486)*;
Fig.977. *Mali, 2013*; **Fig.978.** *Sri Lanka, 2009*; **Fig.979.** *Benin, 2016*; **Fig.980.** *Turkey, 2012.*

INDIVIDUAL COUNTRIES

WEBCRAFT
CUBA | USA

TOWARD
RAPPROCHEMENT
2016

981

WHITE HOUSE STA.
MAR
16
2016
WASHINGTON, DC 20500

UNITED STATES

UNITED STATES — COUNTRIES REPRESENTED:

GRENADA - 2016 - Figs.994-997

ST. VINCENT - 2016 -
 Figs.998-1001, 1002-1005

TUVALU - 2016 - Figs.982-993

US - 2016 - Fig.981

Fig.981. US, 2016; **Figs.982-993.** Tuvalu, 2016
(Sc 1366-1368); **Figs.994-997.** Grenada, 2016;
Figs.998-1001, 1002-1005. St. Vincent, 2016.

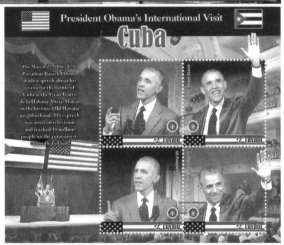

982-987

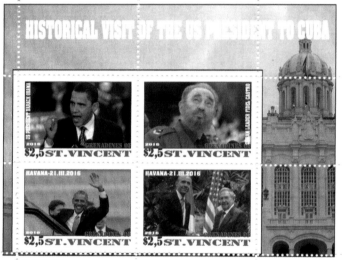

988-991

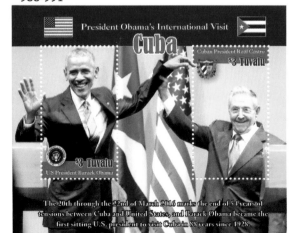

992-993

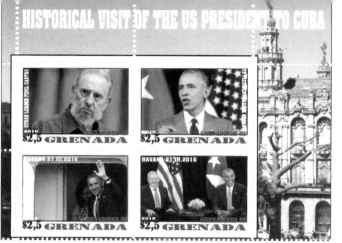

994-997

998-1001

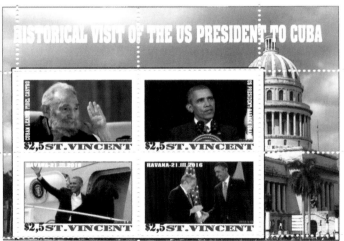

1002-1005

VATICAN CITY/POPES

During the last twenty-three years, three Popes have visited Cuba: John Paul II in 1998, Benedict XVI in 2012 and Francis twice: in 2015 and in 2016.

VATICAN CITY/ POPES – COUNTRIES REPRESENTED:

BENIN - 2016 - **Fig.1015**

CENTRAL AFRICAN REPUBLIC -
 2012 - **Fig.1013**

CONGO, REPUBLIC - 2012 - **Fig.1014**

DJIBOUTI - 2005 - **Fig.1006**

GRENADA - 2012 - **Figs.1008-1012**

GUINEA - 1998 - **Fig.1019**
 - 2012 - **Figs.1016-1018**

GUYANA - 2004 - **Fig.1032**

MALI - 1998 - **Figs.1022-1024**

MOZAMBIQUE - 2016 - **Fig.1035**

POLAND - 2003 - **Fig.1021**

RWANDA - 2013 - **Fig.1007**

TOGO - 2012 - **Figs.1029-1031**
 - 2020 - *not illustrated*

TURKMENISTAN - 1998 - **Figs.1005a, 1025,**
 Another identical stamp with value of
 1.000M in souvenir sheet not illustrated

VATICAN - 1998 - **Figs.1026, 1027**
 - 1999 - **Fig.1028**
 - 2002 - **Figs.1020, 1021**
 - 2012 - **Fig.1033**
 - 2015 - **Fig.1034**

1005a

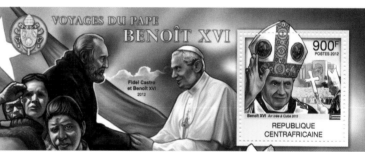

Pope Benedict XVI Visits Cuba
March 26-28, 2012

1008

1009-1012

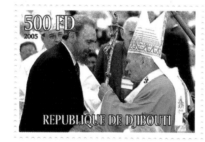

1006

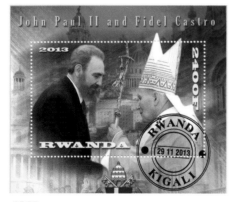

John Paul II and Fidel Castro

1007

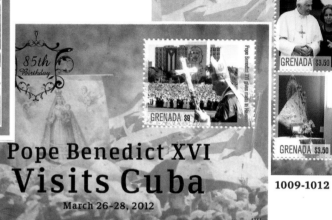

VOYAGES DU PAPE BENOÎT XVI

REPUBLIQUE CENTRAFRICAINE

1013

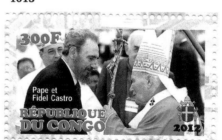

Pape et Fidel Castro
RÉPUBLIQUE DU CONGO 2012

1014

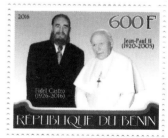

Fidel Castro (1926-2016) — Jean-Paul II (1920-2005)
RÉPUBLIQUE DU BENIN

1015

179

Fig.1005a. *Turkmenistan, 1998 (YT Bl.16);* **Fig.1006.** *Djibouti, 2005;* **Fig.1007.** *Rwanda, 2013;* **Figs.1008-1012.** *Grenada, 2012 (Sc 3861?);* **Fig.1013.** *Central African Republic, 2012;* **Fig.1014.** *Congo, Republic, 2012;* **Fig.1015.** *Benin, 2016.*

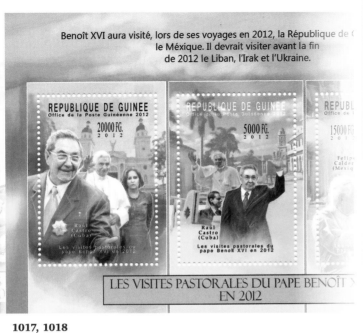

Benoît XVI aura visité, lors de ses voyages en 2012, la République de Cuba ainsi que le Méxique. Il devrait visiter avant la fin de 2012 le Liban, l'Irak et l'Ukraine.

Benoît XVI aura visité, lors de ses voyages en 2012, la République de C le Méxique. Il devrait visiter avant la fin de 2012 le Liban, l'Irak et l'Ukraine.

1016

1017, 1018

1019

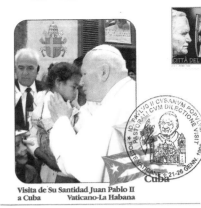

Visita de Su Santidad Juan Pablo II a Cuba Vaticano-La Habana

1026

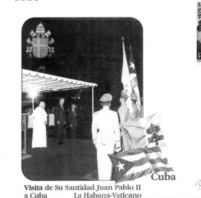

Visita de Su Santidad Juan Pablo II a Cuba La Habana-Vaticano

1027

180

1020

1021

1022-1024

75.00 M

Republic TÜRKMENISTAN

1025

1028

Figs.1016-1018. *Guinea, 2012 (Gu 12410b);* **Fig.1019.** *Guinea, 1998 (Sc 1438-1442?, YT 127);* **Fig.1020.** *Vatican, 2002 (Sc 1296u);* **Fig.1021.** *Poland, 2003 (Sc 3668);* **Figs.1022-1024.** *Mali, 1998 (Sc 974a, b, c);* **Fig.1025.** *Turkmenistan, 1998;* **Figs.1026, 1027.** *Vatican, 1998;* **Fig.1028.** *Vatican, 1999 (Sc 1118).*

Les visites pastorales du Pape

Benoît XVI en 2012

Cathédrale de la Havane

POSTES 2012
2000F
Le Pape Benoît XVI rencontre Fidel Castro à La Havane, 2012

REPUBLIQUE TOGOLAISE

1029

Les visites pastorales du Pape Benoît XVI en 2012

POSTES 2012
750F Raul Castro

Réplique de la "Géographie de Ptolémée", un présent du Pape Benoît XVI

Pape Benoît XVI

REPUBLIQUE TOGOLAISE

75

REP

1030

Pape Benoît XVI en 2012

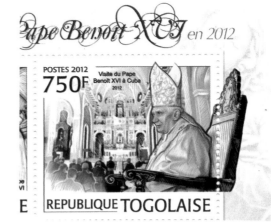

POSTES 2012
750F Visite du Pape Benoît XVI à Cuba 2012

REPUBLIQUE TOGOLAISE

1031

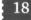
181

GUYANA $100

1998

THE POPE WITH FIDEL CASTRO

1032

VISITA APOSTOLICA DI SUA SANTITÀ BENEDETTO XVI IN MESSICO E A CUBA

23 - 29 Marzo 2012

Città del Vaticano 0,70

1033

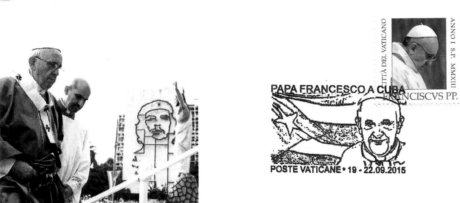

GEOCOVER

VIAGGIO APOSTOLICO DEL SANTO PADRE A CUBA

19-22 SETTEMBRE 2015

CITTÀ DEL VATICANO ANNO I S.P. MMXIII

PAPA FRANCESCO A CUBA

FRANCISCVS PP.

POSTE VATICANE • 19 - 22.09.2015

1034

80º aniversário do Papa Francisco

MOÇAMBIQUE 2016

66.00 MT

Papa Francisco com Fidel Castro

MOÇAMBIQUE 2016

1035

Figs.1029-1031. *Togo, 2012 (Mi 4603-4607);* **Fig.1032.** *Guyana, 2004 (Sc 3852a);* **Fig.1033.** *Vatican, 2012 (Sc 1542);* **Fig.1034.** *Vatican, 2015;* **Fig.1035.** *Mozambique, 2016.*

1036-1040

VENEZUELA

VENEZUELA — COUNTRY REPRESENTED:

VENEZUELA - 1972 - Figs.1036-1040

‑ 2014 ‑ Figs.1043, 1044

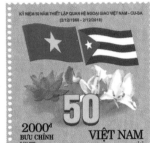

1041

1043, 1044

VIETNAM

VIETNAM — COUNTRY PRESENTED:

VIETNAM - 1963 - Fig.1042

‑ 2010 ‑ Fig.1041

‑ 2021 ‑ Figs.1042a, 1042b

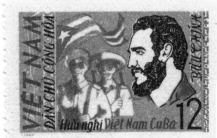
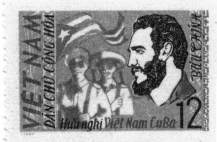

1042

1042a **1042b**

Figs.1036-1040. *Venezuela, 1972 (Sc 996-1000);* **Fig.1041.** *Vietnam, 2010 (Sc 3403);* **Fig.1042.** *Vietnam, 1963 (Sc 246);* **Figs.1042a, 1042b.** *Vietnam, 2021;* **Figs.1043, 1044.** *Venezuela, 2014 (Sc 1726).*

FOREIGN RELATIONS

REGIONAL & WORLD ORGANIZATIONS

1044a

1044b

BOLIVARIAN ALLIANCE FOR THE AMERICAS

(ALBA).

Organized in 2004, its current members (Venezuela, Cuba, Bolivia, Nicaragua, Dominica, Ecuador, Antigua and Barbuda, Saint Vincent and the Grenadines, Saint Lucia, Grenada and the Federation of Saint Kitts and Nevis) hold periodic meetings in furtherance of their agenda.

BOLIVARIAN ALLIANCE FOR THE AMERICAS —
COUNTRY REPRESENTED:

BOLIVIA - 2015 - **Fig.1044a, 1044b**

Fig.1044a, 1044b. *Bolivia, 2015 (Sc 996-997, YT 1560-61);*
Fig.1045. *Germany, DDR 1974 (Sc 1520);* Fig.1046. *Bulgaria,*
1979 (Sc 2259, Mi 2746, SG 2720, YT 2438).

COUNCIL FOR MUTUAL ECONOMIC ASSISTANCE

(COMECON/ CAME).

Under the leadership of the Soviet Union, the Council was created in 1949 to coordinate the economic relationships among of the European socialist countries. In 1972 Cuba joined the group (Vietnam would do so in 1978). Member countries would issue stamps displaying all their respective flags on several occasions, including the celebration of the 30th and 40th anniversaries of the founding of the Council.

1045

COUNCIL FOR MUTUAL ECONOMIC ASSISTANCE —
COUNTRIES REPRESENTED:

BULGARIA - 1979 - **Fig.1046**
GERMANY, DDR - 1974 - **Fig.1045**
 - 1989 - **Fig.1050**
HUNGARY - 1974 - **Fig.1051**
MONGOLIA - 1979 - **Fig.1049**
 - 1987 - **Fig.1047**
RUSSIA - 1979 - **Fig.1048**

1046

1047

1048

1049

1050

1051

IBERO AMERICAN SUMMIT / CUMBRE IBEROAMERICANA

1052, 1053

The Ibero American Summit (Ibero-American Conference of Heads of State) convened for the first time in Guadalajara, México, in 1991. The third meeting took place in Salvador, Bahia, Brazil; the 12th meeting was held in Bávaro, Dominican Republic, and the following year in Santa Cruz, Bolivia.

IBERO AMERICAN SUMMIT — COUNTRIES REPRESENTED:

BOLIVIA - 2003 - Fig.1054
BRAZIL - 1993 - Fig.1054a
DOMINICAN REPUBLIC - 2002 - Figs.1052, 1053

1054

1054a

Fig.1047. *Mongolia, 1987 (Sc 1583)*; Fig.1048. *Russia, 1979 (Sc 4759)*; Fig.1049. *Mongolia, 1979 (Sc 1047, Mi 1192, YT 1019)*; Fig.1050. *Germany, DDR 1989 (Sc 2720, Mi 3221)*; Fig.1051. *Hungary, 1974 (Sc 2271, Mi 2271)*; Figs.1052, 1053. *Dominican Republic, 2002 (Sc 1388-1389)*; Fig.1054. *Bolivia, 2003 (Sc 1211)*; Fig.1054a. *Brazil, 1993 (Mi 2525, SG 2578)*.

INTER AMERICAN CARIBBEAN MEETING

The first meeting was convened in Havana in 1939; the second took place in Ciudad Trujillo, Dominican Republic, in 1940, and the third in Port-au-Prince the following year.

INTER AMERICAN CARIBBEAN MEETING — COUNTRIES REPRESENTED:

DOMINICAN REPUBLIC - 1940 - Figs.1055-1057
HAITI - 1941 - Figs.1058-1061

INTERPARLIAMENTARY CONGRESS

The First Inter-Parliamentary Conference was held in Paris in 1889. Its 77th Congress convened in Managua in 1987.

INTERPARLIAMENTARY CONGRESS — COUNTRY REPRESENTED:

NICARAGUA - 1987 - Fig.1062

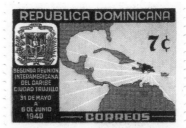
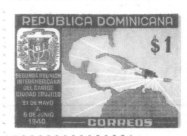
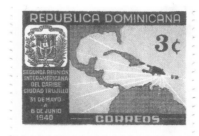

1055-1057

1062

1058-1061

Figs.1055-1057. *Dominican Republic, 1940 (Sc 362-4);* **Figs.1058-1061.** *Haiti, 1941 (Sc 358-359, C12-13);* **Fig.1062.** *Nicaragua, 1987 (Sc 1616).*

LATIN AMERICAN INTEGRATION ASSOCIATION / ASOCIACIÓN LATINOAMERICANA DE INTEGRACIÓN

(ALADI).

Created in 1980 by the 1980 Montevideo Treaty, it replaced the Latin American Free Trade Association. On the occasion of its 20th anniversary some countries issued commemorative stamps.

LATIN AMERICAN INTEGRATION ASSOCIATION — COUNTRIES REPRESENTED:

MEXICO - 2000 - Fig.1063

URUGUAY - 2000 - Fig.1064

1063

1065

1064

LATIN AMERICAN PARLIAMENT

The Latin American and Caribbean Parliament (Parlatino) was created in 1964. Its 40th and 50th anniversaries were commemorated in stamps which show the Cuban flag.

LATIN AMERICAN PARLIAMENT — COUNTRIES REPRESENTED:

MEXICO - 2014 - Fig.1066

PERU - 2004 - Fig.1065

VENEZUELA - 2004 - Figs.1066a, 1066b, 1066c, 1066d

1066

1066a, 1066b, 1066c, 1066d

186

Fig.1063. Mexico, 2000 (Mi 2849); **Fig.1064.** Uruguay, 2000 (Sc 1873); **Fig.1065.** Peru 2004 (Sc 1444) **Fig.1066.** Mexico, 2014 (Sc 2918); **Figs.1066a-1066d.** Venezuela 2004 (Sc 1444).

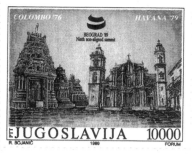

1070

1071 **1072**

1067

REPUBLIK INDONESIA

1068

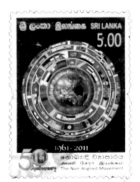

1069

NON-ALIGNED MOVEMENT/ MOVIMIENTO DE PAÍSES NO ALINEADOS

Founded in Belgrade in 1961, it provided a forum for countries which did not want to be associated with either the US or the Soviet block during the Cold War. The 5th Conference was held in Sri Lanka (1976), the 6th in Havana (1979), the 9th in Yugoslavia (1989), the 10th in Indonesia (1992), the 13th in Malaysia (2003), and the 17th in Algeria (2014).

NON-ALIGNED MOVEMENT — COUNTRIES REPRESENTED:

ALGERIA 2014 - **Figs.101, 102, p.36**
INDONESIA - 1992 - **Fig.1068**
MALAYSIA - 2003 - **Fig.1067**
SRI LANKA - 2011 - **Fig.1069**
YUGOSLAVIA - 1989 - **Fig.1070**

ORGANIZATION OF SOLIDARITY WITH THE PEOPLE OF ASIA, AFRICA AND LATIN AMERICA

The OSPAAAL was founded in Havana in January 1966, with over 500 delegates and 200 observers from more than 80 countries.

ORG. OF SOLIDARITY WITH PEOPLE OF ASIA, AFRICA & LATIN AMERICA— COUNTRIES REPRESENTED:

KOREA, DPR - 1966 - **Fig.1071**
VIETNAM, DPR - 1968 - **Fig.1072**

Fig.1067. *Malaysia, 2003;* **Fig.1068.** *Indonesia, 1992;* **Fig.1069.** *Sri Lanka, 2011 (Mi 3410?);*
Fig.1070. *Yugoslavia, 1989 (Sc 1994);* **Fig.1071.** *Korea, DPR, 1966*
(Sc 665, Mi 670); **Fig.1072.** *Vietnam, DPR, 1968 (Sc 529).*

187

PAN AMERICAN UNION/ ORGANIZATION OF AMERICAN STATES

(OAS/OEA).

1074, 1075

The Pan American Union was created in 1890 to promote cooperation among the countries of Latin America. In 1948 it was transformed into the Organization of American States, with headquarters in Washington, D.C. The Government of Cuba —but not the country itself—was expelled from membership between 1961 and 2009, and thus, the Cuban name and flag have never been absent from in its logo.

1073

PAN AMERICAN UNION — COUNTRIES REPRESENTED:

ARGENTINA - 1974 - **Fig.1076**

BAHAMAS - 1998 - **Figs.1074, 1075**

BOLIVIA - 1940 - **Fig.1073**

BRAZIL - 1984 - **Fig.1077**

CHILE - 1990 - **Fig.1078**

 - 1991 - **Fig.1079**

COLOMBIA - 1962 - **Figs.1080-1082**

COSTA RICA - 1960 - **Fig.1083**

DOMINICAN REPUBLIC - 1940 - **Figs.1084-1088**

 - 1990- **Fig.1090**

 - 1998- **Figs.1089, 1089a**

ECUADOR - 1940 - **Figs.1093-1096**

 - 1959 - **Fig.1098**

 - 1960 - **Figs.1091, 1092**

 - 1973 - **Fig.1097a**

 - 1998 - **Fig.1097**

 - 2004 - **Fig.1099**

HAITI - 1995 - **Figs.1108-1113**

HONDURAS - 1940 - **Fig.1117**

NICARAGUA - 1940 - **Fig.1115**

 - 1993 - **Fig.1114**

PANAMA - 1940 - **Fig.1116**

 - 1958 - **Figs.1100-1107**

PARAGUAY - 1973 - **Fig.1118, 1118a, 1118b**

 - 2018 - **Fig.1119**

PERU - 1998 - **Fig.1126**

US - 1940 - **Figs.1123-1125**

URUGUAY - 1958 - **Figs.1120-1122**

 - 1974 - **Fig.1127**

 - 1984 - **Fig.1128**

VENEZUELA - 1965 - **Fig.1129**

 - 1973 - **Fig.1131**

 - 1998- **Fig.1130**

Fig.1073. *Bolivia, 1940 (Sc 644).* **Figs.1074, 1075.** *Bahamas, 1998 (Sc 903-904, YT 942-3).*

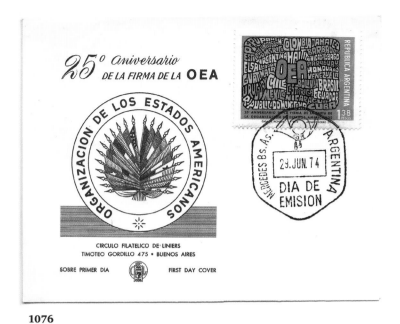

25° Aniversario
DE LA FIRMA DE LA OEA

ORGANIZACION DE LOS ESTADOS AMERICANOS

CIRCULO FILATELICO DE LINIERS
TIMOTEO GORDILLO 475 • BUENOS AIRES

SOBRE PRIMER DIA FIRST DAY COVER

1076

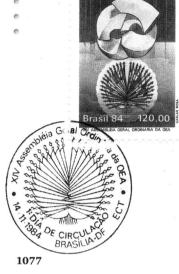

1077

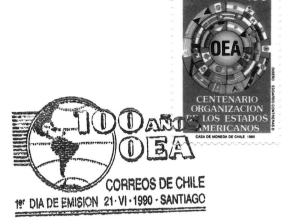

CENTENARIO ORGANIZACION DE LOS ESTADOS AMERICANOS
PRIMER DIA DE EMISION: 21 DE JUNIO DE 1990

1078

MINISTERIO · DE · COMUNICACIONES

ORGANIZACION DE ESTADOS AMERICANOS
1890 - 1961

PRIMER · DIA · DE · SERVICIO

1080-1082

MINISTERIO DE COMUNICACIONES

CONMEMORACIÓN

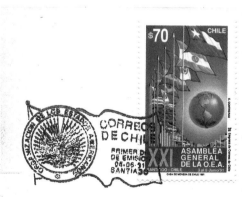

1079

Fig.1076. *Argentina, 1974 (Sc 1020);* **Fig.1077.** *Brazil, 1984 (Sc 1961);* **Fig.1078.** *Chile, 1990 (Sc 894);*
Fig.1079. *Chile, 1991 (Sc 961);* **Figs.1080-1082.** *Colombia, 1962 (Sc 743, 744, C433, Mi1019).*

REGIONAL & WORLD ORGANIZATIONS | FOREIGN RELATIONS

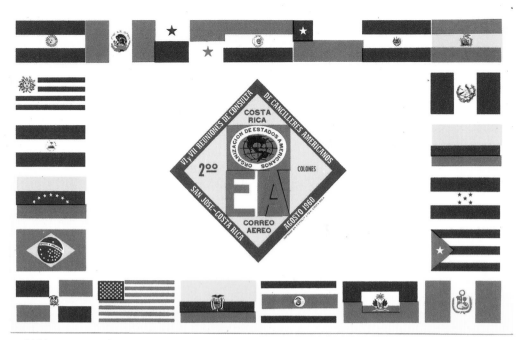

1083

1084-1088

1089, 1089a

1090

Fig.1083. *Costa Rica, 1960 (Sc C297);* Figs.1084-1088. *Dominican Republic, 1940 (Sc 351-355);* Fig.1089, 1089a. *Dominican Republic, 1998 (Sc 1880-81);* Fig.1090. *Dominican Republic, 1990 (Sc 1087).*

Inspired by Cuba! DELIVERING CUBA THROUGH THE MAIL ★ C U E T O

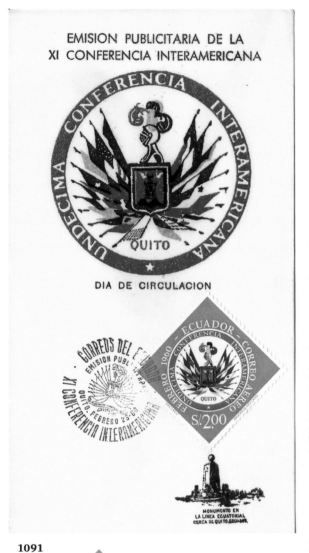

EMISION PUBLICITARIA DE LA
XI CONFERENCIA INTERAMERICANA

UNDECIMA CONFERENCIA INTERAMERICANA

QUITO

DIA DE CIRCULACION

1091

1092

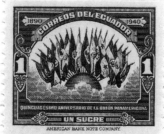

1093-1096

50
AÑOS DE LA O. E.

UNITED NATIONS

1097

50 AÑOS
OEA

2.600
SUCRES

ECUADOR

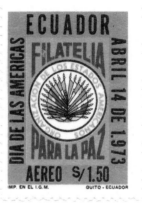

ECUADOR
FILATELIA
DIA DE LAS AMERICAS
ABRIL 14 DE 1.973
PARA LA PAZ
AEREO S/. 1.50
IMP. EN EL I.G.M. QUITO - ECUADOR

1097a

1098

1099

Figs.1091, 1092. Ecuador, 1960 (Sc C365-366); Figs.1093-1096. Ecuador, 1940 (Sc 394-397); Fig.1097. Ecuador, 1998 (YT 1404); Fig.1097a. Ecuador, 1973 (Sc 572); Fig.1098. Ecuador, 1959 (Sc C352, Mi 1010, SG 1144, YT PA353); Fig.1099. Ecuador, 2004 (Sc 1709).

REGIONAL & WORLD ORGANIZATIONS | FOREIGN RELATIONS

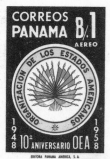
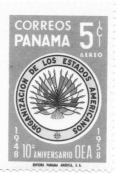
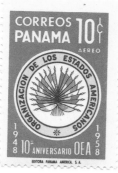

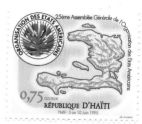

1100-1107

1108-1113

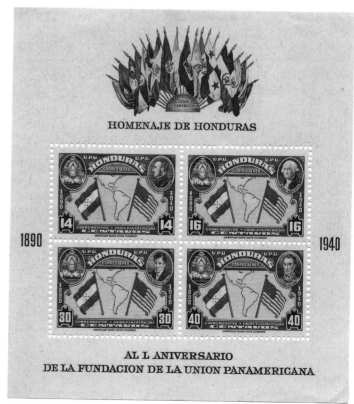

192

1114 **1115** **1116**

Figs.1100-1107. Panama, 1958 (Sc 414-417); Figs.1108-1113. Haiti, 1995 (Sc 859-864); Fig.1114. Nicaragua, 1993 (Sc 1980); Fig.1115. Nicaragua, 1940 (Sc C253, Mi 910); Fig.1116. Panama, 1940 (Sc C62); Fig.1117. Honduras, 1940 (Sc C100).

1117

Lellis 1

1118, 1118a, 1118b

PAN-AMERICAN UNION
FIFTIETH ANNIVERSARY

Commemorating Fiftieth Anniversary of the founding of the Pan American Union on April 14, 1890 of all the American Republics.

FIRST DAY COVER

1123

50th. ANNIVERSARY OF THE FOUNDING OF THE PAN-AMERICAN UNION 1890 — 1940

1124

paraguay OEA: 70 AÑOS

OEA Más Derechos para más gente 70

₲ 10.000

1119

DIA DE LAS AMERICAS — 14 DE ABRIL

44c URUGUAY 23c URUGUAY 34c URUGUAY

1120-1122

PERU s/. 2.70

1948 1998

CINCUENTENARIO DE LA ORGANIZACION DE LOS ESTADOS AMERICANOS

1126

WASHINGTON, APR. 14 9:00 AM 1940 D. C.

193

UNION OF AMERICAN REPUBLICS
1940

Commemorating
The Fiftieth Anniversary
of the founding of the
PAN AMERICAN UNION

OFFICIAL SEAL COURTESY - PAN AMERICAN UNION

Dr. A.H.W
29 York
Balto.

1125

Figs.1118, 1118a, 1118b. *Paraguay, 1973 (Sc 1486-1495);* **Fig.1119.** *Paraguay, 2018, Cinderella;*
Figs.1120-1122. *Uruguay, 1958 (Sc C176-C178);* **Figs.1123-1125.** *US, 1940;* **Fig.1126.** *Peru, 1998 (Sc 1126).*

1127

1128

1129

1130

1131

POSTAL UNION OF THE AMERICAS, SPAIN & PORTUGAL/ UNIÓN POSTAL DE LAS AMÉRICAS, ESPAÑA Y PORTUGAL (UPAEP).

Founded in 1911 as the South American Postal Union, it gradually began admitting other members from the Americas and the Iberian peninsula. On the various anniversaries of its foundation, particularly its centennial in 2011, many countries issued stamps and envelopes illustrating the flags of their members.

POSTAL UNION OF THE AMERICAS, SPAIN & PORTUGAL — COUNTRIES REPRESENTED:

ARUBA - 2011 - **Fig.1132**
COLOMBIA - 2011 - **Fig.1138**
GUATEMALA - 2011 - **Fig.1133**
NICARAGUA - 1981 - **Fig.1139**
PARAGUAY - 2011 - **Figs.1136, 1137**
PERU - 2011 - **Fig.1140**
PORTUGAL - 2011 - **Fig.1135**
SURINAME - 2011 - **Fig.1134**

Fig.1127. Uruguay, 1974 (Sc 873); **Fig.1128.** Uruguay, 1984 (Sc 1155); **Fig.1129.** Venezuela, 1965 (Sc C914); **Fig.1130.** Venezuela, 1998 (Sc 1591); **Fig.1131.** Venezuela, 1973 (Sc 1031, SG 2221).

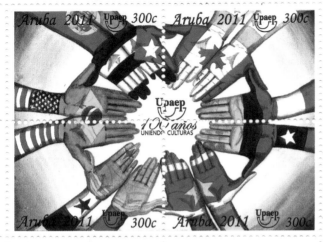

1132

1134

1138

1135

1139

1133

1136

1137

1140

195

Fig.1132. Aruba, 2011 (Sc 376, Mi 540-43); Fig.1133. Guatemala, 2011; Fig.1134. Suriname, 2011 (Sc 1779-82?); Fig.1135. Portugal, 2011 (Sc 3311, YT 3604); Figs.1136, 1137. Paraguay, 2011 (Mi 3054?); Fig.1138. Colombia, 2011; Fig.1139. Nicaragua, 1981 (Sc C979); Fig.1140. Peru, 2011 (Sc 1781).

UNITED NATIONS

(UN/ ONU).

Cuba is a founding member of the UN, created in 1945. The UN played a crucial role during the negotiations leading to the resolution of the October 1962 missile crisis.

UN – COUNTRY & POSTAL AUTHORITY REPRESENTED:

UNITED NATIONS - 1960 - **Fig.1142**

- 1988 - **Fig.1141**

US - 1962 - **Fig.1144**

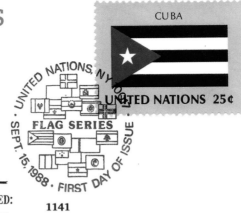

1141

SECURITY COUNCIL
Special Session
to Discuss
CUBA's
Charges
against the
UNITED STATES
"ECONOMIC AGGRESSION"

July 18, 1960

1142

UNITED NATIONS ECONOMIC COMMISSION FOR LATIN AMERICA & THE CARIBBEAN

(CEPAL, ECLAC, UNECLAC).

Established in 1948 and headquartered in Santiago, Chile, is one of the regional commissions of the United Nations.

UN ECONOMIC COMMISSION FOR LATIN AMERICA &
THE CARIBBEAN – COUNTRY REPRESENTED:

MEXICO - 1974 - **Fig.1143**

1143

*THANT'S CUBA TALKS 'FRUITFUL';
HE WILL FLY TO HAVANA TODAY;
BLOCKADE HALTED DURING TRIP*

MEET AT U.N.: U Thant, Acting Secretary General of the United Nations, with Vasily V. Kuznetsov, beside him, Premier Khrushchev's special representative for the Cuban negotiations; Valerian A. Zorin, Soviet delegate to U.N., and Brig. Indar Jit Rikhye, military adviser to Mr. Thant. Mr. Kuznetsov arrived on Sunday for talks about Cuba.

1144

Fig.1141. *United Nations, 1988 (Sc 533, Mi 558);* **Fig.1142.** *United Nations, 1960;* **Fig.1143.** *Mexico, 1974 (Sc C427);* **Fig.1144.** *US, 1962.*

FIRST FLIGHTS & OTHER COMMEMORATIVE COVERS

1927. US – KEY WEST–HAVANA

1145

Fig.1145. US, 1927.

1929. US - MIAMI-HAVANA

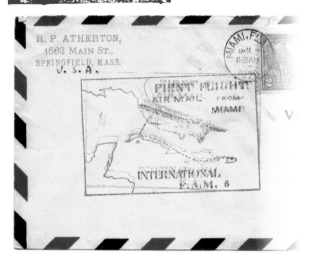

1146

1933. US - GUANTANAMO-MISSOURI U.S. WARSHIPS IN CUBAN WATER

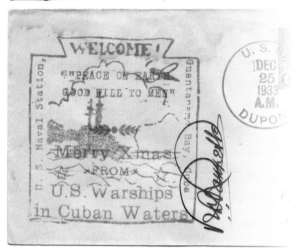

1147

1933. US - USS RICHMOND, BEFORE DEPARTURE, HAVANA FOR PANAMA

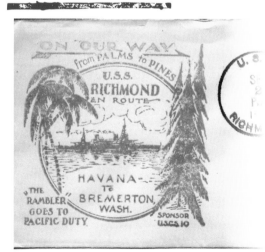

1148

1934. US - GUANTANAMO NAVAL STATION - YONKERS, N.Y.

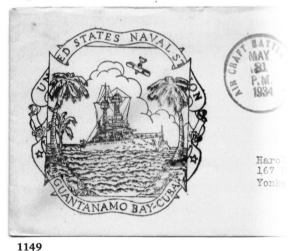

1149

1934. US - 1909 EVACUATION OF CUBA

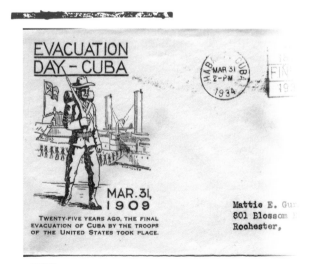

1150

1934. US - USS RICHMOND

1151

Inspired by Cuba! DELIVERING CUBA THROUGH THE MAIL ★ CUETO

Fig.1146. US, 1929; **Fig.1147.** US, 1933; **Fig.1148.** US, 1933;
Fig.1149. US, 1934; **Fig.1150.** US, 1934; **Fig.1151.** US, 1934.

1937. US – SUBMARINE USS PICKEREL GUANTANAMO BAY

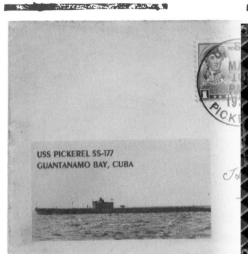

1152

1939. US – GUANTANAMO-MIAMI-CONNECTICUT

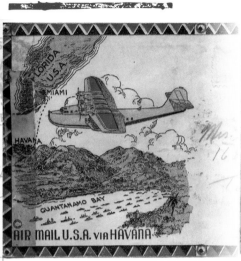

1153

1941. US – GUANTANAMO BAY-NEW JERSEY

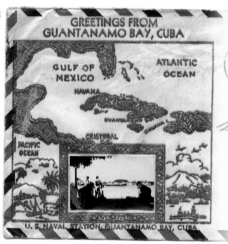

1154

1943. COSTA RICA – FIRST FLIGHT COSTA RICA-CUBA-US

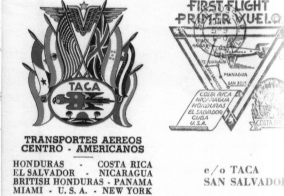

1155

1946. US – NEW ORLEANS-HAVANA

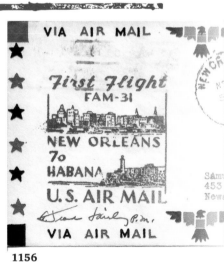

1156

1946. US – TAMPA-MIAMI-HAVANA

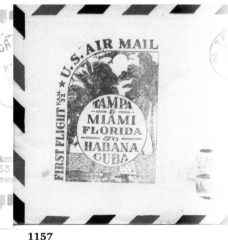

1157

1948. US – HOUSTON, TEXAS-HAVANA

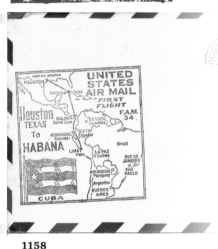

1158

1956. US – NEW YORK-HAVANA

199

1159

Fig.1152. US, 1937; **Fig.1153.** US, 1939; **Fig.1154.** US, 1941; **Fig.1155.** Costa Rica, 1943;
Fig.1156. US, 1946; **Fig.1157.** US, 1946; **Fig.1158.** US, 1948; **Fig.1159.** US, 1956.

FIRST FLIGHTS & OTHER COMMEMORATIVE COVERS

1971. CHILE - SANTIAGO DE CHILE-HAVANA

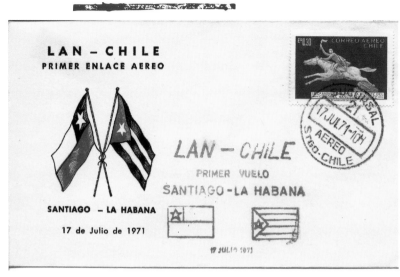

1160

1976. US - BELGIUM, BRUSSELS-HAVANA

1161

1977. US - HAVANA-KEY WEST

1162

1982. SPAIN - SEVILLA-HAVANA (1929).

1163

1982. SPAIN - SEVILLA-CAMAGÜEY (1933).

1163a

1983. SPAIN - SEVILLA-CAMAGÜEY (1933)

1164

Fig.1160. *Chile, 1971;* Fig.1161. *Belgium, 1976;* Fig.1162. *US, 1977;* Fig.1163. *Spain, 1982;* Fig.1163a. *Spain, 1982;* Fig.1164. *Spain, 1983.*

1999. UNITED NATIONS –
GENEVA-HAVANA

PREMIER
VOL
DC-10

CUBANA

GENÈVE - LA HABANA
via Paris - Orly

PAR AVION LUFTPOST VIA AEREA

Vol de CUBANA opéré avec
DC-10 de Air Outremer (France)

PHILATELISTEN-CLUB SWISSAIR
Poste restante

LA HABANA Cuba

1165

2006. US – USS PEORIA

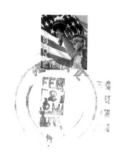

UNITED STATES NAVY
USS PEORIA PF-67
World War II Ships with Coast Guard Crews

*a 303' Tacoma Class Patrol Frigate built in Sturgeon Bay, WI
commissioned on 2 Jan 1945. During WW II she served as a
convoy escort to Algeria & weather station ship in the No. Atlantic.
Decommissioned 15 may 1946 & transferred to the Cuban Navy.*

1166

2011. THE NETHERLANDS –
AMSTERDAM-HAVANA

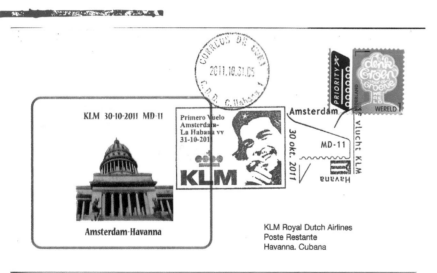

1167

2018. US – USS NEVADA

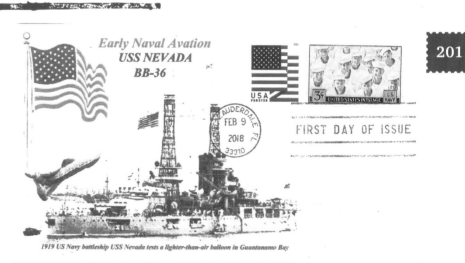

201

1168

Fig.1165. *United Nations, 1999;* Fig.1166. *US, 2006;* Fig.1167. *The Netherlands, 2011;* Fig.1168. *US, 2018.*

MISCELLANEOUS

CUBAN MAP & SYMBOLS

Cuba's flag and coat of arms, and the map of the island as well, are often used in many foreign stamps, as they provide colorful, easily recognizable symbols of the country.

Throughout this book, the Cuban flag peeks out of many stamps, particularly in those which reflect Cuba's participation in foreign affairs, games and congresses. The map of the island is always part of the narrative of the 1492 Columbus expedition and, occasionally, it will appear in the context of the island's proximity to its neighbors.

VISUAL ARTS, MUSIC & DANCE

This section includes two 1930s Cuban paintings by Bulgarian artist Kyril Zonef [Kiril Tsonev] (1896-1961), a painting by Cuban Mario Carreño (1913-1999) who went to reside in Chile and four pieces by Cuban-American artist Emilio Sanchez (1921-1999): "Los Toldos" (1973), "Ty's Place"(1976), "En el Souk" (1972) and Untitled (Ventanita entreabierta) (1981). Other images depict some of Cuba's most significant contributions to music, like the habanera, mambo and cha cha cha.

For individual musicians, see chapter on People.

VISUAL ARTS, MUSIC & DANCE — COUNTRIES REPRESENTED:

BARBADOS - 1975 - **Fig.1170**
BRAZIL - 2005 - **Fig.1169**
BULGARIA - 1987 - **Fig.1172**
 - 1996 - **Fig.1173**
CHILE - 1993 - **Fig.1171**
SPAIN - 2015 - **Fig.1174**
US - 2005 - **Figs.1175, 1176**
US - 2021 - **Figs.1177-1180**

Brasil 2005
R$ 0,80

Son

José Antonio Medina

Emissão Conjunta Brasil - Cuba

1169

BARBADOS
50 CENTS

CROP-OVER FESTIVAL · Cuban Dancers

1170

CHILE

Empresa de Correos de Chile · DIAG : A. INOSTROZA

PRIMER DIA DE EMISION

PINTURA CHILENA

SANTIAGO · CAPITAL IBEROAMERICANA DE LA CULTURA 1993

80 PESOS

MARIO CARREÑO "TARDE AMANECER"

CASA DE MONEDA DE CHILE 1993

1171

EMILIO SANCHEZ FOREVER/USA EMILIO

EMILIO SANCHEZ FOREVER/USA EMILI

КИРИЛ ЦОНЕВ
СЛУШАТЕЛКИ НА МАРИМБА

НР БЪЛГАРИЯ · ПОЩА · 1987
25ст

1172

БЪЛГАРИЯ BULGARIA
ПОЩА 3.00
южни плодове
1896 КИРИЛ ЦОНЕВ 1961
К. КЪНЕВ
1996

1173

ESPAÑA B

CORREOS

Torrevieja 2015

61. Certamen Internacional de Habaneras y Polifonía

EFEMÉRIDES · RCM-FNMT 2015

1174

EMILIO SANCHEZ FOREVER/USA EMILI

LET'S DANCE · BAILEMOS FIRST DAY OF ISSUE
New York, NY 10199 September 17, 2005

CHA CHA CHA
37 USA

MAMBO
37 USA
2005

1175 **1176**

203

EMILIO SANCHEZ FOREVER/USA EMIL

1177-1180

Fig.1169. *Brazil, 2005 (Sc 2967, Mi 3422-23, SG3436-7, YT 2926-27);*
Fig.1170. *Barbados, 1975 (Sc 425);* **Fig.1171.** *Chile, 1993;* **Fig.1172.** *Bulgaria, 1987 (Sc 3277, Mi 3601, YT 3119);*
Fig.1173. *Bulgaria, 1996 (Sc, 3904, Mi 4198, SG 4049, YT 3643);* **Fig.1174.** *Spain, 2015 (Sc 4059, Edifil 4981);*
Figs.1175, 1176. *US, 2005 (Sc 3941-3942);* **Figs.1177-1180.** *US, 2021 (SC 5594-97).*

COMMUNICATION & TRANSPORTATION

1765.
SPAIN-CUBA MAIL

SPAIN-CUBA MAIL — COUNTRIES REPRESENTED:

SPAIN - 2005 - **Fig.1181**

VENEZUELA - 1966 - **Fig.1182**

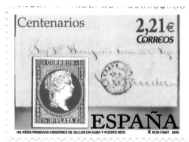

1181

1182

Fig.1181. *Spain, 2005 (Sc 3378, Edifil 4191)*; Fig.1182. *Venezuela, 1966 (Sc 1892)*; Fig.1183. *Gambia, 2005 (Sc 2930)*; Fig.1184. *Antigua, 2005 (Sc 2823)*; Fig.1185. *Marshall Islands, 2005 (Sc 868)*; Fig.1186. *Spain, 1964 (Sc 1254, Edifil 1605)*; Fig.1187. *Liberia, 2005 (Sc 2352)*.

1769-1805.
SANTÍSIMA TRINIDAD FLAGSHIP

Not to be confused with the Manila galleon of the same name, the *Nuestra Señora de la Santísima Trinidad* was built in the Royal Shipyard in Havana on March 3, 1769 and, in time, became the heaviest-armed ship in the world. It was lost in 1805 during the Battle of Trafalgar. The ship has been featured in Cuban stamps and a scale-model replica is displayed in the Fuerza Castle Maritime Museum in Havana.

SANTÍSIMA TRINIDAD FLAGSHIP — COUNTRIES REPRESENTED:

ANTIGUA - 2005 - **Fig.1184**

GAMBIA - 2005 - **Fig.1183**

LIBERIA - 2005 - **Fig.1187**

MARSHALL ISLANDS - 2005 - **Fig.1185**

SPAIN - 1964 - **Fig.1186**

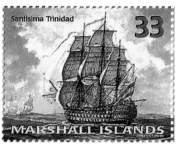

1185

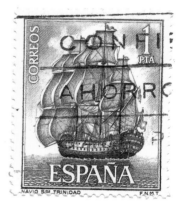

1186

1183

1184

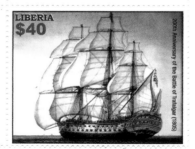

1187

1188

1189

1190

1191

1837.
FIRST RAILROAD IN THE SPANISH WORLD

In 1837, Cuba became the first territory in the Spanish-speaking world to have a functioning railroad (and the second in the Americas, after the US).

FIRST RAILROAD IN THE SPANISH WORLD — COUNTRY REPRESENTED:

SPAIN - 1988 - **Fig.1188**

1839.
AMISTAD SCHOONER

Slave ship which was the subject of a mutiny by the Mende captives, who in 1839 had been enslaved in Sierra Leone and taken to Havana. Subsequently, en route to Camagüey, the ship was diverted to New York, and the fate of the protagonists was ultimately resolved in a landmark decision by the US Supreme Court (1841).

AMISTAD SCHOONER — COUNTRIES REPRESENTED:

GHANA - 1998 - **Fig.1189**
SIERRA LEONE - 1984 - **Fig.1190**

1861.
USS SANTIAGO DE CUBA

205

Wooden, side-wheel US steamship built in 1861, assigned to Havana and elsewhere to protect the interests of the Union during the US civil war.

USS *SANTIAGO DE CUBA* — COUNTRY REPRESENTED:

NICARAGUA - 1990 - **Fig.1191**

Fig.1188. *Spain, 1988 (Sc 2555, Edifil 2949);* Fig.1189. *Ghana, 1998 (Sc 2039, Mi 350);*
Fig.1190. *Sierra Leone, 1984 (Sc 646);* Fig.1191. *Nicaragua, 1990 (Sc 1780).*

35th ANNIVERSARY

CUBA

EXPERIMENTO DEL COHETE *Postal* AÑO DE 1939

1192

XXXV ANIVERSARIO EXPERIMENTO DEL COHETE POSTAL 1939 — HABANA — 1974 AMSTERDAM, OCTUBRE 15, 1974

1939.
LAUNCHING THE POSTAL ROCKET IN CUBA. 25TH ANNIVERSARY.

On October 15, 1939 Cuba launched a postal rocket. A very detailed bibliography on the subject has been prepared by Cuban philatelist Ernesto Cuesta and is available online at www.philat.com/biblio/CUES-Rocket.pdf

LAUNCHING THE POSTAL ROCKET IN CUBA — COUNTRY REPRESENTED:

NETHERLANDS - 1974 - Fig.1192

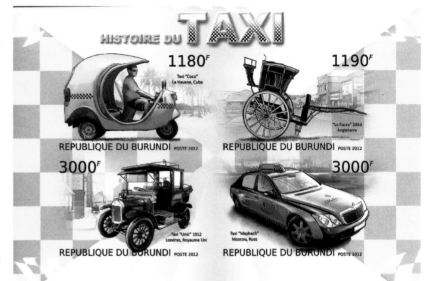

1194

ROYAL VISIT • Thirty One October 1985
$5
Petit Martinique
Carriacou
Isle De Rhonde
GRENADA·GRENADINES

1193

ATLANTIC OCEAN

H.M.Y. BRITANNIA

CARIBBEAN SEA

Petit Martinique Carriacou

1985.
UK ROYAL VISIT TO GRENADA

UK ROYAL VISIT TO GRENADA — COUNTRY REPRESENTED:

GRENADA GRENADINES - 1985 - Fig.1193

1990s.
COCO TAXI

This curious looking two/three-passenger vehicle was introduced in Havana in the 1990s, catering mostly to foreign tourists.

COCO TAXI — COUNTRY REPRESENTED:

BURUNDI - 2012 - Fig.1194

Fig.1192. *The Netherlands, 1974;* **Fig.1193.** *Grenada Grenadines, 1985 (Sc 707);* **Fig.1194.** *Burundi, 2012 (Sc 1253 a).*

1998.
HELICOPTER CARRIER JEANNE D'ARC STOPOVER IN HAVANA

HELICOPTER CARRIER STOPOVER IN HAVANA — COUNTRY REPRESENTED:

FRANCE - 1998 - Figs.1195, 1196

1195

CORRESPONDANCE
PHILATELIQUE

M. LECHEVALIER
9, Rue Jules Ferry
02000 LAON

1196

OUR LADY OF CHARITY (NUESTRA SEÑORA DE LA CARIDAD DEL COBRE)

In 1612, three native Cubans (two indians, one slave) found a small statute of the Virgin Mary floating in the Bay of Nipe (today´s Holguin province in Northeast Cuba). During the following centuries, the devotion of Cubans to Our Lady of Charity steadily grew, and in 1916 she was declared the Patron Saint of the island. For a discussion of her presence in Cuban philately, see Emilio Cueto, *La Virgen de la Caridad del Cobre en el alma del pueblo Cubano*, Ciudad de Guatemala, Guatemala, Ediciones Polymita, 2014, pp. 116-117.

OUR LADY OF CHARITY — COUNTRIES REPRESENTED:

GRENADA - 2012 - Fig.1012, p.179
MOZAMBIQUE - 2016 - Fig.1035, p.181
TOGO - 2012 - Fig.1031, p.181
VATICAN - 2012 - Fig.1033, p.181

Figs.1195, 1996. *France, 1998.*

NOTE ON BOOK DEVELOPMENT

This book developed over time, and during the time of the COVID-19 pandemic. Emilio Cueto discovered new stamps and added these during in the production process, necessitating minor numbering differences to meet publication in 2021. The book includes all stamps known and available as of July 21, 2021.

The numbering differences are: derivative numbers (38), not assigned (3), and not illustrated items (9). Details on these:

- Derivative numbers (38): 76a, 76b, 77a, 106a, 106b, 125a, 146a, 346a, 424a, 500a, 662a, 842a, 842b, 842c, 842d, 842e, 842f, 842g, 842h, 879a, 962a, 970a, 959a, 1005a, 1042a, 1042b, 1044a, 1044b, 1054a, 1066a, 1066b, 1066c, 1066d, 1089a, 1097a, 1118a, 1118b, 1163a

- Not assigned (3): 206, 207, 630

- Not illustrated (9): four Chad, p.37; Sasha Yakutia, p.37; Togo, p.179; Turkmenistan, p.179; two US, pp.71, 127

EMILIO CUETO

DELIVERING CUBA THROUGH THE MAIL

Cuba's Presence in Non-Cuban Postage Stamps & Envelopes

The "Copyright & Fair Use Evaluation"
is available as a digital appendix:
https://ufdc.ufl.edu/AA00081344/00001/pdf

209

LIST OF COUNTRIES & POSTAL AUTHORITIES

211

LIST OF COUNTRIES & POSTAL AUTHORITIES

213

The first in the *Inspired by Cuba* series by Emilio Cueto and from the LibraryPress@UF. The volumes in this series celebrate Cuba as depicted from across the world, with this first volume focusing on Cuba in ceramics.

Inspired by Cuba!
A *survey* of Cuba-themed ceramics

From fine china to tobacco jars to baseball memorabilia, this amazing collection represents a wide range of Cuban-themed ceramics…

Inspired by Cuba explores the many ways in which the island of Cuba has been immortalized in ceramics. The pieces range from the mid-18th century to recent years. These objects represent many years of collecting and fall into two classifications. First, those pieces illustrated with images and symbols of the island or its people, or with references to named places, official institutions or commercial establishments inside, and even outside, the island. Next, those items which use the name of Cuba (and variations thereof) or Havana, as a catchy, attractive brand that appeals to consumers' fascination and desire for all things Cuban.

Buy a print copy at https://upf.com/book.asp?id=9781944455088.

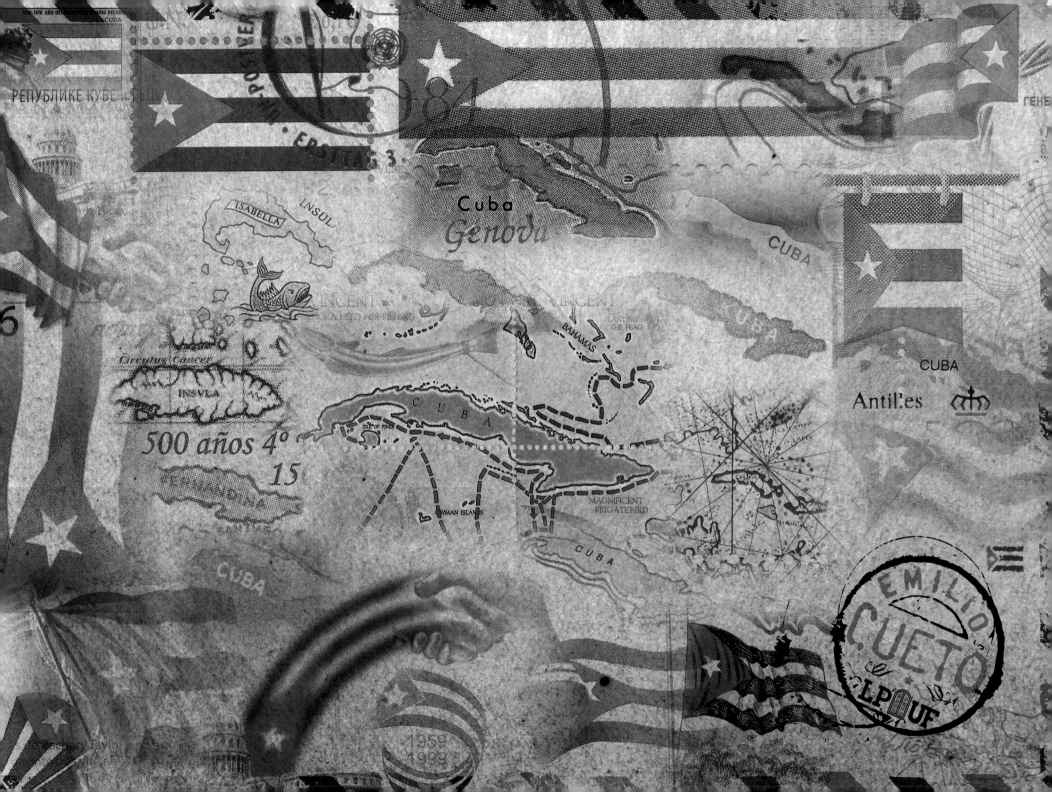

Inspired
by
CUBA

Cuba's Presence in Non-Cuban
Postage Stamps & Envelopes